MUSSOLINI'S ROME

ITALIAN AND ITALIAN AMERICAN STUDIES

Stanislao G. Pugliese

Hofstra University
Series Editor

This publishing initiative seeks to bring the latest scholarship in Italian and Italian American history, literature, cinema, and cultural studies to a large audience of specialists, general readers, and students. I&IAS will feature works on modern Italy (Renaissance to the present) and Italian American culture and society by established scholars as well as new voices in the academy. This endeavor will help to shape the evolving fields of Italian and Italian American Studies by re-emphasizing the connection between the two. The following editorial board of esteemed senior scholars are advisors to the series editor.

Queer Italia: Same-Sex Desire in Italian Literature and Film
edited by Gary P. Cestaro
July 2004

Frank Sinatra: History, Identity, and Italian American Culture
edited by Stanislao G. Pugliese
October 2004

The Legacy of Primo Levi
edited by Stanislao G. Pugliese
December 2004

Italian Colonialism
edited by Ruth Ben-Ghiat and Mia Fuller
July 2005

Mussolini's Rome: Rebuilding the Eternal City
Borden W. Painter Jr.
July 2005

Representing Sacco and Vanzetti
edited by Jerome A. Delamater and Mary Ann Trasciatti
forthcoming, September 2005

Carlo Tresca: Portrait of a Rebel
Nunzio Pernicone
forthcoming, October 2005

MUSSOLINI'S ROME

Rebuilding the Eternal City

BORDEN W. PAINTER, JR.

First published in hardcover in 2005 by
PALGRAVE MACMILLAN™
175 Fifth Avenue, New York, N.Y. 10010 and
Houndmills, Basingstoke, Hampshire, England RG21 6XS.
Companies and representatives throughout the world.

PALGRAVE MACMILLAN is the global academic imprint of the Palgrave Macmillan division of St. Martin's Press, LLC and of Palgrave Macmillan Ltd. Macmillan® is a registered trademark in the United States, United Kingdom and other countries. Palgrave is a registered trademark in the European Union and other countries.

ISBN-13: 978-1-4039-8002-0 paperback
ISBN-10: 1-4039-8002-0 paperback

Library of Congress Cataloging-in-Publication Data is available from the Library of Congress.

A catalogue record of the book is available from the British Library.

Design by Letre Libre

First PALGRAVE MACMILLAN paperback edition: January 2007

10 9 8 7 6 5 4 3 2 1

Printed in the United States of America.

Transferred to digital printing in 2007.

CONTENTS

Preface and Acknowledgments vii

List of Maps and Illustrations xi

Introduction xv

1. Mussolini's Obsession with Rome 1

2. Celebration and Construction, 1932–1934 21

3. Sports, Education, and the New Italians 39

4. Architecture, Propaganda, and the Fascist Revolution 59

5. Population, Neighborhoods, and Housing 91

6. Axis and Empire 115

7. War and Resistance 141

Appendix I *Chronology* 163

Appendix II *Fascist Place and Street Names* 167

Notes 169

Bibliography 185

Index 193

PREFACE AND ACKNOWLEDGMENTS

I developed the idea for writing this book during numerous trips to Rome over the past three decades. Trinity College's undergraduate program in Rome, founded in 1970, afforded me the opportunity to return to Rome often as teacher, administrator, and researcher. In 1971 I taught in the summer program and began to explore Rome from our site in a convent on the Aventine Hill. How glorious it was to discover the ancient, medieval, Renaissance, and baroque sites of the city!

From the Aventine I could look over the Circus Maximus to the Palatine Hill. Just to the left was the Capitoline and to the right the Arch of Constantine and the Colosseum. Around the corner from our campus was the fifth-century church of Santa Sabina, and just down the street the Knights of Malta with Piranesi's famous keyhole view of St. Peter's Dome. I discovered the word palimpsest as an apt description of Rome as one layer of history upon another.

As I explored the neighborhood and the city, I began to notice the remnants of a more recent layer of Rome's history, the fascist period. There on the modern retaining wall of the ancient Theater of Marcellus was the *fascio,* the bundle of sticks with a protruding ax that gave fascism its name and its symbol. The Theater of Marcellus looks out on a wide street that is obviously modern. In fact, it is clearly of fascist origin, for there are large fascist-era office buildings on both sides of the street. The largest one, now the Anagrafe, Rome's hall of records, bears the plaque with Mussolini's name still quite legible.

In the early 1980s I began to read articles about architecture during the fascist period and about many of the buildings erected by the regime in Rome. Fascist architecture, art, and culture had begun attracting scholarly attention on a large scale for the first time since World War II. Then in 1982 I organized a conference on "Mussolini and Italian Fascism" at Trinity College with papers given by an international group of historians, including Renzo De Felice and Denis Mack Smith. An archivist from the Archivio Centrale dello Stato in Rome presented a paper that caught my interest. He described the ACS's efforts to organize its collections of documents relating to the Exhibition of the Fascist Revolution, the Mostra della Rivoluzione Fascista (MRF) of 1932. A few years

later, I commenced reading about the MRF at the archives and thus began research on Rome during the fascist period.

The research on the Mostra led to a wider study of Rome's transformation by Mussolini. I began to think about this book in the fall of 1996 while teaching in Trinity College's Rome program, especially while taking students on several walking tours of "Mussolini's Rome." I returned for another semester in 2000. This time I had more information to share with my students and hundreds of slides to use in showing them how the fascist regime had transformed the city. In between these two semesters in Rome, several colleagues in modern Italian history encouraged me to write a book about Mussolini's transformation of Rome that would be both comprehensive and concise. I also began to give slide lectures on the subject to both academic and more general audiences. The enthusiastic reception of these lectures further convinced me that a book on fascist Rome would appeal to a variety of readers. Rome is, after all, one of the great cites of the world, attracting millions of readers and visitors every year. Such a book would open up a new way to see and understand the city.

The scholarly interest that began in the early 1980s has borne fruit in many articles and monographs on various aspects of fascist art, architecture, culture, and propaganda. This book combines a synthesis of much of that scholarly work with my own research. I trust that the result will be of interest to scholars, students, and general readers.

There are many friends and colleagues to thank for the help, inspiration, and advice I received over the years. The late George Cooper encouraged me to begin teaching courses on modern Italy in the early 1970s. Michael Campo founded Trinity's Rome program in 1970, which opened up opportunities for teaching and research in Italy and continues to this day to inspire and inform me in countless ways. More recently my colleagues John Alcorn and Dario Del Puppo provided support for this subject through the Barbieri Endowment for Italian Culture at Trinity. I am grateful to Kristin Triff for her enthusiastic support and her perspective as an architectural historian. Colleagues at the Rome program, especially Livio Pestilli, Francesco Lombardi, and Patricia Osmond, have helped me literally find my way around Rome as well as offered help and advice that could come only from natives and residents of the city.

The list of fellow historians of modern Italy whose work, example, and friendship have been so important to me includes Philip Cannistraro, Alexander De Grand, Frank Coppa, Joel Blatt, Ruth Ben-Ghiat, Marla Stone, Mary Gibson, Roy Domenico, John Davis, Mark Seymour, Alice Kelikian, Andy Canepa, Spencer Di Scala, Roland Sarti, Alexander Stille, and the late Claudio Segre. Some were regulars at the Columbia University Seminar on Modern Italy,

which provides a wonderful forum for those of us close enough to New York to attend. Special thanks to Stan Pugliese, whose interest in my presentation on "Mussolini's Rome" to the seminar in March 2003 led to the contract with Palgrave Macmillan.

I did the research for this book in a number of places. The Yale libraries contain many books and periodicals from the 1930s. A trip to the Wolfsonian Institution in Miami Beach allowed me to read a number of difficult-to-find Italian publications from the period. The Archivio Centrale dello Stato and the Biblioteca Nazionale in Rome are rich in materials and relatively easy, by Italian standards, to use. In the fall of 2000 I spent many hours at the library of the American Academy in Rome and, thanks to its hardworking copying machines, could bring thousands of pages of material home. Trinity College's library has excellent resources in modern Italian history that I have relied on for the past three decades. I am indebted to the staff at all these institutions for their professionalism and many kindnesses.

My daughter Ellen Dollar gave me the benefit of her skill and experience as an editor by going over the final draft. My Trinity colleague Tom Truxes then read the entire text and made many suggestions that improved the final version. Jo Lynn Alcorn patiently and expertly designed the map. Melissa Nosal and the editorial staff at Palgrave Macmillan provided help and guidance every step of the way, from manuscript to book.

I dedicate this book to my wife Ann. Her love and support kept me on track in my four decades at Trinity. Together we made Rome our second home and spent countless hours exploring it in search of Mussolini's Rome. Her good sense and good suggestions helped at every stage of writing. Any shortcomings in the final product are, of course, mine.

LIST OF MAPS AND ILLUSTRATIONS

MAPS

Roma di Mussolini xx
Historic Center and E'42 129

ILLUSTRATIONS

(Dates indicate when photographs were taken)

1.1 The Site of Roman Temples in the Largo Argentina, 1929 9
1.2 Work on the Via del Mare, Victor Emmanuel Monument
 in the background, 1929 11
1.3 Clearing the Via del Mare, Capitoline on the left,
 Theater of Marcellus in the background, 1930 12
1.4 Mussolini opens the first part of the Via del Mare,
 Theater of Marcellus in the background, 1930 13
1.5 Mussolini, Muñoz on his left, in the Piazza Bocca
 della Verità, Arch of Janus in the background, 1930 13
1.6 Casa Madre dei Mutilati, 2000 15
1.7 Mussolini examines the model of the Foro Mussolini, 1929 15
1.8 The Foro Mussolini during the construction
 of the Ponte Duca d'Aosta, 1939 16
2.1 Via dell'Impero from the Colosseum to
 the Victor Emmanuel Monument, 1932 23
2.2 Military parade on the Via dell'Impero, c. 1937 25
2.3 The Mostra della Rivoluzione Fascista,
 the Via Nazionale, 1932 27
2.4 New Governatorato building, Via del Mare, 1938 34
2.5 Palazzo Braschi, Corso Vittorio Emanuele,
 Elections,1934 37

3.1 Mosaics, "IX May XIV E[ra] F[ascista]
 Italy Finally Has Its Empire" Foro Mussolini, 2000 42
3.2 Mussolini reviews military and youth formations,
 Stadio dei Marmi, Foro Mussolini, 1939 44
3.3 Athletes in the Stadio dei Marmi, Foro Mussolini, c. 1932 45
3.4 The Casa Littoria during construction, Foro Mussolini, 1940 48
3.5 Building for the Gioventù Italiano
 del Littorio (GIL) by Luigi Moretti, Trastevere, 1999 52
3.6 Alessandro Manzoni Elementary School,
 Via Vetulonia, (originally named
 for Mario Guglielmotti), 1999 56
4.1 Rome University, Administration Building, 1999 65
4.2 Mussolini Opens the Aventine Post Office,
 Via Marmorata, 1935 67
4.3 Mussolini and Giuseppe Bottai at inauguration
 of the project for the Via della Conciliazione, 1936 70
4.4 Mussolini visits workers on the
 Via della Conciliazione, 1937 71
4.5 Demolition of the north curve
 on the Piazza Navona, 1937 72
4.6 Piazza Augusto Imperatore, Mausoleum
 of Augustus on the right, 2000 75
4.7 Mostra Augustea della Romanità, Via Nazionale, 1937 76
4.8 Mostra delle Colonie Estive, Circus Maximus, 1937 81
4.9 Mussolini visits the work in the Agro Pontino, 1931 85
4.10 Town Hall, Littoria (now Latina), 2003 88
5.1 ONMI Building, Trastevere, 2000 93
5.2 Albergo Rosso, Garbatella, 1999 97
5.3 Case popolari on the Via Donna Olimpia, 1938 99
5.4 Case convenzionate, Viale XXI Aprile, 2000 101
5.5 Case convenzionate, Prenestino neighborhood, 1930 102
5.6 Mussolini at the cornerstone laying
 for the INCIS housing at the Porta Metronia, 1938 103
5.7 Model for the INCIS housing at Porta Metronia, 1938 103
5.8 Via Porta Angelica, 2003 104
5.9 Case popolari, Via Marmorata,
 Testaccio neighborhood, 2000 107
5.10 Caserma Mussolini, Viale Romania, 1938 111

6.1 Mussolini laying the cornerstrone
 for the Istituto Luce, 1937 118
6.2 La casa dei Marescialli d'Italia
 (now the Consiglio Superiore della Magistratura),
 Piazza Independenza, 2000 126
6.3 Mussolini views the model for E'42 (EUR), 1938 128
6.4 Palazzo della Civiltà Italiano,
 (The "Square Coliseum"), EUR, 1940 130
7.1 Mussolini reviews antiaircraft forces, Colosseum, 1939 143
7.2 Pyramid of Caius Cestius, Porta S. Paolo,
 with memorials to the resistance
 and the liberation of Rome, 1997 152
7.3 Memorial to Giacomo Matteotti, 2003 154
7.4 Memorial at the Fosse Ardeatine, 1988 155
7.5 Obelisk of Axum about to be dismantled, 2003 159
7.6 Mussolini as the culmination of Rome's history, EUR, 2001 160

PHOTO CREDITS

The Author: 1.6, 3.1, 3.5, 3.6, 4.1, 4.6, 4.10, 5.1, 5.2, 5.4, 5.8, 5.9, 6.2, 7.1, 7.3, 7.4, 7.6

Istituto Luce (Gestione Archivi Alinari): 1.1, 1.2, 1.3, 1.4. 1.5, 1.7, 1.8, 2.2, 2.3, 2.4, 2.5, 3.2, 3.4, 4.2, 4.3, 4.4, 4.5, 4.7, 4.8, 4.9, 5.3, 5.5, 5.6, 5.7, 5.10, 6.1, 6.3, 6.4, 7.1

Archivio Fratelli Alinari: 3.3, 2.1

Kristin Triff: 7.5

INTRODUCTION

This book is about a Rome often seen but not noticed: the Rome of fascism, or "Mussolini's Rome." Fascism transformed Rome. The city has a fascist imprint that has changed the way we experience the city today. Many of Rome's monuments, from the Colosseum to Saint Peter's, have fascist settings. Beyond the historic center, there stand whole areas or "cities" constructed by the fascists, such as the Foro Mussolini, now Foro Italico; the city for sports and physical education; the Città Universitaria, or university city, for Rome; the Cinecittà for producing films; and EUR, the Esposizione Universale di Roma, the fascist city of the future.

Mussolini's Rome gives us a picture of Italian fascism that puts into sharp relief fascism's character and identity. Mussolini sought to rebuild the city in his own image as the centerpiece of his "fascist revolution." It thus embodied the values of the regime and its goal to change Italy through producing a new generation of Italians. Fascism's definition of itself and its historic role were nowhere more clearly seen than in Rome. The purpose of this book is to bring together for the first time a comprehensive history of Rome during the fascist period, showing how and why Mussolini transformed the city. It offers a perspective on the regime that has significance for any definition of Italian fascism. Mussolini's Rome—its streets, buildings, stadiums, and what took place in them—embodied the fascism that ruled Italy for twenty years.

Something of what Mussolini sought to achieve in those twenty years can be captured by looking at his activities on one particular day, a day typical for him. On February 28, 1938, the Duce made a triumphal trip through the city of Rome to visit the sites of public works that were transforming the city. Much had already been accomplished in the sixteen years of his regime, but the work never let up. The story that appeared the next day on the front page of the Fascist Party daily, *Il Popolo d'Italia,* followed the Duce's rapid progress from one site to another in a way that summarized what had changed and what was changing. Here was a new Rome for all Italy and the world to see.

Mussolini's visit on that day took him first to places near the Piazza Venezia: the Victor Emmanuel Monument, the Capitoline Hill, the Palatine Hill, and

the Circus Maximus. The wide, new, fascist Via del Mare, running from the Piazza Venezia to the Circus Maximus, exposed ancient buildings such as the Theater of Marcellus, the Arch of Janus, and the Temples of Vesta and Fortuna Virilis. The regime had cleared the Circus Maximus of buildings and shacks several years before and made it the site of fascist exhibitions and demonstrations. On this particular day, it was the site of the Exhibition on National Textiles that had opened in November for five months. Mussolini moved on to the far end of the Circus, where his new Africa building (today the Food and Agricultural Organization, FAO, of the United Nations) was under construction next to the ancient Obelisk of Axum, brought from Ethiopia the year before as a symbol of fascism's new empire. Not far away, the new Ostiense train station, near the Porta San Paolo, was nearing completion in time for Adolf Hitler's arrival in early May. Mussolini visited the partially completed Via Imperiale, the grand boulevard that would eventually link the historic center of Rome with the Lido and the site of the planned Universal Exposition of Rome (EUR) scheduled for 1942, the twentieth anniversary of the March on Rome. As *Il Popolo d'Italia* proclaimed, Mussolini's Rome would achieve a new *grandezza,* or grandeur, for the present and the future.

Mussolini fell from power just five years later in July 1943, and in April 1945 partisans executed him and strung his body up in a gas station in Milan. War and defeat stalled and then ended Italian fascism's transformation of Rome. The new postwar Italy identified itself as "antifascist" and set about erasing the memory of fascism and its leader. In Rome the names of fascist streets and sites changed so that there was no more Via del Mare, no more Foro Mussolini, no more Viale Adolfo Hitler. Statues of Mussolini and other remnants of fascism, especially the omnipresent fascist symbol, the fasces (a bundle of rods with a protruding ax blade), were destroyed. In a modern version of ancient Rome's *damnatio memoriae,* the present sought to rewrite the past to suit present needs. The results in Rome, however, could be only partial. The Via del Mare became the Via del Teatro di Marcello, but the fascist street remains, as do the imposing fascist office buildings lining it. The sports complex known as the Foro Mussolini became the Foro Italico, but the obelisk with Mussolini's name on it remains, as do the fascist mosaics, commemoratory tablets, and buildings from the 1930s. The Viale Adolfo Hitler became the Viale delle Cave Ardeatine, commemorating victims of the Nazi occupation, but the street still leads to the fascist Ostiense Station, where Mussolini greeted Hitler on May 3, 1938.

Architectural historian Spiro Kostof got it right when he concluded thirty years ago that "the Duce's *damnatio memoriae* was halfhearted. His name disappeared from most inscriptions, and the fasces chiseled or painted out. But his

imprint upon the Eternal City was ineradicable."[1] And so it remains today that throughout Rome are streets, stadiums, railroad stations, schools, post offices, apartment complexes, and structures of all kinds from the fascist period. Mussolini's Rome shaped the way we see Rome today, and it gives us an invaluable perspective on the history and nature of Italian fascism.

Interest in Mussolini's Rome has emerged in the past several decades after its neglect in the postwar years. Most Italians wanted to forget about the Duce and twenty years of fascism. Intellectuals adopted a firmly antifascist stance, and historians concentrated great energy on antifascist themes and the armed resistance. These interests and attitudes rejected any notion that fascist art, architecture, and culture were subjects worthy of study. As the Italian intellectual Norberto Bobbio put it, "Where there was culture it was not fascist and where there was fascism it was not culture. There never was a fascist culture."[2]

In a 1950 article, architectural critic Henry Hope Reed depicted the fascist imprint on the city as the "third sack" of Rome since unification in 1870. The speculators came first, then the traffic planners, and then the "Fascist imperialists." Mussolini sought to re-create ancient Rome and to expand the city's population at all costs. The results were, first, the "destruction of a great deal of the baroque city, to reveal endless vistas of historic rubble," and second, "the extension of [the city's] boundaries and the building up of innumerable acres of modern apartment buildings."[3]

Italo Insolera's *Roma moderno, un secolo di storia urbanistica* (1962) contained valuable information on the fascist period, but the dominant opinions dismissed or ignored the fascist imprint on Rome. The situation changed dramatically in the 1970s and early 1980s as scholars began to reassess the fascist period with respect to the regime's cultural policies and patronage. Urbanists and architectural historians in this country and Italy led the way. Spiro Kostof wrote the catalog for the 1973 exhibit on modern Rome that remains a landmark for the study of fascist Rome: *The Third Rome, 1870—1950: Traffic and Glory* (1973).[4] Antonio Cederna's *Mussolini Urbanista: lo sventramento di Roma negli anni del consenso* appeared in 1979. A 1982 exhibit in Milan and its catalog, *Anni Trenta* (1982), encouraged a wider interest in objects and artifacts of the 1930s.

The Italian architectural historian Giorgio Ciucci led the way in the study and reassessment of the fascist regime's relationship to architecture and architects in the 1980s. His book *Gli architetti e il fascismo: Architettura e città 1922–1944* (1989) provided a compact and comprehensive guide to urban architecture during fascism. Ciucci's visits to American universities and participation in international conferences and symposia sparked new interest in the United States.[5]

Among American architectural historians, Diane Ghirardo emerged as the major advocate for a new look at the fascist period. In her path-breaking 1980 article, "Italian Architects and Fascist Politics: An Evaluation of the Rationalist's Role in Regime Building,"[6] she argued that many of Italy's leading modern architects, such as Giuseppe Pagano and Giuseppe Terragni, were "ardent Fascists" in the 1930s who willingly and enthusiastically accepted commissions from the regime. She subsequently declared that she wished to contest "the prevailing impression in most histories that Mussolini oversaw uniquely negative architectural and urban transformations unusually responsible for the degradation of the twentieth-century city."[7] Other American architectural historians have made notable additions to the growing body of scholarly work on the fascist period.[8]

By the 1990s the historiography of Italian fascism included work by a host of historians eager to explore the culture of the fascist period. The regime's cultural policies and its efforts to mobilize the Italian people through those policies gained a place in the mainstream of scholarship. The American historian Philip Cannistraro's *La Fabbrica del Consenso* paved the way in 1975 by examining the regime's attempt to control cultural life through its Ministry of Popular Culture, nicknamed "Minculpop."[9] Marla Stone, Ruth Ben-Ghiat, Jeffrey Schnapp, Simonetta Falasca-Zamponi,[10] and other historians have advanced our knowledge and understanding of fascism's mix of art, architecture, culture, and propaganda in pursuing its revolution to transform Italy and Italians. This body of work has sparked new debate on Italian fascism's cultural policies and practices. The study of Mussolini's Rome illustrates the definition of history as an ongoing debate among historians about the meaning of the past.[11]

This book focuses on the transformation of Rome as a central and revealing part of fascist policy and goals. It is a textbook of the fascist regime and what it sought to do and be throughout all the changes, contradictions, successes, and failures of its two decades. Mussolini's Rome reveals fascism as it presented itself through its policies, programs, and practices. Fascist Rome would be modern while basking in the glory of imperial Rome. It would transform youth through education, sports, and physical training. It would build a new social and economic order through corporatism and social welfare, from maternity benefits to housing for all classes of society. All these themes and more make up the story of Mussolini's Rome.

The ultimate failure and defeat of fascist Italy is clear enough today, but at the time, fascism appeared to be strong, resolute, and successful. Many observers viewed it as a legitimate, durable ideology and government. In the context of the 1930s, Mussolini's new Rome stood as a manifestation of fascism's energy and

modernity. Rome demonstrated that the Duce could do much more than just make the trains run on time.

The story concludes with the birth in Rome of militant antifascism and the armed resistance in September 1943, the liberation by Allied forces on June 4, 1944, and the postwar efforts to remove as much as possible of Rome's fascist layer. Those efforts proved to be largely cosmetic, for so thoroughly had Mussolini changed the city that, given only minor damage during the war, most of what he wrought remains today. For better or worse, the Rome of today is not only the city of Roman emperors, Catholic popes, and Italian kings; it is also the "Roma di Mussolini."

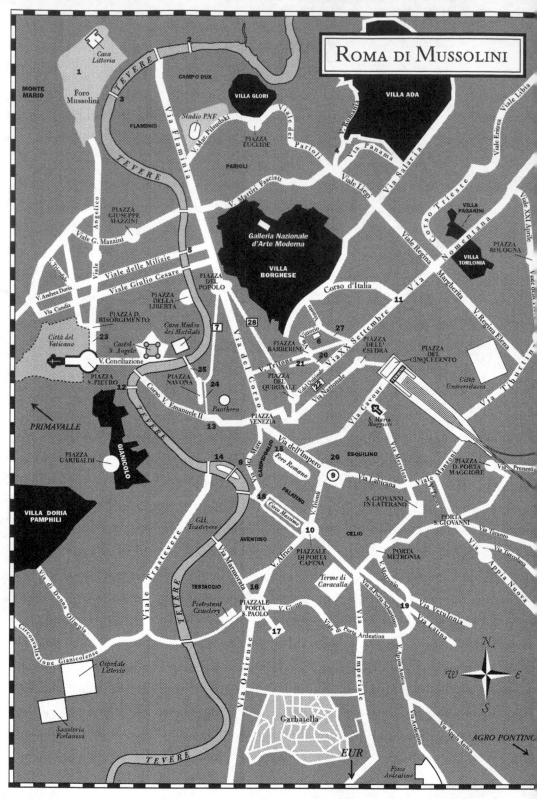

Roma di Mussolini

1. Stadio dei Marmi, Stadio Olimpico
2. Ponte XXVIII Ottobre
3. Ponte Duca d'Aosta
4. Caserma Mussolini
5. Ponte Littorio
6. Ministero delle Corporazioni
7. Mausoleo di Augusto, Ara Pacis
8. Teatro di Marcello
9. Colosseo, Arco di Constantino
10. Obelisco di Axum, Ministero Africa Italiana
11. Porta Pia, Monumento al Bersagliere
12. Ponte Principe Amedeo Savoia Aosta
13. Largo Argentina
14. Ghetto, Sinagoga
15. Ara dei Caduti Fascisti
16. Uff. Postale Aventino, Parco Cestio
17. Stazione Ostiense
18. Piazza Bocca della Verità
19. Porta Latina
20. Via Quattro Fontane
21. Via Rasella
22. Palazzo delle Esposizioni
23. Via Porta Angelica
24. Corso Risorgimento
25. Via Zanardelli
26. Parco Colle Oppio, Parco Traiano
27. Via XXIII Marzo
28. Spanish Steps

One

MUSSOLINI'S OBSESSION
WITH ROME

On October 28, 1922, King Victor Emmanuel III invited Benito Mussolini, leader of the Fascist Party, to form a government. It was a triumphant moment for Mussolini, who had founded the fascist movement only three and a half years before with a few hundred followers in Milan. The movement had taken off by 1920, attracting thousands of adherents, especially veterans of the Great War. Mussolini transformed the movement into a political party that offered Italians a hypernationalism and promised to give Italy new life through a program of internal unity and external strength. Fascism promised its own revolution, but one that would produce a new Italy and new Italians while saving the nation from class warfare and a bloody Bolshevik-style revolution.

Italy's postwar liberal, democratically elected governments seemed paralyzed in the face of internal unrest, unemployment, strikes, factory occupations, peasant seizure of lands, and political divisions. The Catholic Popular Party would not cooperate with the larger Socialist Party which, in turn, suffered a schism when a minority of its members founded the Italian Communist Party in January 1921. Fascism represented itself as a new, fresh, and energetic movement that would tame the socialists and communists, protect property, and bring about change without the trauma of armed revolution. Fascists gained local power in areas of central and northern Italy through the raids of their blackshirted squads, who used intimidation and violence to gain the upper hand. In the face of a paralyzed national government, the fascists threatened to seize

power in October 1922, when columns of black shirts began marching on Rome from areas of fascist strength. Rather than risk armed conflict between the marchers and the army, the king asked the fascists to form a government.

At the age of thirty-nine, Mussolini became Italy's youngest prime minister. The fascist anthem, "Giovinezza" ("Youth"), conveyed the message that fascism brought youth, energy, and new ideas to Italy. The fascist party, however, still had a relatively small number of members in the Italian Parliament, so Mussolini formed a coalition government with the immediate aim of bringing the country a measure of stability. At first the new government did well enough, but in 1924 a socialist member of Parliament and most outspoken critic of the regime, Giacomo Matteotti, died at the hands of fascist thugs with at least the tacit approval of Mussolini. Following the arrest of the assassins, the government seemed hesitant and on the verge of collapse, but Mussolini, always the opportunist and skillful political tactician, used the crisis to defy his critics to transform Italy into a one-party dictatorship by 1926.

Italy had become fascist Italy. Prime Minister Mussolini now became the Duce, the leader of fascism and fascist Italy. His civilian, often formal, diplomatic dress gave way to a uniform of the fascist militia. The Duce used his considerable oratorical skills to galvanize popular opinion behind his movement and his regime. Mussolini knew how to play to the crowd, to court and seduce the throngs who gathered to hear him. In 1929, he moved his office from the Palazzo Chigi to the Palazzo Venezia on the piazza adjacent to the national Victor Emmanuel II monument, symbol of Italian unity and the resting place of Italy's Unknown Soldier. The balcony of the Palazzo Venezia provided him with his most famous podium from which to harangue the crowds who filled the vast space of the Piazza Venezia for the "oceanic" rallies that were the icon of Mussolini's Rome. Mussolini had declared the center of Rome, this sacred space of the nation, to be the "heart" of the new fascist Italy. "Guides to the city, which formerly began their descriptions of the city with the Campidoglio or the Vatican, now began with Piazza Venezia."[1]

Mussolini brought to his office a fascination—even an obsession—with Rome. It is true that as a socialist he had denounced Rome as a "parasitic city of landladies, shoeshine boys, prostitutes and bureaucrats," but as a fascist he understood the importance of Rome and its history in the formation of a new ideology that would wed past and present.[2] He now saw it as his mission to make the city once more a place of greatness and grandeur worthy of Rome's imperial past. The city's rich history, monuments, and sites could now be used and refashioned by the regime to define and display the new fascist Italy. Fascism prided itself on being modern, dynamic, and progressive, and Mussolini saw no

contradiction in using Rome's history to define its mission and point toward the future. "The idea of Rome obsessed Mussolini's mind since the end of World War I, not only because it was the seat of government he sought to capture but also because of its mystic power around which the new order could be forged."[3]

Some months before the March on Rome, Mussolini declared on April 22, 1922:

> Rome is our point of departure and reference. It is our symbol or, if you wish, our myth. We dream of a Roman Italy, that is to say wise, strong, disciplined, and imperial. Much of that which was the immortal spirit of Rome rises again in Fascism: the Fasces are Roman; our organization of combat is Roman, our pride and our courage is Roman: *Civis romanus sum.* It is necessary, now, that the history of tomorrow, the history we fervently wish to create, not be a contrast or a parody of the history of yesterday. The Romans were not only warriors, but formidable builders who could challenge, as they did challenge, their time.
>
> Italy has been Roman for the first time in fifteen centuries, in war and in victory. Now it must be Roman in peacetime: and this renewed and revived *romanità* bears these names: discipline and work.[4]

Mussolini's historical memories of Rome were highly selective. Most important to his sense of Romanness, or *romanità,* was the Rome of the emperors, especially the first emperor, Augustus. Least important was the Rome of unified Italy from 1870 to 1922. Fascism regarded that period as a failure, a time of decadence, when the interests of political parties and politicians had failed to fulfill the dreams and hopes of Italy's nineteenth-century drive for unity known as the Risorgimento. Fascism would change all that and fulfill the Risorgimento, using Rome's past greatness as a standard for the new Italy. The period between the Roman Empire and modern unification—the Middle Ages, the Renaissance, and Baroque periods—ended up somewhere between, often deserving of fascist respect, but sometimes Rome's buildings and churches would have to fall to the *piccone,* or pickax, of progress as the regime destroyed the old to create the new and uncover the glories of the imperial past.

The fascist regime offered a number of reasons for changing Rome's urban landscape. Clearing away old and often decrepit buildings opened spaces around imperial sites, such as the Theater of Marcellus, for display, making contemporary Italians proud and inspiring the awe of tourists. The space gained allowed the construction of new, wider streets to accommodate modern traffic. The lost housing, usually characterized by the regime as unsanitary slums, would lead to a healthier Rome. The government moved displaced citizens to new areas outside the city center that provided less crowded living

conditions with new housing and state-sponsored social services. An unspo-
ken motive of the regime was to move these working-class populations to areas
where they could be more easily watched and controlled. Mussolini's Rome
would exploit Rome's past in constructing a new, modern city worthy of its
new leader. No resident or visitor could fail to be impressed by the changes
taking place, for fascist Rome was one big construction site until war and de-
feat brought a halt to the ongoing transformation of the city.

Mussolini made his intentions about changing Rome clear in word and
deed soon after assuming office. Rome's traditional birthday, April 21, became
a fascist holiday and the occasion for speeches, ceremonies, and, as the years
moved along, the opening of new streets, buildings, and monuments. Mussolini
also made it the Fascist Day of Labor, thus discarding May 1, May Day, which
had been identified with socialism. On April 21, 1924, Mussolini, having had
himself declared a "citizen of Rome,"[5] spoke at the Capitoline, the Campi-
doglio, the city's historic and civic center:

> I like to divide the problems of Rome, the Rome of this 20th century, into two
> categories: the problems of necessity and the problems of grandeur
> (*grandezza*). The second cannot be faced without resolving the first. The prob-
> lems of necessity flow from the development of Rome and are enclosed in this
> duality: housing and communications. The problems of greatness are of an-
> other type: it is necessary to liberate from the mediocre disfigurements of the
> old Rome, but next to the ancient and medieval it is necessary to create the
> monumental Rome of the 20th century. Rome cannot, must not be only a
> modern city, in the by now banal sense of the word, it must be a city worthy
> of its glory and this glory must unceasingly renovate in order to hand down,
> as a heritage of the fascist era, to the generations to come.[6]

At the same site on December 31, 1925, the Duce expanded on his plans for
Rome with more details of what he had in mind. He would build great new av-
enues while opening up space around the great monuments of Rome: the im-
perial forums, Augustus's Tomb, the Theater of Marcellus, the Capitoline, and
the Pantheon. Thus would emerge the new fascist Rome, the Third Rome that
would "spread over other hills, along the banks of the sacred river, even to the
shores of the Tyrrhenian Sea."[7]

Mussolini moved quickly to change the Roman city government from an
elected to an appointed one. He established the Governatorato, with a governor
directly responsible to him, effective January 1, 1926. He thereby consolidated
his control over the city and the work that he planned to accomplish there.[8] The
Governatorato then published a richly illustrated monthly magazine showing
the changes taking place throughout the city. *Capitolium* quickly became the

chronicle of Rome's transformation, reporting on archaeological digs, construction, restoration, "liberation" of ancient structures, and the appearance of everything new: apartments, post offices, parks, government buildings, monuments, and more. Every year the December issue also included an extensive appendix of statistical reports on trade, commerce, building, health services, and demography. In 1926, Mussolini also established the Institute for Roman Studies, Istituto Nazionale di Studi Romani, "an academic organization devoted to the study of the Eternal City,"[9] which also published articles in a journal three times a year.[10]

Mussolini thus took the steps necessary to make *romanità* an integral part of the fascist state and fascist ideology. His concept of *romanità* sought to combine fascism's emphasis on youth, revolution, modernity, and the establishment of a new and vibrant Italy with the glories and achievements of ancient Rome. Historians tended in the immediate aftermath of fascism's demise to dismiss the cult of Rome as propaganda and rhetoric, but more recently Emilio Gentile and other historians have argued that this attempt to reconcile the past with the present formed a powerful and useful ideology that could appeal both to intellectuals and the population at large. It was both as propaganda and ideology that *romanità* played a major role in Mussolini's Rome.[11] This use of antiquity in the service of modern politics expressed itself "in Mussolini's interwar renovations of Rome, which stripped venerable edifices . . . of all later architectural excrescences and removed surrounding buildings, so that these ancient structures could exist as monumental exemplars of the new fascist Italy."[12]

The first governor of Mussolini's Rome was Ignazio Cremonesi, a fascist industrialist previously chosen as mayor in a coalition government following Mussolini's appointment as prime minister. Cremonesi served as governor in 1926 and 1927. His successors were Prince Ludovico Spada Potenziani (1927–28), Prince Francesco Boncompagni Ludovisi (1928–35), Giuseppe Bottai (1935–37), Prince Piero Colonna (1937–39), and Prince Gian Giacomo Borghese (1939–43). The only one not from the Roman aristocracy was Bottai, a native of Rome and leading fascist minister.[13] This association of Roman aristocrats with the new Rome gave added legitimacy to Mussolini's efforts.

The Duce's determination to transform the city caught the attention of foreign observers early on and throughout the 1930s. American newspaper correspondent Edwin Ware Hullinger wrote a number of newspaper articles that he then published as a book, *The New Fascist State*, in 1928. His chapter on "'Remodeling' Rome" outlined Mussolini's ambitious plans to change the city. There would be new streets, the clearing of overcrowded areas to reveal historic "edifices and monuments," the development of underground railways and subways,

and the building of new areas to the south of the historic center. "It is a plan to redeem the old and remake the new Rome," Hullinger wrote.[14]

In 1937 a *National Geographic Magazine* lead article presented "Imperial Rome Reborn." The fifty-seven pages, richly illustrated with both black-and-white and color photographs, gave a glowing account of the major changes accomplished by the regime.[15] The article conveyed a positive appraisal of Mussolini's Rome. It noted, for example, the successful program of freeing ancient monuments through demolition, quoting one of the official guides: "Old ruins are more imposing if surrounded by parks and squares instead of slums. Il Duce may by inference point and say, 'That's what you once were; I'll make you great again.'"[16]

Mussolini would employ dozens of architects, planners, engineers, historians, archaeologists, and traffic experts to accomplish his goals, but he alone provided the vision and the "master plan" for the new city.

> "I consider myself without false modesty the spiritual father of the Master Plan of Rome," he said in 1932; and he was right. It was his vision that was being concretized: the misery and mediocrity will be made to disappear from Rome, *grandezza* returned, Rome extended once more to the utmost limits of its physical size and imperial power. It was his decision to move his office . . . to Palazzo Venezia that made the urban space in front of the Vittoriano the indisputable heart of Fascist Rome, and diverted toward it the energies of all the major routes into the city. And it was his power, centralized and unequivocal, that made possible staggering urban operations concluded in a matter of a year or two, paths of glory cut through the most recalcitrant urban tissue according to schemes that previously would have languished in the familiar Roman thicket of special interests and involved legislation.[17]

Throughout his regime Mussolini poured considerable energy and resources into rebuilding Rome as a manifestation of the fascism and the revolution he claimed would transform Italy and Italians. The new fascist Rome, Mussolini's Rome, would define fascism and embody fascist self-presentation and identity. The new Rome—its streets, buildings, exhibits, and spectacles—would proclaim all the essential messages of fascism. Typical of the regime's proud pronouncements on Rome's importance are these words from the government's English-language monthly tourist publication, *Travel in Italy:*

> Rome to-day [October 1935] represents the most perfect expression of Fascist Civilization as a monumental city in which, the remains of her glorious past, restored to their original splendour in an appropriate setting, are worthily continued in every aspect of modern life. In fact, as evidence of the continuity of Rome's greatness, the Regime decreed that within the bounds of the most an-

cient monumental nucleus of the city, place should be found for the buildings, that following a Unitarian conception are destined to confer to the city, an aspect corresponding to the new position that Mussolini's Italy now occupies in the world.[18]

FIRST PROJECTS

Mussolini's plans to transform the city and make it a showplace of fascism began to take shape in several projects begun in the late 1920s. The opening up of the square we now know as the Largo Argentina and the construction of a new street, the Via del Mare, by the Capitoline, both demonstrated changes to historic areas that would now give older sites a new fascist imprint. The construction of a new "sports city," the Foro Mussolini, represented a thoroughly new and thoroughly fascist site. Taken together, these early efforts set the direction and shape of the new Rome.

Work around the Largo Argentina began in 1926, and it was opened to the public on April 21, 1929, Rome's traditional "birthday." April 21 became second only to October 28, the anniversary of the March on Rome, as a day to dedicate completed works of the regime. It was "a red-letter day in the history of humanity. Fate decreed . . . on that day, Rome should be born and with it a type of civilization still forming the power and pride of every Nation in the world."[19] Plans to change the area predated the fascist regime, but it was only in 1926 and 1927 that the desired demolition of older buildings took place. Mussolini wanted to show in this and subsequent projects that fascism would deliver what previous governments had only promised.

The Largo di Torre Argentina and its historic eighteenth-century Teatro Argentina have nothing to do with the South American country of the same name. In the fifteenth century, the bishop of Strasbourg built its tower, or *torre*, which survives only in a truncated form, but the name remains, coming from the Latin name of the diocese: Argentoratum. In 1925 the area was a maze of alleys and decrepit housing.

Demolition work began in 1926, and a developer presented plans for new buildings, but Mussolini's personal intervention would change the direction of the project. The destruction of the late sixteenth-century church of San Nicola ai Cesarini uncovered the first of four ancient temples. The exact dates of the temples remain unknown to this day, but archaeologists determined at the time that they dated from Republican Rome and were among the oldest buildings existing in the city.[20]

The Duce visited the site on October 22, 1928. One of the archaeologists, Corrado Ricci, pointed out the sorry legacy of post-1870 Rome in its rapid and careless development, which had not respected the ancient city. Ricci's message impressed Mussolini. During his visit, the Duce announced: "I would feel my-self dishonored if I allowed a new structure to rise even one meter here."[21] Today the ruins of the four ancient temples are visible, below street level, in this cleared area that had been, in fascist terms, a slum.

This pioneering project had all the elements that Mussolini subsequently emphasized in his projects for transforming Rome: improving the flow of traf-fic, preserving and "liberating" ancient monuments, tearing down buildings of little or no historical value, and above all, demonstrating the fascist ability to carry out projects that others had only talked about. Thus Mussolini's Rome demonstrated to the world fascism's leadership in urban planning by combining the practical needs of the city with the political goals of the regime.

The policy of transforming Rome that unfolded during the twenty-year regime sought to demonstrate fascism's ability to achieve major change effi-ciently and dramatically. Remaking Rome in Mussolini's image had far greater political and historical significance than making the trains run on time. The constant demolition and construction, the appearance of new buildings, streets, and neighborhoods persuaded both Italians and foreigners that fascism meant dynamism and durability. Ezra Pound's characterization of Mussolini in 1935 reflected the image of the Duce as builder and artist: "I don't believe any esti-mate of Mussolini will be valid unless it *starts* from his passion for construction. Treat him as *artifex* and all the details fall into place. Take him as anything save the artist and you will get muddled with the contradictions."[22]

The project included a restoration and renovation of the Teatro Argentina's interior by the architect Marcello Piacentini (1881–1960). A native of Rome, Piacentini emerged early as Mussolini's favored architect. His many designs, his overseeing of several major projects, and his ideas on urban planning and archi-tectural design would have a major impact on Mussolini's Rome.[23]

To the south of the corner next to the theater, the Via del Plebiscito ran into the Piazza Venezia. The corner diagonally across the Largo Argentina led into the Via delle Botteghe Oscure and Via San Marco, which also connected to the Piazza Venezia. The regime widened both these streets in the 1930s as part of its plan to improve the flow of traffic across the city. Heavy traffic continues on these streets today, including the many buses that pass through the Piazza Venezia.

The opening of the Largo Argentina afforded Antonio Muñoz (1884–1960) an opportunity to emerge as Mussolini's right-hand man in the future demoli-

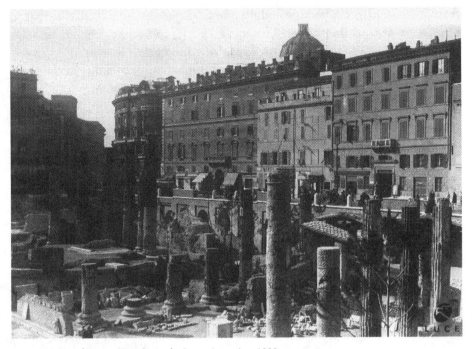

1.1 The Site of Roman Temples in the Largo Argentina, 1929

tion of Rome's historic center. He already had established a reputation as a re-storer of ancient and medieval monuments.[24] Initially he had vacillated in the debate over the Largo Argentina but ended by enthusiastically supporting Mussolini's decision to preserve the ancient site. In his 1935 book, *Roma di Mussolini,* he trumpeted the Duce's wisdom in setting a course that meant the "triumph of Archeology against the strong forces of economic interest."[25] In 1928, Mussolini appointed him director of antiquities and fine arts for the Governatorato, and for the next fifteen years he played a major role in transforming the city for the Duce. In his book, Muñoz rejoiced in the regime's efforts to expose the great monuments of the past in the city's historic center: the Roman Forum, the Imperial Forums, the Colosseum, the Theater of Marcellus, and more. The epoch of Mussolini, he declared, would take its place with great builders in Rome's past: the Emperor Augustus, Pope Leo X, and Pope Sixtus V. "Only the energy of a great ruler could bring about in such a short time such a profound renovation."[26]

The Theater of Marcellus stood surrounded by tenements in one of Rome's old working-class neighborhoods adjacent to the Capitoline Hill. The first blow of the pickax to "liberate" the theater fell on April 21, 1926. In the next four

years, a whole neighborhood would disappear, including the picturesque Piazza
Montanara next to the theater. The act of "liberating" an ancient monument
went hand in glove with the construction of a broad new avenue, the Via del
Mare, which would later link up with streets and boulevards leading to the Lido
and the sea.

The work immediately in front of the medieval church of the Aracoeli to
create the new street began with great fanfare on October 28, 1927. The regime
dismissed the destroyed housing as an unhealthy slum. The only building
thought worthy of preservation was the church of Santa Rita, tucked away by
Michelangelo's stairway to the Capitoline. Designed by Carlo Fontana and built
in 1600, this fine example of baroque architecture was carefully disassembled for
future reconstruction. The reconstruction began in 1938 next to the by-then
liberated Theater of Marcellus at the entrance to the Piazza Campitelli. The
church reopened on April 21, 1940.[27] It is an art gallery and studio today.

The Theater of Marcellus had its origins under Julius Caesar and was com-
pleted by the Emperor Augustus in A.D. 13, dedicated to his nephew who had
died at the age of 25. When work began in 1926, small shops filled its arches
and the ground level was several feet above the original. It faced the Piazza Mon-
tanara, a busy market. It all stood on the same spot as the ancient olive oil mar-
ket, the Foro Olitorio, next to the Tiber where ships deposited their cargo.[28]
Adjacent to it stood columns from the temple of Apollo built in 32 B.C. After
Mussolini's demolition, the neighborhood was gone and these monuments of
imperial Rome stood free and open to view from the new Via del Mare.

Mussolini led a large entourage of officials, including Muñoz, to open this
first piece of the Via del Mare on October 28, 1930. The wide new street
opened both the view of and access to the Capitoline Hill. The work of clearing
the south side of the Capitoline, just around the corner from the Via del Mare,
continued for several more years, and eventually the result would make the
Capitoline stand out with a new prominence. Down the street just past the The-
ater of Marcellus stood the church of Santa Nicola in Carcere, with ancient
columns embedded in its walls. The area beyond would furnish space for large
new fascist office buildings a few years later.

The Via del Mare culminated at the Piazza Bocca della Verità and the me-
dieval church of Santa Maria in Cosmedin. In the first phase of the project, from
1926 to 1930, several more ancient sites fronting the piazza were "liberated."
First was the fourth-century Arch of Janus, and just behind it the early medieval
church of San Giorgio in Velabro, recently restored by Muñoz. Across the
street, near the Tiber, stood two ancient temples. The circular one, known tra-
ditionally but erroneously as the Temple of Vesta, and the rectangular Temple of

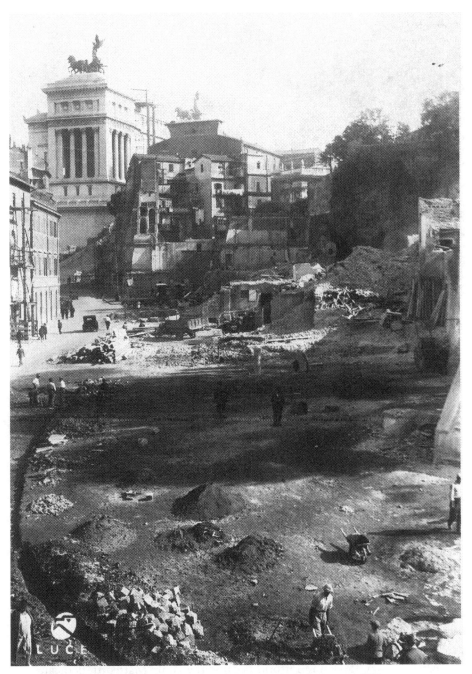

1.2 Work on the Via del Mare, Victor Emmanuel Monument in the background, 1929

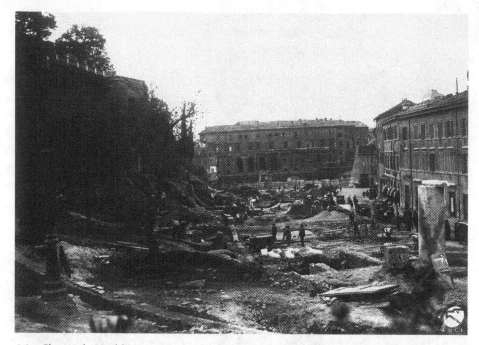

1.3 Clearing the Via del Mare, Capitoline on the left, Theater of Marcellus in the background, 1930

Fortuna Virilis date from about 100 B.C. or earlier. Work continued on the Via del Mare throughout the 1930s until its official completion on April 21, 1939.[29] No visitor to Rome in the 1930s could fail to see this new fascist street in the heart of historic Rome. It remains today as a major example of the fascist urban landscape, unchanged except for the name. It now begins at the Capitoline as the Via del Teatro di Marcello and then becomes the Via Luigi Petroselli, named after Rome's communist mayor from 1979 to 1981.

The regime accomplished a number of other construction projects at this time. The first of the four bridges built during the fascist period opened in 1929.[30] The Ponte Littorio crossed the Tiber from the area above the Piazza del Popolo and connected with the developing area around the Piazza Mazzini north of the Vatican. The name comes from the *fascio littorio,* the symbol of fascism. The *fascio* was a bundle of rods with a protruding ax blade. An official known as the lector, the *littorio,* carried this symbol of unity in ancient Roman processions.[31]

After the war, the Ponte Littorio became the Ponte Matteotti, dedicated to the antifascist deputy murdered in 1924. A monument to Matteotti by the bridge arose on the fiftieth anniversary of his death in 1974, marking the spot

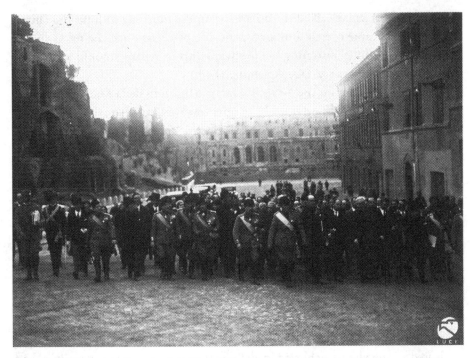

1.4 Mussolini opens the first part of the Via del Mare, Theater of Marcellus in the background, 1930

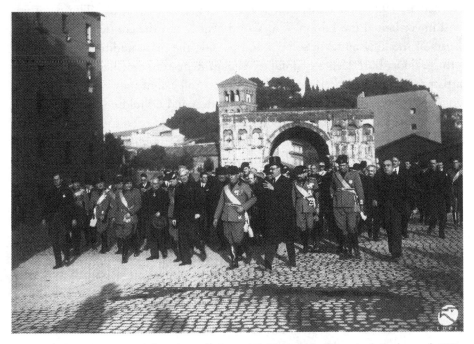

1.5 Mussolini, Muñoz on his left, in the Piazza Bocca della Verità, Arch of Janus in the background, 1930

of his abduction as he walked to Parliament on the morning of June 10. Thus a fascist name became overtly antifascist, and the place assumed the resonance of an antifascist shrine, illustrating the postwar effort to rename monuments in an attempt to rewrite history. (See Appendix II)

The new building for the Naval Ministry, Ministero della Marina, appeared just above the Ponte Littorio in 1928. Across town, near the site of the proposed new university campus, the Air Force Ministry, Ministero dell'Aeronautica, opened in 1931. Designed by Roberto Marino, this gave a home and head-quarters for "the most modern means of transportation together with the bold-est and most important arm of war in the future."[32] Another new structure in 1931 provided both residences and treatment facilities for blind veterans: the Work House for Blind War Veterans, the Casa di Lavoro per i Ciechi di Guerra, on Via Roveretto in the Nomentana district. The rationalist architect Pietro As-chieri used curved lines in the principal building as part of a strikingly modern design.[33]

More centrally located was the Casa Madre dei Mutilati, between the Cas-tel Sant' Angelo and the nineteenth-century Palace of Justice, on the Tiber just beyond St. Peter's and the Vatican. Marcello Piacentini designed this facility dedicated to the victory achieved in the Great War and those veterans who had suffered wounds and disabilities, the *mutilati*.[34] The modest-sized building opened in 1928 and underwent a major expansion by 1937. The paintings within celebrated the Libyan War, World War I, and the conquest of Ethiopia. Busts of the king and Mussolini stood outside the main auditorium. Sculpted bronze doors bore scenes of military engagements and war heroes. The list of artists executing the interior works read like a roll call of Italy's best talent, now engaged in the twin tasks of exalting the nation and upholding fascism.[35]

The boldest new project announced by the regime dedicated a new site to a sports complex. The site, several miles up and across the Tiber, took years to develop as the Foro Mussolini. By unveiling the project in 1927, the regime made it clear that the work of transforming Rome amounted to more than pro-jects in the historic center devoted primarily to recovering ancient monuments. The Foro Mussolini would give Rome a new, modern complex, or "city," de-voted to sports, physical fitness, and youth. The distinguished architect Enrico Del Debbio received the commission to design and develop a modern monu-ment honoring the Duce and developing a new generation of Italians as part of the fascist revolution.

Marcello Piacentini declared that Italy had built for the first time a city of physical education in the tradition of the ancient gymnasium but in a modern form consistent with the regime's program. The foro stood as a national center

1.6 Casa Madre dei Mutilati, 2000

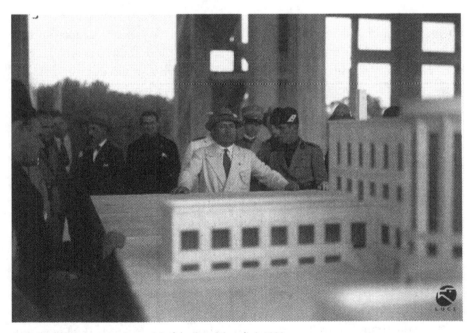

1.7 Mussolini examines the model of the Foro Mussolini, 1929

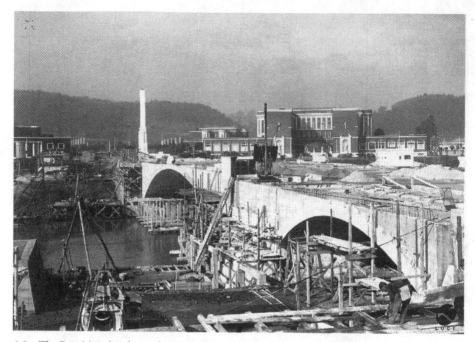

1.8 The Foro Mussolini during the construction of the Ponte Duca d'Aosta, 1939

for physical culture dedicated to the character formation of new generations of Italians.[36] While this sports complex was fascism's most ambitious and prominent center for the physical education of young fascists, it did not stand alone. It was part of a network of facilities developed during the 1930s to implement the regime's programs for the training and development of its youth.[37]

The first buildings in the Foro Mussolini opened in 1932, with the great marble obelisk dedicated to the Duce. The latter remains, to this day, as the most visible symbol of the foro. It overlooks the entrance, soars 60 feet into the air, and weighs 300 tons.[38] The regime lost no opportunity to publicize the creation of this great monument, soon dubbed "the Monolith," il Monolito. It offered a dramatic demonstration of Mussolini's determination to make the city over in his own image.[39]

PIANO REGOLATORE OF 1931

By the early 1930s, Mussolini's Rome was taking shape. In 1931, the Duce and his advisers approved a new city plan: the Piano Regolatore. Rome had pro-

duced earlier plans in 1873, 1883, and 1909, but this one provided the fascist blueprint for Rome's development. The governor of Rome, Prince Francesco Boncampagni Ludovisi, appointed a commission in March 1930 "on directions from Mussolini, to consolidate the planning ideas of the period into a master plan for Fascist Rome."[40] Not surprisingly, the plan, officially adopted on July 6, 1931, differed from earlier ones in its obvious attempt to incorporate the regime's messages throughout the city, especially "the parallelism between the deeds of the regime and its classical precedent."[41]

The two principal features of the plan were the ordering of the old city and the creation of new zones for expansion. It looked to the future by providing for an expanding population. Improved traffic and provision of green spaces, new rail facilities, more schools, additional covered markets, and two large hospitals were among the services and benefits the plan aimed to provide for the city's inhabitants.[42]

Although the plan pointed in new directions for Rome's development, it would not interrupt the momentum of the work already under way, according to the regime. "While there has thus begun the realization of the new master plan, it does not slow down the rhythm of the works with regard to works of ordinary necessity such as schools, aqueducts, streets, sewers. These works should be intensified and modified in order to embody the grand lines of the new master plan."[43]

The Piano Regolatore of 1931 foresaw Rome nearly doubling its population to 2 million inhabitants. There is a bit of irony here, as the regime in the 1930s would champion the values of "rurality" and place restrictions on migration from the farm to the city. Mussolini's fascism was nothing if not eclectic and flexible, sometimes to the point of pursuing apparently contradictory policies. The rural-urban tension inherent in the policies of the 1930s reveals a common thread of social control by the regime. Cities always have the potential to spawn social unrest, and governments generally find it easier to keep rural populations quiet. Given the reality, however, of Rome's continued growth, the fascist regime's ambitious building programs had clear advantages: They supplied work for common laborers; they removed lower class populations from central parts of the city to the new, outlying sections, or *borgate;* and they included social service and welfare programs.

Rome did experience a high and rapid rate of population growth during the fascist period. When Mussolini took office in 1922, Rome's inhabitants numbered about 700,000. A decade later the number had passed 1 million. In 1941 it reached 1.4 million.[44] The 1931 plan would proceed uninterrupted to

provide for the growing population and to bring about the great new "Roma di Mussolini" that was slated to emerge.[45] Thanks to fascism and Mussolini, Rome now held the map of its future:

> Today Rome has a city plan worthy of its greatness: among the magnificent ac-
> complishments owed to the Duce's will this undoubtedly can be counted
> among the greatest, both because it is the logical consequence of the spiritual
> valuation of Rome that synthesizes the unity of the fatherland, that only the
> Fascist Regime has known how to realize, and because it constitutes also the
> necessary basis that will allow the posterity of distant ages to identify along side
> the Rome of the Caesars, and the Rome of Sixtus V, the Rome of Mussolini re-
> newed and surpassing ancient greatness.
>
> The city plan of Rome is no more like the past a matter of ordinary ad-
> ministration, imposed by special contingent needs, but becomes a true and
> proper plan of battle, one of those bloodless battles that Fascism under the
> guidance of its Chief has known how to fight and win in order to start the Fa-
> therland toward a brighter future.[46]

This statement in the Piano Regolatore fit clearly into the fascist military metaphor constantly employed to signify the major policies of the regime: the battle for the lira; the battle for self-sufficiency in grain; the battle of births to increase Italy's population; and the battle to plan and construct a new city. Victories in all these individual battles would lead to the new Italy promised by the fascist revolution.

Postwar assessments of the plan's effectiveness are more mixed. Robert Fried concluded: "Most of the goals of the plan were never achieved, even though it remained in force, legally speaking, until 1959."[47] Italo Insolera pointed to a lack of connection and coordination between various projects because city officials, not the authors of the plan, carried them out. He mentioned, as an example, making neighborhoods more densely populated than called for in the plan. The architecture critic Henry Hope Reed thought that "the Fascist plan for Rome was at bottom traffic planning, this time conditioned by the Dictator's imperial ambitions."[48] Piero Rossi judged the plan as the "contradictory fruit of weighty political, economic and cultural compromises." Its goal of developing the city toward the east collapsed due to the regime's lack of political will.[49] On the other hand, Diane Ghirardo's more positive assessment of the regime's plans and accomplishments is based less on the success or failure of the 1931 master plan and more on an evaluation of what the regime did compared with governments before and after fascism.[50]

Mussolini used the Piano Regolatore of 1931 as an instrument in his transformation of Rome, but he never allowed it to restrict his freedom to shape the

city to his own vision and for his own political purposes. More important than any particular plan or project was Mussolini's belief that architecture had the power to make Rome his city and the embodiment of his fascist revolution. In his conversations with the journalist Emil Ludwig between March 23 and April 4, 1932, the Duce declared that "architecture is the greatest of all the arts, for it is the epitome of all the others." Ludwig responded, "Extremely Roman," and Mussolini confirmed, "I, likewise, am Roman above all."[51]

Two

CELEBRATION AND
CONSTRUCTION, 1932–1934

THE DECENNALE

The year 1932 marked an important stage of development for fascist Rome. The tenth anniversary of the March on Rome, the Decennale, offered the regime the opportunity to celebrate its achievements and especially to introduce new spaces and events in Rome. An English-language pamphlet of the state-sponsored tourist agency boasted that the regime had "completely transformed Italy" in its first decade. "Anyone visiting Rome after an absence of ten years can hardly believe that so many and such important works could have been accomplished during this short period of time." It pointed to the Via dell'Impero, the new towns in the reclaimed areas of the Pontine Marshes, and the opening up of the city's ancient monuments.[1] Mussolini's imprint already gave the city a new look appropriate to the rhythm of modern life, with one construction project after another superimposing a new and beautiful city on imperial Rome.[2] "It is not exaggerated to affirm that side by side with old Rome and even within its walls, another city has sprung up or rather has been revealed during the last ten years: a new Rome that deserves to be visited as much as the old one generally described in guide-books."[3]

Fascist "spectacle" found new forms of expression that shaped the subsequent development of the city and its use as the showpiece of the regime. In particular, two events marked the Decennale on October 28–29, 1932: the opening

of the new Via dell'Impero, running from the Piazza Venezia to the Colosseum; and the opening of the special Exhibit of the Fascist Revolution (Mostra della Rivoluzione Fascista), which would attract nearly 4 million visitors in the next two years.

THE VIA DELL'IMPERO

The new Via dell'Impero appeared as another fascist victory in the struggle to unite Italians and to give Italy a new sense of purpose and accomplishment. Plans to change the streets in the city's historic center did not originate with the fascist regime. In 1873 Alessandro Viviani developed the first Master Plan, which included a new street from the Colossseum to the Piazza Venezia.[4] The regime could now boast that it had finally acted to carry out this work in yet another "action speaks louder than words" message. The vast project took several years, tearing down an entire neighborhood, creating a street thirty meters wide, and providing a principal avenue for parades and propaganda. Aesthetics, archaeology, traffic, and public health furnished the rationale for the work, along with the government policy of putting people to work.

The new street provided a major new artery and an outlet for the Via Cavour, which carried traffic down from Rome's main train station, Termini. According to the regime, the demolition of the neighborhood meant the end of crowded, unhealthy living conditions. Residents would be welcomed in the outlying neighborhoods newly constructed for them. These *borgate* provided new public housing and health services. On both sides of the avenue, excavation opened up imperial forums for visitors and tourists to see. Not only was there a new view of the Colosseum, but the Basilica of Maxentius was "liberated" as well and became a site for outdoor concerts. The street's twenty-meter width provided ample room for traffic, while ten additional meters of sidewalks could accommodate large numbers of pedestrians.

The Via dell'Impero perfectly expressed the fascist wedding of past and present, traditional and modern that became the hallmark of Mussolini's Rome. "Undoubtedly it is the most interesting and majestic road in the world" appealing to lovers of ancient Rome as well as "ordinary tourists partial to modern and handsome thoroughfares."[5] One fascist hailed it as "certainly the grandest fascist monument, having captured the unique vision of today's Rome, and having restored to the life of the people the most beautiful structures, formerly suffocated by superstructures, hovels and alleys. It will have the greatest importance in the orientation of the new Italian taste."[6] Clearly the Via dell'Impero embodied the concept of *ro-*

2.1 Via dell'Impero from the Colosseum to the Victor Emmanuel Monument, 1932

manità and Mussolini's claim that the new Rome expressed the political revolution that was transforming Italians into a new, energetic, and thoroughly fascist people.

Visitors entering the new street from the Piazza Venezia and the Victor Emmanuel Monument viewed the combination of Trajan's Column, Trajan's

Market, Trajan's Forum, and Augustus's Forum on the left, and Caesar's Forum on the right. Just beyond Trajan's Forum was the Forum of Nerva. Statues of Caesar, Augustus, Trajan, and Nerva lined the street. The street also offered new access to the Roman Forum.

On April 21, 1934, the regime unveiled four stone tablets of maps of the Roman Empire on the new wall running alongside the forum by the Basilica of Maxentius. "The four maps together construct a narrative depicting the empire from its earliest days until the period of its greatest territorial extent under Trajan."[7] After the conquest of Ethiopia, a fifth map, added on October 28, 1936, depicted fascism's new empire and was dedicated to the martyrs of fascism. The plan at this time was to build the new Fascist Party headquarters, Palazzo del Littorio, across the street where the Mostra della Rivoluzione Fascista would be on permanent display, with a *sacrario,* or chapel, in honor of the fascist martyrs. This overtly fascist fifth map disappeared at the end of World War II, but the other four remain today.[8]

A paper read before the Royal Institute of British Architects in 1934 by Dr. Guido Calza trumpeted the achievement of the Via dell'Impero. The new street occupied a central and integral place in the bold plans for a new Rome:

> To-day modern life comes into contact and runs its course side by side with the ancient monuments. Until three years ago, the traveler arriving in Rome and proceeding from the station to S. Peter's, although he crossed half the city, never encountered any of the classical monuments. But now, through the Via Nazionale, he can see the majestic ruins of the Hall of Trajan's markets and from the Piazza Venezia he can have a view of the Basilica of Constantine and of the Coliseum. And half way down the Corso Vittorio [Emmanuele] he is suddenly confronted with the four temples of the Republican period in the Argentina zone, which have opened for us a new page in the topography of ancient Rome.[9]

Consistent with the regime's presentation of such stupendous accomplishments, Dr. Calza pointed out the sheer volume and scope of a project that required the clearing away of forty thousand cubic meters of earth "during the work of pulling down and readjusting the Forum." He also answered those critics who argued that the Via dell'Impero now covered up large portions of the newly excavated imperial forums. Part of the project, he reminded his audience, was to provide improved traffic flow in a modern city. "It is a modern street which also endeavours to give value to the remains of the Imperial Forums and monuments, and give a panoramic view of them which, in some particular spots, is superb." What is certain, he concluded, "is that with the new street we

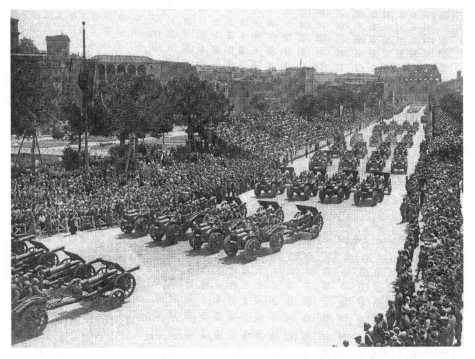

2.2 Military parade on the Via dell'Impero, c. 1937

have gained much more than we have lost."[10] The debate over that point continues to this day, but there was no doubt at the time that Mussolini had constructed a prime space for fascist celebrations and commemorations.

The inaugural parade featured units of veterans wounded in World War I, the *mutilati*. In subsequent years the street hosted dozens of parades. Ceremonial events on these occasions might encompass the Victor Emmanuel Monument and its Tomb of the Unknown Soldier, or the space between the Colosseum and the Arch of Constantine. Here was the first major step in transforming the historic center of Rome into a setting for fascist spectacle.

THE MOSTRA DELLA RIVOLUZIONE FASCISTA

The next day, October 29, 1932, Mussolini and a host of officials opened the Exhibit of the Fascist Revolution, the Mostra della Rivoluzione Fascista, or MRF, as it was commonly known. It stood at the center of the Decennale, celebrating the first decade of fascist rule. The anniversary year offered the regime an opportunity to proclaim publicly its successes and to display fascism's history,

achievements, and bright future. Mussolini's reputation stood high in Italy and abroad. Emil Ludwig's conversations with the Duce that year revealed a confident leader expressing his views on a wide variety of subjects. Ludwig's book, *Talks with Mussolini,* would appear in many languages. Public works projects gave Italians jobs and produced proof of the regime's construction of a new society. Rome furnished the principal site of fascism's celebration of itself for the entire world to see. The Exhibit of the Fascist Revolution was the centerpiece of the Decennale and the Year X of the fascist calendar.[11]

By then, Italians were used to seeing the fascist date for events in addition to the traditional date of the Christian calendar. Year I began on October 28, 1922. As fascism celebrated the end of its first decade with the opening of the MRF, a new year, Anno XI E.F., or Era Fascista, began.

The exhibit spanned two critical years, 1932–1934, of Rome's development as the physical, historical, and architectural embodiment of Italian fascism and its aspirations. It demonstrated the fascist revolution while the city demonstrated fascism's synthesis of past and present as the basis of the future "continuing revolution." The setting for the exhibit was a city undergoing a fascist transformation. The new streets and buildings were part of the ongoing *mostra,* or exhibit, of the Roma di Mussolini. Mussolini's sometime mistress and cultural advisor, Margherita Sarfatti, put it this way: "What opened in Rome is not only 'the exhibit'; much more is it 'the demonstration' of the Fascist Revolution."[12]

The exhibit's site was the Palazzo delle Esposizioni on the broad, nineteenth century Via Nazionale that began just above the Piazza Venezia and ran up toward the Termini station. It had already served in May and early June as the site for a special exhibition, the Mostra Garibaldina, commemorating the fiftieth anniversary of Giuseppe Garibaldi's death. Mussolini used the occasion to incorporate the historical memory of the great hero of Italian unification into the presentation of his fascist movement as the fulfillment of the Risorgimento. The exhibit drew over 200,000 visitors, a demonstration of the Palazzo delle Esposizioni's effectiveness as a site for major exhibitions. In addition, Mussolini presided at the unveiling of a new statue on the Janiculum to Garibaldi's wife Anita, a hero in her own right during the short-lived Roman Republic of 1848–49. It stood near the huge equestrian monument of Garibaldi himself, overlooking Rome from the Piazza Garibaldi.[13]

Nothing illustrates better than the Mostra della Rivoluzione Fascista the way in which the regime created new settings and new events to convey its message. More than twenty of Italy's finest artists and architects collaborated in designing an exhibit that Mussolini ordered to be "most modern." A new, strikingly modern façade covered the 1882 palazzo. The clean horizontal and

vertical lines featured four aluminum columns, each thirty meters high, in the form of the fasces, the ancient Roman symbol that fascism had adopted as its own.

Originally scheduled to close in April 1933, the exhibit's success in attracting visitors led Mussolini to extend its life to a full two years. Nearly 4 million Italians and foreigners viewed the exhibit during that period. In Rome they saw not only the exhibit but also the many new buildings, streets, and monuments completed or under construction by the regime. The Papal Holy Year of 1933 meant that religious pilgrims would also see the wonders of the new Rome under the Duce's forceful leadership. Here was a dynamic fascism that was rooted in the Italian and Roman past while simultaneously transforming Italy into a great and modern nation. *Romanità* and revolution were at the heart of fascism's self-presentation from 1932 to 1934.

The fascist leaders Dino Alfieri and Luigi Freddi organized the exhibit and wrote the official catalog that provided a complete account in text and photographs of the exhibit.[14] They attracted a variety of Italy's most dynamic and talented artists, painters, and sculptors to design the exhibit's twenty-two rooms. The architects Adalberto Libera and Mario De Renzi designed the

2.3 The Mostra della Rivoluzione Fascista, the Via Nazionale, 1932

façade; Enrico Prampolini, the futurist painter, contributed two murals; the rationalist architect Giuseppe Terragni designed the room dedicated to the March on Rome; and the painter Mario Sironi produced four key rooms.

Once inside the exhibit, visitors traveled through fascist history in a series of rooms that began with Italy's decision to enter the war in 1915 and continued through the triumph of fascism with the March on Rome. The variety of modern styles, such as rationalism and futurism, were evident, and critics agreed that the forms were dynamic and engaging. The culmination of the exhibit was the *sacrario* dedicated to the fallen, or *Caduti,* the martyrs of the fascist movement. A huge illuminated cross in the darkened room was surrounded by rows of the word *Presente,* while the fascist hymn "Giovinezza" played softly in the background. Shrines to the heroes who had given their lives for the fascist cause became common in Rome and throughout Italy.

The exhibit subordinated the theme of the regime's achievements to the major themes of fascism's heroic history. The MRF authenticated the fascist revolution. Fascism, according to the official catalog, had overthrown the old order, unleashing the energy of the piazza and mobilizing the forces of the nation, which were guided by Mussolini's thought and leadership. Fascism had saved the nation from a bloody, Bolshevik-style revolution that promised only to divide Italians through class warfare. The fascist revolution, on the other hand, had the capacity to unite all classes and regions of Italy, thereby freeing the nation from its fragmentary historical legacy and fulfilling the original Risorgimento. The modern style thus matched the revolutionary substance of the exhibit. Italians of all regions and classes could come to Rome and experience, in the MRF and in the city, the new Italy being created by Mussolini and fascism.

The writer and critic Barbara Allason recalled visiting the MRF with her sister. Allason was an active member of the antifascist underground in Turin at the time and so was hardly well disposed toward the regime. The two took advantage of the discounted train fares to make the trip to Rome, noting that some people beat the system by going to Rome with the discount, visiting the exhibit briefly to validate their tickets, and then enjoying a holiday in Rome. She conceded, however, that the exhibit's style was impressive. The rooms dedicated to early fascism, the squads, the repression of strikes, and then the fascist "return to order" conveyed authentically to her the fascism she despised. Everywhere she saw "infinite" pictures, portraits, and representations of Mussolini. "Altogether it was a scene constructed by an ingenuous and very able director, ephemeral and spectacular as would be the Fascist revolution itself."[15]

Only after going through the sacred space of the *sacrario* on the ground floor did the visitor move upstairs to the rooms dedicated to what fascism had

accomplished after the March on Rome. Visitors to the exhibit, nevertheless, could see and experience the regime's dynamic in the surrounding environment of the newly emerging fascist Rome: the events, the buildings, and the streets that together formed fascism's self-presentation and self-definition.

The regime kept careful records of how many visitors came and who they were.[16] Italians of all classes, backgrounds, and regions flocked to the exhibit. The royal family, party and military leaders, government officials and employees, factory workers, members of professional organizations, schoolchildren of all ages, members of the government-sponsored leisure organization known as the Dopolavoro ("after work"), and more attended. The regime made every effort to encourage groups and individuals to visit by reducing rail fares and subsidizing party organizations.

Fascist officials also made special efforts to attract foreign visitors and especially foreign dignitaries. In fact, foreign politicians, statesmen, and ambassadors could hardly avoid the exhibit, as their enthusiastic fascist hosts insisted on taking them on the mandatory tour. Franz von Papen, Josef Goebbels, Hermann Göring, Ramsey MacDonald, Sir John Simon, Èamonn De Valera, Austin Chamberlain, James Roosevelt, Engelbert Dolfuss, Anthony Eden, Sir Oswald Mosley, and the king of Siam were among those favored with guided tours. The fascist press always emphasized how favorably impressed these visitors were with what they saw. Anthony Eden, Great Britain's foreign secretary, recalled his visit in February 1934: "In an interval during this visit I was taken to the Fascist Museum. I did not find the place congenial and I did not want to be uncivil to my hosts, so that I was glad when the embarrassing ordeal was over. All the same, Fascism as practiced in Italy at the time was less dragooning and pervasive than Nazi rule in Germany."[17]

The exhibit attracted considerable attention on the outside as well as the inside. The site on the Via Nazionale was ideal: a wide, straight, post-unification street located just steps away from the historic center. Each day a different honor guard had duty at the exhibit, thus providing constant "changing of the guard" ceremonies that attracted the attention of hundreds of passersby. Often a parade up the Via Nazionale preceded the change of guard.

The site would work equally as well for the Exhibit of Augustus, La Mostra Augustea della Romanità, in 1937 celebrating the two-thousandth birthday of the emperor. In fact, the public announcement of that exhibit came out in September 1934, just a month before the closing of the MRF.[18] When it opened the Palazzo would have yet another new, temporary façade to attract attention. New versions of the Exhibit of the Fascist Revolution appeared in 1937 and 1942, relocated to the National Gallery of Modern Art in the Villa Borghese Park. In 1934 the party sponsored a contest for the design of a new party headquarters,

the Palazzo del Littorio, which would provide space for a permanent exhibit of the revolution and an archive for the party's history on the Via dell'Impero.[19]

The success of the Exhibit of the Fascist Revolution helped shape the regime's policy with respect to exhibits in various parts of the city, and treated Rome itself as an exhibit or demonstration of achievement in the ongoing fascist revolution. The combination of history, propaganda, and tourism proved a valuable way for the regime to broadcast its messages to a popular audience. This exhibit furnished the model for the regime's subsequent ambitious program of exhibitions in Rome and throughout Italy.

The American political scientist Herman Finer lived in Rome in 1933 and visited again in 1934 to study the fascist regime. He published the results of his work in 1935 as *Mussolini's Italy.* Finer's summary of the power and effectiveness of the Exhibit of the Fascist Revolution captures the success of the exhibit that, in turn, encouraged the regime in its subsequent use of Rome as a center of exhibitions, new buildings and complexes, and the constant ceremonies at key sites in the city:

> To this exhibition millions have flocked, brought to Rome by reduced fares and by excursions arranged by the various associations of the regime. What a seductive gift to the poor workman or peasant who has, perhaps, never been out of a tiny village or town! To be given an excursion to Rome, in the company of his boon companions of the *piazza* or the local inn, headed by a more or less tuneful band, and preceded sometimes by home-made banners, carrying the name of the hometown, and then to be made a fuss of in Rome, perhaps photographed by the newspapers! And there, spread in front of him (and no one can deny it!) are these evidences of the stupidity of the rest of the world, the wickedness and malice of Socialism and Communism, the immaculate patriotic purity, heroism, and self-sacrifice of the Fascist, and the Duce, that good, big, but sometimes angry, father! Why, you can even see the original document drawn up by D'Annunzio for the Government of Fiume; letters to and from the Duce; portions of the bridge over the Arno from which the young manufacturer's son, Berta, was thrown, his fingers cut off, bleeding into the river by the wicked "subversives"—yes, *ecco!* There are the bloodstains! Who can deny that Fascism is right? The Revolution ye have always with ye![20]

During the two years of the Exhibit of the Fascist Revolution, 1932 to 1934, further changes took place in the area of the Piazza Venezia and the Via dell'Impero. The creation of the Via dei Trionfi, the makeover of the Circus Maximus, and the extension of the Via del Mare produced new spaces for Mussolini's Rome in the very heart of imperial Rome. These streets functioned as "open-air museums of live history" for Mussolini and his regime.[21]

VIA DEI TRIONFI AND COLLE OPPIO PARK

In 1933, a visitor could walk from the Piazza Venezia and the Victor Emmanuel Monument to the Colosseum on the broad sidewalk along the new Via dell' Impero. Turning right at the Colosseum, one could look through the Arch of Constantine down the Via di San Gregorio, a straight and rather narrow street that came out at the south end of the Circus Maximus. In late summer that year, work began to widen the street and transform it, and it was renamed the Via dei Trionfi. Running between the Palatine and Celian hills and past the church of S. Gregory the Great, this new street recalled the ancient triumphal route into the city that would now be a site for parades and special events sponsored by the regime.

Antonio Muñoz supervised the work to widen the street. He designed the fountain, near the Arch of Constantine, that remains today, although only stain marks indicate where the fascist symbol had once flanked it on both sides. The project preserved a fragment of the ancient aqueduct of Domitian on the side of the Palatine Hill that brought water to the imperial palaces, and the tram tracks were moved from the middle of the street to the side of the Celian Hill. Mussolini and the king participated in the parade and inaugural ceremonies on October 28, 1933. On the same day, the Duce also visited the completion of the work on the Via del Mare that fully "liberated" and opened up the Capitoline Hill. Muñoz wrote that both projects carried out aspects of the master plan of 1931.[22]

The Via dei Trionfi joined the Via dell'Impero at the Colosseum. Muñoz celebrated the access that the streets gave to archaeological sites in the area and four of Rome's seven hills: the Capitoline, the Celian, the Aventine, and the Palatine. Equally, if not more important, however, was the modern character of these streets that opened new vistas joining ancient and modern. Here would march the legions of the new Rome of Mussolini. "It is not rhetoric to say that the spirit of the new Italy is reconnected to that of ancient Rome, whose stones acquire once again the life and valor of twenty centuries ago."[23]

In 1936 the Governatorato, under the leadership of Giuseppe Bottai, opened the Parco Traiano on the area of the Esquiline Hill that included the site of the Domus Aurea, Nero's Golden House, and the site of Trajan's Baths. The park of 60,000 square meters provided an ancient site for modern Romans to promenade with their families. It joined the Colle Oppio park, which had opened in 1928 and had an entrance off the Via Labicana that overlooked the Colosseum.[24] Together these two parks provided a large green space within the historic center.

Mussolini visited the site of the Parco Traino with Bottai and Antonio Muñoz in August 1935 and encouraged the completion of the work. Once the necessary demolition was finished, the work on the park got under way at the beginning of 1936. Mussolini returned to open it to the public on April 21, 1936. The Governatorato accomplished this work "following the orders of the DUCE and the directives of S[ua] E[ccelenza] Bottai, who assisted the carrying out of this great work from distant Africa . . . in order to contribute to the greatness and the beauty of the new Rome of Mussolini."[25]

Muñoz quoted Mussolini's speech to the Italian Senate about the Piano Regolatore of 1931 on the importance of "new parks, gardens, baths, gyms" in the more densely populated areas of the city that would provide "air and light: fundamental and necessary conditions of health." That was why the government put so many resources into creating more open areas in all parts of the city.[26]

CIRCUS MAXIMUS TO THE PIAZZA VENEZIA

By 1934 the government had only to clear the Circus Maximus and to construct new streets in that area to link up with the Via del Mare, which took one back to the Victor Emmanuel and the Piazza Venezia. This project thus completed a circuit that began at the Piazza Venezia, ran down the Via dell'Impero to the Colosseum, turned right down the Via Trionfi, and then right again to the Circus Maximus and onto the new Via del Circo Massimo, to the two republican temples at the Piazza Bocca della Verità; it turned right once more to go along the Via del Mare past the Theater of Marcellus on the left and the Capitoline on the right, finally arriving back at the Piazza Venezia. This whole area would host major events throughout the 1930s.

Once the site of ancient chariot races, the Circus Maximus in 1934 was filled with a clutter of buildings for the city gas works and a miscellany of shacks and sheds. The government's English-language tourist monthly described the area in the bleakest terms:

> The district was left utterly abandoned and this wonderful zone of Imperial Rome, once so important and animated, was forgotten so that gradually it was covered with ramshackle squalid cottages, sheds, hayricks, small workshops, rag-pickers' sorting dumps and factories of artificial manure. The entire area of the "Circus Maximus" was, so to speak, coverted [sic] into the city's rubbish dump, shunned by the citizens and overlooked by the city authorities.[27]

The regime's work in September and October completely cleared the space. A new street took shape on the Aventine hillside directly across from the Palatine Hill. In order to accomplish this change, the Governatorato had to remove the Jewish cemetery on the slope of the Aventine overlooking the Circus Maximus. The cemetery had run out of space in 1894, when a special section for Jews was opened in Rome's main cemetery, Campo Verano. In 1934, the Governatorato made arrangements with the Jewish community and the chief rabbi of Rome, Dr. Angelo Sacerdoti, to exhume the bodies and transfer them to Verano.[28] A plaque with a Hebrew inscription stands on the site of the cemetery, which is now Rome's municipal rose garden, the Rosa Comunale.

The new Via del Circo Massimo had at its summit and midpoint a semicircular Piazzale Romolo e Remo, today the Piazzale Ugo La Malfa, with a panoramic view of the Circus Maximus and the Palatine Hill. The regime planned a monument to Giuseppe Mazzini on this site, but it was completed only after World War II, when Italy became a republic.[29] On October 28, 1934, Mussolini, on horseback, led the opening day parade of 15,000 athletes.

The Circus Maximus provided a premier site for fascist exhibitions in the 1930s. Four major ones took place between 1937 and 1939: (1) the Exhibit of Summer Camps, June to September 1937; (2) the Exhibit of National Textiles, November 1937 to March 1938; (3) the Exhibit of the Leisure Time Organization, the Dopolavoro, May to August 1938; and (4) the Exhibit of Autarchy of Italian Minerals, November 1938 to February 1939. Each exhibit had its own temporary buildings and pavilions. The central location made the site easy to find for foreign tourists as well as native Romans. Thus a visitor in the 1930s, gazing over the Circus Maximus, might imagine the chariot races of ancient Rome, but what he saw was a space filled with evidence of fascism's efforts to construct a new Italy.[30]

The Via del Mare's completion took several years. When finished, it provided another broad avenue for both vehicular and pedestrian traffic from the Victor Emmanuel to the Piazza della Bocca Verità and around the corner to the Circus Maximus. Along the way, just past the Theater of Marcellus, arose large new office buildings in the distinctly new style of Roman red brick, punctuated by windows with white marble borders and occasional upper story arcades. Buildings of these types, using ancient Roman models and motifs, are found all over the city. The largest one, on the Via del Mare, housed the Governatorato of Rome, the very agency carrying out so many of the demolition and construction projects of the period. It remains today as the Anagrafe, or main record-keeping division of Rome's city government.

The emergence by 1934 of the new complex of streets and spaces south of the Piazza Venezia gave Mussolini the opportunity to make his balcony and the

2.4 New Governatorato building, Via del Mare, 1938

Victor Emmanuel Monument the heart of fascist Rome and the new fascist empire. He reconfigured the Victor Emmanuel, opened eleven years before the March on Rome, so that it had a new and thoroughly fascist context. Honoring Italy's 650,000 fallen in World War I, the tomb of the Unknown Soldier, the *milite ignoto,* provided the sacred, central point for numerous ceremonies. Here Italy and fascism became one.

Between 1932 and 1934, foreign dignitaries and delegations, Italian groups of all sorts, and other visitors to the Mostra della Rivoluzione invariably were led by their fascist hosts to ceremonies at the Victor Emmanuel. Newsreels by the Luce organization featured both the ceremonies and the new construction in the vicinity. Parades in these years took place on the Via dell'Impero and the Via dei Trionfi and later along the Via del Mare as well. The historic center of the city became the center of fascism's new *romanità.* Between 1928 and 1943, Luce cameras captured 249 events at the Victor Emmanuel that were seen in movie theaters throughout the country.[31]

The frequent parades on the new streets gave eyewitnesses and newsreel viewers a new and fascist perspective on the Victor Emmanuel. Now it often appeared in the background of parades and ceremonies in the new ceremonial fascist center created by Mussolini. The area provided a sacred space for fascist

liturgy. Mussolini succeeded in reducing the huge Victor Emmanuel to a subordinate role in the ceremonial life of his fascist regime.

Demolitions in the immediate area of the Victor Emmanuel provided space for trees and benches that were integrated into the new, semicircular space adjacent to the monument. This provided more room for the many buses that ran through the Piazza Venezia to various routes throughout the city, and improved the flow of traffic generally. At the same time, the monument stood out more prominently, with buildings no longer boxing it in on both sides. These changes amplified the space available to fill the piazza with thousands of citizens flocking to hear Mussolini's frequent speeches from his balcony on the Palazzo Venezia. The cleared area in front of the Victor Emmanuel became the Foro Italico and then, after declaration of the fascist empire in 1936, the Foro d'Impero Fascista.

Philip Hannan, future archbishop of New Orleans, lived in Mussolini's Rome as a seminarian. His memoirs of that time offer frequent criticism of the fascist dictatorship, but he acknowledged the fervent acclamation of the Duce in the mid-1930s:

> When he came out on the balcony, the crowd gave another roar—more salutes, then everything grew still. When he speaks, he takes a grip on the balcony railing and starts to throw his whole body into the effort of speaking. He uses powerful, sweeping gestures. After his speech he goes almost immediately inside—but he'd be furious if the people didn't recall him with their cheers. He gets about ten encores. Ordinarily, before each speech, the people yell in quick, staccato fashion, "Duce,duce,duce,duce . . ."[32]

The new streets stretching out from the Victor Emmanuel monument, the Via dell' Impero and the Via del Mare, also provided easier access to the Capitoline Hill with its piazza and palazzi designed by Michelangelo. In 1938, the regime added the paving to the piazza that completed Michelangelo's plan.[33] The Museo Mussolini was the new name for the Palazzo Caffarelli, once the German embassy and reopened after restoration on October 31, 1925.[34] This museum contained artifacts discovered during Rome's rapid expansion after 1870.[35]

The full exposure, or "isolation," of the Capitoline became a reality in 1939 with the demolition of the housing on the southern slope facing the Church of Santa Maria della Consolazione. This work opened up the Via Jugano coming off the Via del Mare and going up a slope to a newly opened Piazza Consolazione, with a winding street up to the Capitoline.[36]

Next to the Palazzo Senatorio, the seat of Rome's city government, stood a monument, or altar, to the fascist "fallen," the Ara dei Caduti Fascisti, which

overlooked the Arch of Septimius Severus in the Roman Forum. The altar's tomblike block of Egyptian granite had formed the base of the obelisk of Sallustiano in ancient Rome, which had fallen during Alaric's sack of Rome in 409. Pope Sixtus V (1585–1590) had plans for its use that were never carried out. The fascists discovered it and used it to construct this monument to celebrate the fourth anniversary of the March on Rome.[37]

The new monument provided a fascist counterpart to the Tomb of the Unknown Soldier at the Victor Emmanuel. The construction of the Via dell'Impero included a new street running up to the site, the Via dell'Ara Littoria, now called the Via San Pietro in Carcere. On one occasion Mussolini declared that just as the monument to the Unknown Soldier symbolized the sacrifices of the war, the monument on the Capitoline recalled the "Fallen of our Revolution."[38] This fascist monument quickly disappeared after the liberation of Rome in 1944.

At the same time that the regime constructed the Via dell'Impero, the Via del Mare, and the Via dei Trionfi, it isolated the Castel San'Angelo, which encased the original tomb of Hadrian. It accomplished this particular "liberation" of an ancient monument by constructing a large open park that exposed it from every angle. The installation of lighting allowed for the spectacular illumination of the site at night. "Via dell'Impero, Via del Mare, Via dei Trionfi, the isolation of the Mole Adriana signals four fundamental points in the development of Mussolinian Rome. These new streets opened among the sacred ruins have revealed hidden magnificence and have carried the dynamism of modern life among the glories of the past giving perhaps, an urban function to the ruins."[39]

The Castel Sant' Angelo now provided Romans with a surrounding park, the Parco Adriana, set next to the Casa Madre dei Mutilati and the nineteenth-century Palace of Justice. A new fascist building arose across the street from the park on the Via Crescenzio in 1938, Anno XVI, E.F. Designed by architect Attilio Spacarelli, the six-story red-brick building housed the provincial offices of the Fascist National Institute of Social Welfare, the Istituto Nazionale della Previdenza Sociale, or INPS.[40]

By 1934, this historic area had undergone changes that no one could miss. The regime, of course, trumpeted this transformation of the city, but foreigners noted the changes as well. Valentine Thomson's article, "Mussolini Builds a Rome of the Caesars," appeared in the *New York Times* Sunday Magazine on March 19, 1933. She quoted Mussolini's boast: "In a very few years Rome will seem a miracle to all people in the world—vast, ordered, beautiful as in the time of Augustus." Antonio Muñoz took her on a tour of the newly opened archaeological sites in the area. Mussolini also put her in touch with the official in

charge of relocating the estimated 98,000 Romans displaced by the recent de-molitions. Mussolini emphasized the benefits of such removals from "the un-wholesome hovels, letting in air, light and sun" to the city, while relocating the displaced persons to clean, new areas toward the hills or the sea.[41] A similar ar-ticle on Mussolini and Rome appeared in the Sunday magazine section on August 25, 1935, by Anne O'Hare McCormick. The author also met with Mussolini and was conducted on tours by Professor Muñoz. She concluded that "it was a great project of town-planning, now so near completion that the Rome of yes-terday is almost erased in favor of the Rome of Augustus, on one hand, and the Rome of tomorrow on the other."[42]

A week before the closing of the Exhibit of the Fascist Revolution, Mus-solini initiated the project to isolate the tomb of Augustus. His picture appeared on the front page of *Il Popolo d'Italia;* in it he wielded the *piccone* to begin the demolition that would "liberate" yet another monument of ancient Rome. The article boasted of the achievements of "La Roma di Mussolini" and declared: "The Romans were great builders and soldiers, besides being colonizers and cre-ators of the law. The Italy of Mussolini reassumes the strongest characteristics of the Race that spread the light of civilization in the world."[43]

2.5 Palazzo Braschi, Corso Vittorio Emanuele, Elections,1934

By the middle of the decade, the fascist transformation of Rome was well under way and visible to any resident or tourist. A visitor from Prague described the change:

> Anyone who has not seen Rome for some years has difficulty in recognizing it. Entire quarters have disappeared, without leaving the slightest trace, to give light to the old Rome, Imperial Rome which is full of surprise at finding itself in the very new Italian Empire. The double gesture of the Duce is of great interest. He redeems the remains of the ancient Empire and at the same time creates a new one. The present marches "pari passu" with the great traditions of the past.[44]

When the Exhibit of the Fascist Revolution closed on October 28, 1934, the regime made a point of announcing the imminent implementation of the fascist corporate state. Corporatism promised a "third way," between *laissez-faire* capitalism and the state-controlled economies of socialism. It would provide "corporations" for various economic activities in which each had representatives of owners, employees, and the state. Through this mechanism the state could monitor conflict and seek resolutions in the best interest of the nation. An article, "From Exhibit to Corporations," linked the emerging corporations to the carrying out of the "Revolution that is and the Revolution that is becoming."[45] Newspaper articles featured pictures of the huge new Ministry of Corporations, designed by Marcello Piacentini, which had opened on the Via Veneto on November 30, 1932. This imposing building symbolized the regime's corporate nature and housed the bureaucracy that was now to make it a reality.

There is an irony here that suggests both fascist Rome's achievements and its shortcomings. Historians generally agree that the much-vaunted corporate state never reached fruition. It did provide jobs for fascist bureaucrats, but it accomplished little else. Indeed the reform law of February 5, 1934 established a new, more complicated structure for the Ministry of Corporations that only upheld the bureaucracy at the expense of any effectiveness as fascism's third way.[46] The new building, still standing in its prominent location on one of Rome's most fashionable streets, both housed the bureaucracy and concealed the emptiness of the promises and claims of the regime. It symbolizes the short-term success and long-term failure of Mussolini's Rome.

Three

SPORTS, EDUCATION, AND THE NEW ITALIANS

Mussolini promised to bring about a fascist revolution that would produce a new and powerful Italy led by a new breed of Italian men, who would be physically fit, imbued with a martial spirit, disciplined, and always ready to fight and, if necessary, die for fascism and the fatherland. Women supported the men as wives and mothers but also participated in sports, physical training and a thoroughly fascist education. Fascism came to power as a youth movement and promised that through youth a new Italy would emerge.

Fascist Rome devoted considerable space to sports facilities, large and small, and schools. Education was a matter of training the mind and the body in keeping with classical ideals, now in the service of the fascist state. Mussolini boasted that the perfect fascist youth carried both book and gun: "Libro e moschetto, fascista perfetto," as he put it. No resident or visitor could miss the stadiums, fields, and buildings devoted to training and educating the city's youth and the incessant propaganda proclaiming fascism's missionary zeal in raising a new fascist generation. Giuseppe Prezzolini stated the goal in his book on Italy for an English-speaking audience, written in the late 1930s: "It has been said before, but it bears repeating, that a sweeping revolution has taken place in the social life of the Italians—the home has given the young to the State. A new political and educational technique has been introduced, designed to mould not only the intelligence and memory, but the child's whole being, body and soul alike, and involving not merely his scholastic record but his entire character and future."[1]

Prezzolini's statement manifested the totalitarian pretensions of Mussolini's state. It is consistent with the oft-quoted declaration in the *Enciclopedia Italiana* of 1932 that "[f]or the fascist, everything is within the State, and nothing human or spiritual exists, much less has value, outside the State. In that sense Fascism is totalitarian, and the fascist State, the synthesis and unity of every value, interprets, develops and empowers the whole life of the people."[2]

FORO MUSSOLINI

The regime built its new "sports city" in Rome to demonstrate its commitment to training youth in sports and physical fitness. This new complex required the development of new spaces outside the historic center. The regime chose a spot north of the Vatican, just below Monte Mario. Here arose the Foro Mussolini, today's Foro Italico. The forum, or *foro,* suggested once again Mussolini's imperial image, for only emperors had forums built and named in their honor. A modern, fascist forum evoked the connection to ancient, imperial Rome while providing facilities for "the spiritual and physical education of new generations of Italians."[3] At the forum, images of ancient models of physical prowess mixed with modern sports and modern notions of physical vigor and health.

The chief architect for the project, Enrico Del Debbio, chose the site between the river and Monte Mario. It was a low-lying, swampy area that hunters favored for marsh birds. Del Debbio and Renato Ricci, leader of the youth organization Opera Nazionale Balilla or ONB, managed to overcome opposition to using the spot. For Del Debbio, the new project would help fulfill fascism's promise to improve the health of the nation by providing much-needed facilities. He saw the endeavor as part of the modern effort to fulfill the ancient ideal of Greece and Rome "of strengthening the mind through a healthy body."[4]

Work on the Foro Mussolini began in 1928 under the direction of Del Debbio.[5] Following Del Debbio's death in 1935, the rationalist architect Luigi Moretti took his place. The first nucleus of buildings opened on November 4, 1932, as part of the Decennale, celebrating the tenth anniversary of the March on Rome. Work continued on the complex until the early years of the war. Changes followed World War II, especially the rebuilding of the Olympic Stadium, but most of what remains dates from the fascist period. To explore Mussolini's "city of sport" today is to explore a major monument of Mussolini's Rome.

The Duke of Aosta Bridge, Ponte Duca d'Aosta, provided the access to the *foro* from the Parioli section across the river. The regime announced a contest for the bridge's design in 1935. Vincenzo Fasolo's plan, chosen from among eigh-

teen entrants, won. The bridge had the capacity for a far larger flow of traffic than the ancient Milvian Bridge. The modern design of the bridge only reinforced the overall message of modernity inherent in the design and purpose of the Foro Mussolini.[6] Work began in 1936, taking advantage of the latest techniques of construction, and the bridge opened in 1939. It had clean, simple lines, with a long central arch spanning the river and two smaller arches covering the embankments. The sculpted reliefs at both ends depict scenes of World War I.

The obelisk dedicated to Mussolini dominated the entrance to the forum facing the bridge. It stood more than sixty feet high and was fashioned from a three-hundred-ton block of Carrara marble, which the fascists claimed was the largest piece of marble in history. It left Carrara in late 1928 and took months to reach its intended site in Rome. The regime spared no effort in telling the dramatic story of the obelisk's journey from Tuscany to its new home overlooking the Tiber.[7]

The base of the column bore the inscription DUX, Latin for duce, or "leader." The letters spelling "Mussolini" ran vertically up the shaft. Constantino Costantini designed this tribute to the Duce that became known simply as "il Monolito," the Monolith. American troops occupied the site after Rome's liberation in 1944 and saved the obelisk from the destruction taking place throughout the city as Romans sought to erase the most obvious remnants of fascism and its leader.[8]

The building on the north side was the Academy of Physical Education, originally the Istituto Superiore Fascista di Educazione Fisica that provided a home then and now for Italy's Olympic Committee, or CONI. Del Debbio designed the building, and the four statues of athletes were the work of Silvio Canevari and Carlo Veroli. When the building opened in 1932, it contained a chapel, or *sacrario*, in memory of Mussolini's brother Arnaldo, his closest adviser and confidant as well as editor of the fascist daily newspaper *Il Popolo d'Italia*, who had died the year before.

The first section of the building on the other side of the Monolito housed the Center for Political Preparation. The next section held an indoor public swimming pool and the personal gymnasium of Mussolini, the Palestra del Capo del Governo. Del Debbio's original plan included two indoor and three outdoor pools, although only one indoor pool was completed before World War II. The regime recognized the scarcity of swimming pools in Rome and had ambitious plans to rectify the situation. The goal was to provide pools open to the public, as were the baths of ancient Rome.[9] Mosaics and frescoes with appropriate athletic scenes adorned both the indoor pool and the Duce's gym.

Directly beyond the Monolito between the two buildings lay the Piazzale dell'Impero, designed by Luigi Moretti.[10] Skateboarders make free use of it today, but originally it served as a path to the two stadiums and other facilities. The path doubled as an open-air display of fascist symbols and history. At the lower level are a series of mosaics that depicts fascist and imperial themes, including references to the Duce and slogans of the regime such as "Many enemies, much honor," "Duce, we dedicate our youth to you," and "Better to live one day as a lion than a hundred as a sheep."[11] The mosaics were the work of artists Angelo Canevari, Achille Capizzano, Giulio Rosso, and Gino Severini.

One mosaic is a map of the Via del Mare with its ancient sites: the Theater of Marcellus and the two ancient temples. Across from it is a map of the Foro Mussolini. "What the pair of mosaics presents through myth, then, is a foundation analogy, suggesting that the new empire of 1936 celebrated by this Fascist forum is equivalent in its greatness and portent to the foundation of Rome by Romulus and Remus."[12] Another mosaic quoted the words Mussolini spoke to the crowd on May 9, 1936: "Italy finally has its empire."

A few steps above the pavement's mosaics are marble tablets lining each side of the Piazzale dell'Impero. Each tablet or block is about five feet high and eight feet wide. Each has an inscription commemorating an important event in fas-

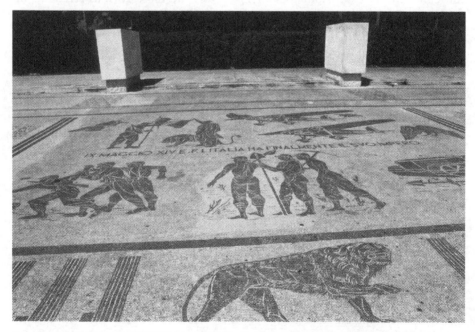

3.1 Mosaics, "IX May XIV E[ra] F[ascista] Italy Finally Has Its Empire" Foro Mussolini, 2000

cism's history from the decision to enter the war in 1915 to the 1930s. The founding of fascism after the war, the March on Rome, the Lateran Accords, the conquest of Ethiopia, the declaration of the new fascist empire, and more were all there. Here was a fascist history lesson laid out in a very public space.

Today the final tablets give the postscript to this fascist version of history. All the messages from the fascist period remained after the war, but the postwar government added tablets to commemorate the fall of fascism in 1943, the national referendum that abolished the monarchy in 1946, and the inauguration of the new Italian Republic in 1948.

Between the Piazzale and the Olympic Stadium lay the Fountain of the Sphere, Fontana della Sfera, completed in 1933 and suggestive of the symbol of New York's World's Fair in 1939. The sphere sat in a basin below ground level with a surrounding fountain spewing water toward the globe that evoked ancient examples found in the Roman Forum, Pompeii, and Herculaneum. Architects Giulio Pediconi and Mario Paniconi did the design. The sphere weighed forty-two tons and, with the Monolito, its transportation from Carrara to Rome made a good news story. The mass of the sphere "symbolizes the strength of Fascism." Giulio Rosso designed the mosaics surrounding the fountain with scenes of "movement in contrast to the static beauty of the [sphere]."[13]

The two stadiums stand just beyond and to the north of the sphere. The first, and larger one, was the Olympic Stadium, sometimes referred to as the Stadio dei Cipressi. Today it bears little resemblance to the original, as it was considerably altered in the 1950s in preparation for the 1960 Olympics and again for the World Cup in 1990.[14] To its right is the Stadium of Marbles, or Stadio dei Marmi, which in contrast, remains in its original state. The name comes from the sixty marble statues of muscular male athletes in various poses. Each statue came from and represented a different city in Italy, another reminder of the importance of Italian unity under the Duce.

The Stadio dei Marmi opened in 1932 as part of the original nucleus and functioned as a centerpiece of activity throughout the 1930s. It had steady use for all sorts of party and youth groups. Pictures from the period feature muscular athletes in motion; fascist boys and girls performing precision gymnastics; and party leaders, led by Achille Starace, leaping through hoops of fire. When members of the Hitler Youth came to Rome, they made an appearance in the stadium, whose seating capacity was 20,000. The regime boasted of its up-to-date seating and equipment: "It is justly considered as one of the most imposing and important [stadiums] in the world."[15]

Flanking the Olympic Stadium to the south stood a complex of facilities and buildings constructed between 1933 and 1937. The Olympic tennis stadium

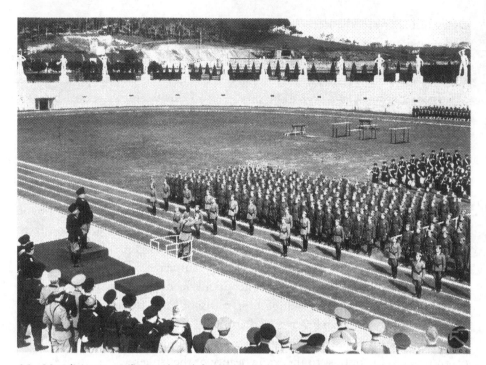

3.2 Mussolini reviews military and youth formations, Stadio dei Marmi, Foro Mussolini, 1939

designed by Costantino Costantini and the tennis training area, Campo di Tennis, appeared in 1933–34.[16] Standing between the two tennis facilities loomed the monumental Statue of the Balilla by Aroldo Bellini. The well-proportioned young male figure strode with confidence and carried a rifle over his shoulder, embodying the fascist virtues of strength, power, physical prowess, and military readiness. Mussolini inaugurated the monument on April 5, 1936, as part of celebrations of the tenth anniversary of the Balilla organization, the Decennale of the Operazione Nazionale del Balilla, or ONB.[17]

At the end of the complex there was a youth hostel, the Foresteria Nord, designed also by Costantini and still in use today. Luigi Moretti designed the striking building across from the hostel that housed the fencing academy, known as the Casa delle Armi, considered by many architectural critics as "certainly the building of greatest architectural interest in the whole complex."[18] Its clean lines and streamlined design make it a prime example of modern architectural style in Mussolini's Rome. Finished in 1936, the Casa delle Armi registered a victory for the modern, rationalist style championed by Giuseppe Pagano in the debate over what constituted appropriate fascist architecture.[19] Pagano's sometime opponent in the debate, Marcello Piacentini, edited the *Architettura*, the official

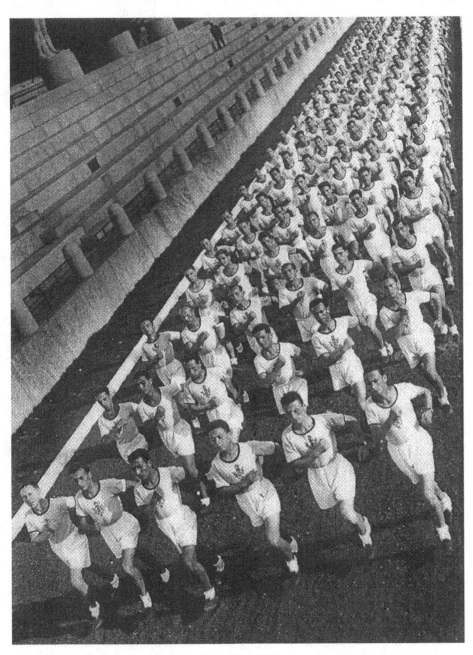

3.3 Athletes in the Stadio dei Marmi, Foro Mussolini, c. 1932

publication of the Fascist Syndicate of Architects. An article in 1937 praised Moretti's building, declaring that although Moretti was "modern," he himself would reject being understood as a "rationalist" architect. What he brought to his work was a balanced sensibility that sought to unify the form and content of his buildings, and so "he is without doubt a classicist."[20]

Recently architect Robert Evans commented: "I admire [Moretti's building] for its combination of functional modern sculptural forms clad in subtly detailed white marble, referencing classical Roman buildings."[21] Unfortunately, the building became a fortified courthouse and the site of "maxi-trials" of Red Brigade terrorists in the 1980s. Today it serves as a police barracks for the army's national police, the Carabinieri. It is in deplorable condition in an unsightly setting. Visitors today can get glimpses of it only from various points along the surrounding fence and by the main gate. Until it is restored and opened again to the public, Moretti's masterpiece can be appreciated only in photographs from the period.

Del Debbio designed the Sun Therapy Camp, the Colonia Elioterapica, which opened in 1934. It sat atop Monte Mario just above the stadiums and overlooking the whole of the Foro Mussolini. It provided treatment to strengthen frail or sick youth with a combination of sun and exercise. This therapeutic institution fit in with fascism's plan of open-air schools and outdoor summer camps, which all reflected the belief that physical health was part of a proper fascist education.

For the fascists, the Foro Mussolini as a sports city represented the "biggest experiment in state education that history records." It had scientific, artistic, historical, and political purposes. It was a "monument that is linked to the Roman imperial tradition, that wants to perpetuate for the centuries the memory of the new fascist civilization, tied to the name of its Condottiere."[22] The vast space between Monte Mario and the Tiber provided a "city populated by youth and dedicated to youth that is here hardened physically and politically, and is prepared . . . to form the ruling cadres of the great sports and military phalanxes that are expressed by Fascism, renewed by the flow of the generations."[23]

The construction of the final fascist addition to the Foro Mussolini began in 1938 and was suspended during the war. It arose as the Casa Littoria, or headquarters for the National Fascist Party, the Partito Nazionale Fascista (PNF). In the 1920s and 1930s, the PNF occupied the Palazzo Vidoni on the Corso Vittorio Emanuele, next to the Church of San Andrea della Valle. Following the Decennale of 1932 and the very successful Exhibit of the Fascist Revolution from 1932 to 1934, Mussolini sponsored a contest for the design of a grand new party building that would sit on the Via dell'Impero near the Colosseum and across from the Basilica of Maxentius.

The contest attracted more than a hundred entries. The committee to evaluate the projects included the governor, Prince Francesco Boncompagni Ludovisi; three architects, Marcello Piacentini, Cesare Bazzani, and Armando Brasini; the administrative secretary of the Fascist Party, Giovanni Marinelli; and the secretary general of the party, Achille Starace. In 1934, Mussolini still publicly favored a modern style of architecture, but the bitter divisions over what constituted proper fascist style prevented a decision for this most fascist of all buildings. Mussolini revived the project in 1937 and suggested a new site on the recently widened and redesigned Viale Aventino, behind the new post office facing the Via Marmorata. The pressure for a more monumental and imperial style had grown since the war in Ethiopia and the declaration of the new fascist empire the year before, and "in three years, the consensus had moved dramatically away from Modernism."[24] In addition, the challenge of placing such a grandiose structure in the heart of the historic center proved a daunting task. The final decision in 1938 led to the site at the Foro Mussolini, just beyond the Stadio dei Marmi.[25]

The winning design by Del Debbio, Arnaldo Foschini, and Vittorio Morpurgo presented a huge building of 540,000 square meters in volume. It provided offices for all the hierarchy of the PNF, including a two-story space for the Duce. The building, 200 meters long, faced a piazza defined by arcades stretching out from both sides and designed to hold 600,000 people. The plan also included a memorial to the fallen fascists, a *sacrario dei caduti fascisti*, in front of the building on the main axis. The space, without the arcades or the *sacrario*, remains today, and the building, completed after the war, is substantially the original design minus a portico projecting over the central entrance.[26] Referred to today as the Palazzo Farnesina, it has been the home of Italy's foreign ministry since 1958.

One grand object planned for the Foro Mussolini never reached completion: the huge Statue of Fascism that was to soar 150 feet into the air. The site for it was beyond the stadiums on a direct line with the obelisk at the entrance. Work got as far as the head of the statue, which bore a striking resemblance to Mussolini. The war put a stop to this piece of megalomania, which was melted down for the war effort.

Taken as a whole, Foro Mussolini provided a fascist showpiece that linked fascism's cult of the body and physical strength with the traditions of imperial Rome. It claimed to bring together scientific, artistic, historical, and political purposes in one huge complex. For the regime, the very word *foro* recalled the glories of ancient Rome, but it also stood for the same sort of political program that engaged the ancient forums as centers of training and education. The

3.4 The Casa Littoria during construction, Foro Mussolini, 1940

forum, dedicated to fascism's Duce, provided for the physical and spiritual education of the new generations of Italians. Therefore, what more appropriate place could there be for the Palazzo del Littorio, the fascist headquarters sometimes referred to as the Casa Littoria, including the permanent Exhibition of the Fascist Revolution?[27] In the words of Renato Ricci, the leader of the Balilla, "The Palazzo del Littorio, the seat of the final Exhibit of the [Fascist] Revolution, will find in the Foro Mussolini a center of fascist life, its natural site and I would say a predestined one."[28]

The importance of the Foro Mussolini to the fascist program of propaganda and spectacle was reinforced by plans that would allow thousands to enter and leave the complex with relative ease. Great attention went to the flow of traffic to the foro. The Duca d'Aosta bridge fulfilled that function, and there was talk of adding another bridge running directly into the Palazzo del Littorio. City buses would bring many citizens, and plans also called for an automobile parking lot.

The Foro Mussolini thus gave the Opera Nazionale Balilla a magnificent sports city to train and showcase youth. In 1937, all the youth groups were unified and consolidated under the Gioventù Italiana del Littorio, or GIL.

The large new administrative headquarters for the GIL, also designed by Costantino Costantini, arose on a site just beyond the Foro Mussolini and the Milvian Bridge.[29]

CAMPO DUX

The fascist regime planned another bridge, the Ponte XXVIII Ottobre, to the east of the Milvian Bridge, which led into the area adjacent to the Parioli section and the Villa Glori park, home to several stadiums and other sports facilities. The regime both developed the facilities and made use of the open space available for the annual rally of fascist youth known as Campo Dux.

The principal stadium in Parioli was commonly known as the Stadio Nazionale; it opened in 1911, the fiftieth anniversary of Italian unification, with a seating capacity of 30,000. Marcello Piacentini supervised expansion and alteration in 1927, which increased the number to 40,000.[30] The name changed to the Stadio del PNF, the Partito Nazionale Fascista. The enlarged stadium had facilities for soccer matches, track meets, fencing, indoor and outdoor pools, and a gymnasium. Four new statues of athletes by Amelto Cataldi graced the entrance.[31] Just beyond it was a smaller stadium, the Campo di Rondanella, and tennis courts, the Tennis Parioli. In addition, there was the horse racing track, Ippodromo di Villa Glori.

The open space between these sites and the Tiber provided ample space for the annual Campo Dux. Up to sixty thousand members of the fascist youth organizations throughout Italy gathered for a week in September. For those boys who were fifteen years old, the event was a rite of passage as they moved from the Balilla to the Avanguardisti. The event began in 1929. "The provincial ONB delegations paid the expenses of the young men attending the camps, and each year participants included thousands of Avanguardisti from all over Italy and from *fasci* abroad."[32] Their activities combined military exercises, sports, and discipline. Participants also visited sites in the city that demonstrated Rome's importance as Italy's capital, now undergoing fascist transformation. In 1933, they saw the Exhibit of the Fascist Revolution, and a contingent of Avanguardisti took a turn as one of the daily honor guards.[33]

The program of Campo Dux emphasized "the new education of Italy's youth." It was the "greatest manifestation of the [national fascist youth organization] Opera Balilla." The military discipline and sporting exercises attempted to channel youthful instincts into positive social and political education. Various sporting contests taught a healthy spirit of competition. It was not "without

significance that Campo Dux takes place in Rome, the city that completed Italy's unification and that was now fulfilling Mussolini's revolution."[34]

The culmination of the week came in the shadow of the Colosseum on the Via dell'Impero, as the masses of youth, typically 25,000 in number, paraded before the Duce. They represented "the flower of the new generations and were the image of the new power of the fatherland [and] offered a magnificent proof of their preparation and their potent maturity which the Opera Nazionale Balilla has reached . . . in the task assigned to it by the Regime."[35] The Luce organization filmed the rallies every year and included excerpts in the newsreels shown in movie theaters throughout the country.[36]

After World War II, the Italians further developed the whole area for the 1960 Olympic Games. The Stadio del PNF, now the Stadio Flaminio, underwent further rebuilding and expansion. A new, covered Palazetto dello Sport, designed by Paolo Nervi, arose on the site of the Campo di Rondanella. The Olympic Village stood where fascist youth had once gathered for the Campo Dux and where squatters had camped out in the years immediately after the war.[37]

FACILITIES FOR YOUTH GROUPS

In 1935 the Opera Nazionale Balilla, or ONB, obtained a new educational and recreational facility on the historic Aventine Hill, overlooking the Circus Maximus. It was the right place and the right time for the ONB's new complex. The work to clear the Circus Maximus and construct the new Via del Circo Massimo had been completed the previous year. Mussolini had inaugurated the new street and the Piazzale Romolo e Remo, overlooking the Circus Maximus, on October 28, 1934.

The new Balilla building had been a restaurant, the Castello dei Cesari, which fell on hard times and faced going out of business. The owner gave the property to Mussolini as a personal gift. It was and is a prime piece of Roman real estate with a view of the Circus Maximus and the Palatine Hill. Mussolini might well have worried that if he used it for personal purposes, its location on the Aventine Hill might remind people of the last organized political opposition he faced in 1924 during the Matteotti crisis, when antifascist members of parliament withdrew to what they called the "Aventine Secession." The Duce decided to make it over for the ONB.

Mussolini employed the architect Gaetano Minucci to reconstruct the facility. The shell of the building remained, but "the whole ground floor ha[d] been

'reclaimed' [bonificato]" and given a complete transformation. The two floors contained a small theater, a refectory, a locker room and showers, a library, classrooms, a large game room, and offices. Outside were courtyards, terraces, a garden, and ample open space.

Accompanied by Renato Ricci, president of the ONB, Mussolini opened the building on August 3, 1935. Cheering fascist youth, male and female, greeted him. Here was a facility "worthy of the fascist youth organization." To commemorate the event, a chiseled message from Mussolini ran along the wall of the courtyard between the two floors of the building: "On this hill, given by the Duce, the youth of Rome will grow to new destinies. Ever a remnant of a glorious past, they will see the promise of a more splendid future."[38] The building today, complete with these words, houses the National Academy of Dance.

Another Balilla structure was built from 1933 to 1936 in the Trastevere neighborhood. Luigi Moretti's new youth complex opened at the time of the incorporation of the Balilla into the newly organized Gioventù Italiana del Littorio and thus became the Casa della GIL. The location was just over the Tiber, across from the Aventine Hill and the Testaccio neighborhood, steps beyond the Porta Portese. Compared to his Foro Mussolini and exhibits in the Circus Maximus, the youth complex afforded Moretti relatively little space. His solution was to build up. The tower section of the complex on the Via Induno rose six stories, and the adjacent section on the Via Ascianghi had three levels.

The facility contained three types of spaces: 1) health assistance services, 2) sports and recreation facilities, and 3) offices. Each had a separate entrance. Altogether it could service up to two thousand people at the same time.[39] On one side by Porta Portese there was a theater sponsored by the Dopolavoro organization, and on the other side, near Viale Trastevere, a cinema was built. The regime had thus provided a wide variety of social and recreational services in the heart of one of Rome's best-known neighborhoods. Moretti's design had a decidedly modern, rationalist look about it, but Piacentini's journal, *Architettura*, again took the opportunity to classify Moretti as a "classicist" for his attention to symmetry, balance, and harmony in this and other recent projects.[40]

The GIL complex has suffered alterations and deterioration over the years. The Via Aschiangi is now closed to traffic and blocked off by large gates, making it difficult to view the building as originally planned. The fascist slogan "Credere, Obbedire, Combattere" (Believe, Obey, Fight) is still visible over the main entrance.

Across the river in Testaccio was another sports area, or *campo sportive,* which provided space for soccer and other games. It predated the fascist period but was maintained by the regime and disappeared after World War II. The

3.5 Building for the Gioventù Italiano del Littorio (GIL) by Luigi Moretti, Trastevere, 1999

regime did build a Campo Sportivo Guardabassi in the mid-1930s just south of the Circus Maximus adjacent to the Baths of Caracalla, and it is still very much in use today.

The regime's efforts to transform Italy's youth into a new generation of fascists did not go unnoticed by foreigners. Facilities all over the city attested to how important sports and physical training were in fascist Italy. One American resident of Rome pointed out to a visiting journalist the Campo Sportivo Guardabassi and even articulated the moral message put forth by the regime: "Look to your left. See those young Fascists on the athletic field. Beyond them lie ruins of Caracalla's Baths. Vast in size and equipped with every luxury then

known, they marked beginnings of Rome's fall. Here men accustomed to hard campaigning grew soft on enervating pleasures."[41] The author went on to state how impressive it was to have a modern running track beside the grand ruin that so eloquently spoke of ancient "opulence and physical decay."

Athletic events could also take place in traditional spaces such as the Piazza Siena in the Villa Borghese park. The oval-shaped space worked well for equestrian events. It also furnished a site for annual awards to Italy's top athletes. On July 5, 1936, for example, Mussolini decorated "those who in the year XIV had won the highest sports awards" in the eighth gymnastic competition of the Dopolavoro organization.[42]

SCHOOLS

Fascist educational policy vacillated during the years of the regime. The initial reforms of Giovanni Gentile as minister of education favored a traditional humanistic curriculum, whereas Giuseppe Bottai, in the same post in the mid-1930s, was a proponent of a more modern system emphasizing professional and technical education.[43] Nevertheless, the public emphasis consistently touted the importance of education and the construction of new schools for the new generation. Schools of all types, from vocational to classical high school, or *liceo,* appeared prominently in government press and publications. "The means [in the past] were always inadequate for the needs, and only since the advent of Fascism has the development of elementary, secondary and higher education begun to keep abreast of the growth and distribution of the population, as well as of the social, intellectual and national requirements."[44]

Rome had a generous share of schools of all types. Sometimes, the programs as well as the buildings were new. The outdoor school, or *scuola all'aperto,* stressed the benefits of outdoor education for children from ages six to twelve. An early example was built on the Aventine Hill in 1925 by the Governatorato, across the street from the church of Santa Sabina, and dedicated to Rosa Mussolini, the Duce's mother and Italy's most celebrated schoolteacher. Students received the "benefit of air, light, sun, exercise and proper food" that would make even the physically weakest students strong and healthy. The school's 185 students performed physical exercises every day under the guidance of their teachers, which prepared the boys for membership in the Balilla and the girls in the Piccole Italiane. A picture of a school outing in 1929 showed the students raising their arms in the fascist salute as they paraded around the Altar to the Fascist Fallen, the Ara dei Caduti Fascisti, on the Capitoline.[45]

Summer camps, or *colonie estive,* were manifestations of the stress on out-door physical training outside the cities. The Opera Nazionale Balilla ran the camps, which were found throughout the country. "Formidable propagandistic machines for the fascist regime's pledge to the working masses, they nevertheless provided a testing ground for those young architects who wanted to measure the efficacy of their ethic[al] and aesthetic ideals against reality."[46] Rome, of course, was not a site for these camps, but they were featured in the mammoth exhibit of 1937 in the Circus Maximus, which was dedicated to summer camps and state welfare for the young.[47]

New schools often occupied prominent sites to give them maximum visi-bility. The new working-class suburb of Garbatella, south of the historic center between the Porta San Paolo and the basilica of San Paolo fuori le Mura, arose in the 1920s and '30s, with an abundance of public housing.[48] The notable growth in population meant that the existing school facilities fell short of needs. The Governatorato responded by planning a major new school for the central piazza in the neighborhood.

The Piazza Domenico Sauli, built in the 1930s, had truly monumental fas-cist proportions, with a large open space and a church in the middle. The new school, named for the fascist leader Michele Bianchi, dominated the south side of the piazza. It had a central tower and four imperial eagles perched over the main entrance. The facility provided fifty-one schoolrooms divided into two sections, one for boys and the other for girls.[49]

The Governatorato built one of its first vocational schools on the Via Taranto, just to the east of the Lateran, in the Appio quarter. It opened in 1931 with fifteen hundred students. Boys made up two-thirds of student body, and they studied a variety of subjects in the practical arts, such as wood and metal-working, electricity, gardening, and various forms of applied engineering. The girls took subjects in domestic arts, such as sewing, cooking, and weaving. The program included trips to appropriate businesses, industries, and shops, as well as museums and other sites of public or civic importance. At the end of the 1933 school year they paid homage to the Tomb of the Unknown Soldier at the Vic-tor Emmanuel Monument, the Ara dei Caduti Fascisti, and the monument to Anita Garibaldi recently erected on the Janiculum Hill.[50] One of the city's four new major post offices appeared a few years later, several blocks west of the school, and by the end of the 1930s the neighborhood had numerous new apart-ment buildings of five and six stories.

A major new classical high school, the Liceo Virgilio, occupied a central lo-cation along the Tiber across the street from the Ponte Mazzini. The four-story

structure opened in 1937, replacing housing that the regime characterized as "unsanitary." Its ample space included fifty-six classrooms, a gym, and a large auditorium. The original sloping walk to the main entrance is now behind locked gates, but the statue of Virgil still stands guard by the door.[51]

The Liceo Ginnasio Giulio Cesare also opened in 1937, designed by Cesare Valle. The new neighborhood between the Via Salaria and the Via Nomentana provided ample space for a large and prominent site on the Corso Trieste. The school's design, according to the Governatorato, was modern, functional, simple, and harmonious. The school had first-rate facilities: an auditorium seating fifteen hundred people; a gymnasium with a surface of three hundred square meters; ample classrooms; faculty offices; facilities to teach physics, chemistry, natural history, and art history; and a fine library.[52]

The neighborhood just outside the Aurelian Wall at the Porta Latina and the Porta Metronia also underwent dramatic neighborhood growth in the 1920s and 1930s. The regime constructed a new elementary school in 1932 on the Via Vetulonia, within sight of the Porta Latina, designed by a young architect Ignazio Guidi for the Governatorato. The original name honored Mario Guglielmotti, but today it is dedicated to Alessandro Manzoni, Italy's most important nineteenth-century literary figure. The modern exterior enclosed thirty-eight classrooms and other facilities carefully designed for the school's educational functions. Wide corridors and staircases could accommodate heavy student traffic, and attention was given to proper insulation and ventilation as well as ancillary facilities such as a cafeteria and showers.[53] Guidi designed a similar but larger school on the Lido, which opened in 1934.[54]

Mussolini's Rome thus provided the facilities and the programs to train and educate the new generation of Italians who would someday fulfill the promise of the fascist revolution. Romans and visitors saw throughout the city these tangible examples of the new Italy that charted a modern course for an ancient land. The sports programs in particular aimed at a mass audience. As one American put it: "In former days Italian gentlemen fenced and rowed, while the peasants indulged in games of bowls in tavern yards or streets. No sport is a closed book to the young Italians who are growing up today; at the same time participation in these sports is compulsory." She also pointed out that the Italian girl "participates in athletics as freely as her brother."[55] That was just the message Mussolini wanted to convey: that Italy under fascism and his visionary leadership meant the emergence of a new and vibrant nation.

The educational and sports program of fascist Italy certainly had the goal, as stated by Prezzolini, of molding the child's "whole being" for the state.[56] Children

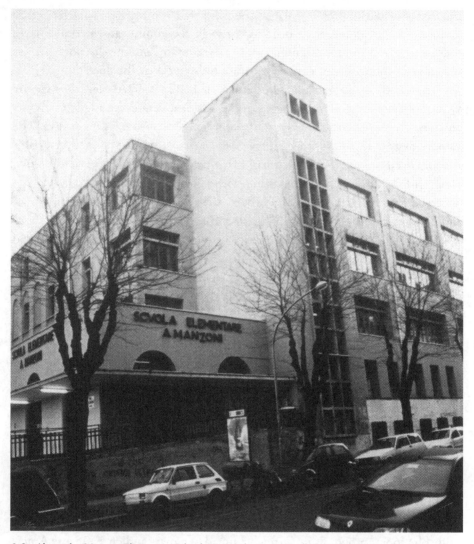

3.6 Alessandro Manzoni Elementary School, Via Vetulonia, (originally named for Mario Guglielmotti), 1999

learned the fascist oath at any early age: "In the name of God and Italy, I swear to carry out the orders of the Duce and to serve with all my strength and, if necessary, with my blood, the cause of the Fascist Revolution."

Beginning in the primary grades, text books incorporated political, and specifically fascist, themes into their lessons. The political and historical messages became more numerous and sophisticated in the higher grades. After the conquest of Ethiopia, the quantity of propaganda in texts increased perceptibly.

Attractive color pictures featured the accomplishments of the regime, the military, youth organizations, and such leaders as the pope and the king. Both Mussolini and Rome received great attention. By 1934 teachers were required to wear uniforms in class. "Militant fascism became dominant everywhere."[57]

One book used in the early years of primary school, *Piccolo Albo di Cultura Fascista,* or *Little Album of Fascist Culture,* introduced students to many of the standard fascist themes: Rome, the Duce, the fascist symbol, the redemption (*bonifica*) of the land outside Rome and the founding of new towns, the reconciliation with the Vatican, and the myriad services offered to the people by fascism.[58]

School texts reveal part of the reason Mussolini's regime failed in its totalitarian aim of producing a new generation of Italian youth wholly devoted to the Duce and to fascism. As much as the Duce and fascism permeated the messages and demanded loyalty, rival objects of loyalty appeared: the king, the pope, the church, the Catholic faith, the armed forces, and the family. "Family life and mother love are central to the life of the society portrayed in all these texts. . . . However much the children might dress in fancy uniforms, sing songs and march around, they still came home to their families whom they never learned to desert, denounce or dislike."[59]

Four

ARCHITECTURE, PROPAGANDA, AND THE FASCIST REVOLUTION

FASCISM AND ARCHITECTURE

The transformation of Rome into Mussolini's Rome required countless contracts for projects large and small. The regime, through the Governatorato, supervised building patronage on a grand scale. Indeed, Mussolini's government acted in the same way throughout Italy. Much was at stake, both in terms of money and architectural style. A central question was: What style would win official recognition as the true "fascist" style?

In the late 1920s and early 1930s, Mussolini often favored a modernist style and gave some encouragement to the rationalist architects. His mistress and cultural adviser, Margherita Sarfatti, supported the so-called Novecento school, which sought to combine traditional motifs with modern ones. With conquest and the declaration of empire having come about by 1936, support grew for projects and buildings on a huge, imperial scale to evoke the grandeur of ancient Rome.

Ultimately, of course, only Mussolini could decide. On the issue of architectural style, he managed to straddle fences, first leaning toward one side and then toward the other, without ever insisting, in any definitive way, on a specifically "fascist style." In this respect, he was quite different form Hitler and Stalin, whose policies sanctioned only one politically correct style in art and architecture. Mussolini's attitude allowed the regime to pursue a policy of "aesthetic pluralism," in the words of historian Marla Stone.[1]

Throughout the regime's history, therefore, a debate took place: a competition among architects championing various styles. What all the architects had in common was a willingness, often an eagerness, to work for the regime and thus participate in constructing the new fascist Italy. Fascist patronage meant both money and prestige. After World War II, the architect Ernesto Rogers commented on the dilemma and ultimate confusion facing artists and architects who sought to work with the government in the 1930s. He admitted that he and many architects readily worked out of a conviction he now saw as an error based on a false syllogism: "Fascism is a revolution; modern architecture is revolutionary, therefore it should be the architecture of fascism. As you saw, the first proposition was wrong, and the consequence could only be disastrous; fascism was not a revolution."[2]

There is some truth to the notion that Mussolini and his regime opened the way for avowedly modern styles initially and then with the advent of empire moved toward a more monumental style, but the pluralism and the eclecticism went on until the fall of fascism. The debate and competition among architects continued as well.

The architect most consistently favored by the regime was Marcello Piacentini. Before the advent of the fascist regime, Piacentini favored a modest approach to historic Rome that would preserve its picturesque qualities, but he reversed his opinions after 1922 and supported the transformation of Rome consistent with Mussolini's vision of "grandeur and necessity."[3] He went on to design a number of buildings for Mussolini's Rome as well as to supervise large projects, including a new campus for the university and the exposition planned for 1942 in an area initially known as E'42 and now called EUR, Esposizione Universale di Roma. He acted as a broker among architects and architectural styles. Beginning in 1932, he edited the new monthly journal *Architettura,* the publication of the National Syndicate of Fascist Architects, and continued to do so until its demise in 1942. Piacentini searched for an architectural style appropriate to fascism that would draw upon Italian traditions while incorporating modern trends.

Piacentini's influence on the shaping of Mussolini's Rome was on a par with that of Antonio Muñoz. They were not rivals, for Muñoz worked primarily on restorations and innovations in the historic center while Piacentini led the architects who designed new buildings, new centers, and new fascist "cities." Although Piacentini accomplished a number of projects throughout Mussolini's Italy, he lived and worked in Rome. He designed and built his own apartment and studio there. Completed in 1932, overlooking the Tiber on the Lungotevere Tor di Nona, the complex combined Roman elements with a "modern sensibil-

ity" that used the red brick and travertine framed windows characteristic of new construction in Mussolini's Rome.[4]

Architects such as Giuseppe Terragni, Enrico Del Debbio, Adalberto Libera, Mario De Renzi, and Luigi Moretti continued to execute projects in a distinctly modern style, and Piacentini regularly called on them and others to work in Rome. The one architect who argued most vociferously and most publicly for modern architecture and against any trend toward monumental architecture was Giuseppe Pagano. Pagano had both a clarity of vision and his own architectural journal, *Casabella,* in which to express that vision. By the mid-1930s, *Casabella* carried out a polemic against monumentalism that, in retrospect, sheds light on work taking place in Mussolini's Rome.

Pagano had associated himself with a group of rationalist architects who formed an International Movement for Rational Architecture, the Movimento Internazionale d'Architettura Razionale, or MIAR, in 1931. Mussolini showed some interest and support, but a controversy erupted, as critics saw rational architecture as subversive of national values. Piacentini charged that rationalism smacked of bolshevism.[5] The movement collapsed in 1931, but that did not prevent important commissions for work in Rome going to some of its members such as Pagano, Pietro Aschieri, Giuseppe Capponi, Giovanni Michelucci, Adalberto Libera, and Mario De Renzi.

Pagano, based in Milan, consistently fought for modern architecture as the most appropriate form for a regime that wanted to show that it was dynamic, modern, and revolutionary. He used the pages of *Casabella* to present his views and to contest the tilt toward monumentality after 1936. Piacentini just as consistently used the pages of *Architettura* to support the more eclectic approach that in the late 1930s increasingly went along with the monumentality abhorred by Pagano. Despite their differences, the two never formally broke, and Piacentini "maintained open communications with those of the Modernists who would accept him."[6]

Pagano's campaign in favor of modern architecture raised profound questions about the relationship of architecture and politics. He took the position that architecture best served politics by concentrating on the core values of art and architecture, especially as expressed by current trends that emphasized rationality, simplicity, and functionality. Opponents condemned this "international style" and argued for forms with roots in Italian history, including the Roman Empire. Pagano thought such imperial monumentality risked losing contact with reality. It would play into the hands of narrow-minded and uncultivated careerists in the regime. By contrast, modern architects sought a monumentality that did not depend on "archaeological forms."[7]

The disagreement did not prevent Piacentini and Pagano from working together on some projects. The debate and competition took place among architects who were all believers in fascism. In the 1930s, the argument was over what style or styles would best serve fascism and the new Italy. Only later, during the war, did some of them break with the regime and, in some cases, go into opposition or even join the resistance movements. Giuseppe Pagano was one of these dissidents; he ended up in Mauthausen concentration camp, where he died just before the war ended. As Diane Ghirardo has pointed out, however, all the major architects joined the fascist party before membership became a requirement for work in October 1932.[8] Hence, as fascist architects they had to advocate positions in the hope that they could convince Mussolini to support them. After all, the Duce devoted vast amounts of time and energy to the transformation of Rome, and Italians heard every day that "Mussolini ha sempre ragione," "Mussolini is always right!"

When an acrimonious public debate erupted in 1934 over modern architecture, Pagano agreed that indeed Mussolini was right. Conservative fascists denounced three designs as so modern as to be subversive of Italian and fascist values. Pagano praised Mussolini for speaking out in favor of the role of modern architects in the fascist revolution. The three new project designs

> were not born in an environment of confident expectation, but in the acid poisonousness of an opposition always alert with its nineteenth-century melancholy. The history of Sabaudia [one of the new towns outside Rome], the history of the Florence station and of Rome's university city are three dramas of modern Italian architecture that have reached a victorious conclusion only because, at a certain moment, the Man who creates our history has openly defended the Italian and artistic faith of modern architects and has silenced the croaking of the frogs. Now those frogs applaud and write articles of praise.[9]

Pagano's dream of receiving Mussolini's definitive support for the modern style never became a reality. His own statement showed his realization that only the Duce had the authority to make the decisions with regard to projects and their style. On the other hand, Mussolini never definitively rejected modern styles, so that the eclecticism and ambiguity concerning architectural design remained until the end of the regime.

In 1936, American political scientist Herbert Schneider published an introductory text on the fascist government of Italy. He expressed skepticism about the degree of change the fascist revolution had achieved. All kinds of people now joined the party for reasons of expediency, and so fascism was losing any distinctive meaning. "Fascism has become Italian, not Italy fascist." The one ex-

ception Schneider noted was architecture. Initially fascist architecture meant lit-
tle more than attaching fascist symbols to conventional structures. Then the
regime began to favor younger artists and to support styles inspired more by the
modern architecture of northern Europe than by models taken from ancient
Rome. Schneider witnessed the controversy we have just examined and com-
mented as follows: "Of the many examples of this revolution in architecture
three might be mentioned as outstanding: the railroad station at Florence, the
severe beauty of which is certainly not Florentine; the new plant of the Univer-
sity of Rome, affording a daring exhibition of the difference between fascist
Rome and the Romes of the Coliseum, of St. Peter's, and of the Victor Em-
manuel monument; and the town of Sabaudia, erected on the land reclaimed
from the Pontine Marshes, one of the finest expressions of fascist genius not
only as architecture, but as a social ideal in general."[10] Schneider's comments
gave fascist architecture just the kind of foreign recognition Mussolini wanted
to achieve.

THE NEW UNIVERSITY OF ROME

Pagano's dream gained partial fulfillment in the design of the new university
campus developed in the early 1930s as one of the biggest and most important
projects for the regime. Before the fascist era, Rome's university, La Sapienza,
had its headquarters near the Piazza Navona, with the buildings of its various
faculties scattered around the city. That all changed with the plan to construct a
university city, a *città universitaria*, in an area beyond Termini, the main train
station. Land had been set aside for this purpose in 1907, but the fascist state
would now see that it got done![11] Construction began in 1932 and went on for
three years, with the opening ceremony taking place on October 28, 1935. The
complex of buildings constituted a true campus in the American sense of a clus-
ter of university buildings set apart from the surrounding neighborhood, a city
within the city. It did for higher education what the Foro Mussolini did for
sports.

The regime boasted that this university would be "both the most modern in
Europe and the most beautiful in the world."[12] Furthermore, it took only three
years to complete the huge project, a speed that only fascism could accomplish:
"The miracle has happened and everyone watches amazed at this enormous com-
plex of buildings destined to welcome the student youth of Italy."[13]

Piacentini acted as chief planner and architectural broker in bringing to-
gether a talented, mostly young, and stylistically diverse group of architects for

the university. The overall result was a campus with a certain symmetry and co-
herence despite the individual design of each building. Mussolini told Piacen-
tini to bring together architects who would represent and could create a national
university. As one architectural historian puts it:

> Since all [the architects] were eager to build for the Fascist state, he did not co-
> opt them; they were willing participants in what they anticipated would be a
> truly national university. Piacentini's decision to engage these architects was a
> bold one: the University would long be a highly visible testament to the
> Regime. To his credit, given the significance of the project, he chose several ar-
> chitects whose talents had yet to be confirmed: Giuseppe Pagano, Gio Ponti,
> Pietro Aschieri, Gaetano Minnucci, Giuseppe Capponi and Giovanni
> Michelucci. The buildings share materials (travertine, brick and stucco) and
> relatively low-rise profiles, but individual architects experimented with court-
> yards, portals, porticoes and massing and, in the case of Capponi's Botany
> School, extensive glazing, or broad curved surfaces as in Ponti's Mathematics
> School.[14]

The monumental colonnaded entrance designed by Arnaldo Foschini faced
the Street of the Sciences, the Viale delle Scienze. Beyond the entrance lay the
axes that define the campus plan. The main one ran straight ahead past build-
ings on either side to the main administration building, the Rettorato designed
by Piacentini himself. A statue of Minerva by Arturo Martini stood before it,
and a bas-relief decorated the building's façade. The Rettorato included the li-
brary, the Great Hall, or Aula Magna, and had, on its flanks, the Faculty of Let-
ters and the Faculty of Jurisprudence. The size and centrality of the Rettorato
and its imposing stairs and columns provided a perfect location for special cer-
emonies such as awarding Gold Ms (M for Mussolini) as scholastic prizes. "Pi-
acentini's Administration Building is the epitome of the popular notion of
Fascist architecture: a stripped neo-Classical architecture, sheathed in marble
and travertine, sited at the dominant point of an axial composition."[15]

The first buildings inside the entrance housed some of the sciences, em-
phasizing the regime's commitment to the modern world of science and tech-
nology. Among them were Foschini's Istituto d'Igiene e Batteriologia and his
Clinica Ortopedica, Aschieri's Istituto Chimica, and Pagano's Istituto di Fisica.
The diversity of style was well illustrated in these major science buildings.
Michelucci's Institute of Minerology, Geology, and Paleontology had simple se-
vere lines that recapture "the classic line of imposing structures of *romanità*."[16]

Pagano's Institute of Physics represented his vision of a modern, rational
building. He based his design on the three major functions of the building: of-
fices for faculty with various specialties, classrooms and auditoriums for students

4.1 Rome University, Administration Building, 1999

attending lectures, and laboratories for professors and graduate students. He included separate entrances to each of these areas of activity in a manner similar to that of Moretti's Gioventù Italiana del Littorio (GIL) complex in Trastevere. Pagano's goal was to "reach the maximum functionality, respecting the needs of the school," and so he sought to bring together the internal elements with the external design of the building "in a unitary way."[17]

The School of Mathematics by Gio Ponti had a semicircular shape. The center of the curve in the rear was broken up by a curved extension housing two auditoriums. The front section of the building was rectangular in shape with an imposing entrance. Giuseppe Capponi's Institute of Botany and Pharmacological Chemistry took its design cues from a more industrial form of architecture that "certainly constituted a novel element in the Roman architectonic panorama."[18] It featured an extended curved vertical line with two central towers and ample use of glass. Both buildings offered a sharp contrast with the "neo-Classical severity of Piacentini's building," and "the contrast between Piacentini's and Capponi's contributions to the University of Rome campus demonstrates the difficulty of defining a particular set of formal elements as typical of fascist building programs."[19]

The most celebrated interior space was the Great Hall, the Aula Magna, whose entrance was at the rear of the Rettorato. (The Rettorato contained the library, with its collection of more than 600,000 volumes.) Its vast space could host large lectures or ceremonial gatherings and provided seating for three

thousand people. Particular attention was given to its acoustics, which were seen as a vital function. The audience faced a large fresco by Mario Sironi, the regime's preeminent artist, whose theme was "Italy among the Arts and Sciences." It featured a central figure, representing Italy, in front of a *fascio*. Sironi executed a number of large mural paintings like this one at other venues in Rome, such as at the Ministry of Corporations, a building also designed by Piacentini.[20]

The regime lauded the University City as a major example of a fascist style of architecture that revived "the taste for the monumental character of edifices, without, however, excessive ornament and external decoration." The university served as the best example of this fascist ideal: "In the University City, Fascist architecture will show that only that art that serves the great ideas can accomplish great undertakings."[21]

Mussolini opened the new campus on October 31, 1935, in the company of fascist officials and the university faculty. In his speech he noted that it was at this very moment that "our soldiers [in Ethiopia], bearers of civilization, advance with their courage, with their sacrifice, without asking anything of anyone." He could not ignore the fact they witnessed the rebirth of the university "while in Geneva the coalition of egoism and plutocracy tries in vain to stop the march of youthful Italy of the Black Shirts."[22]

The American ambassador, Breckinridge Long, attended and noted that Mussolini had indeed railed against the League of Nations and swore that the Italian people would never surrender to this pressure. Apparently the Duce's language had to be toned down for diplomatic reasons before appearing in *Il Popolo d'Italia*.[23]

POST OFFICES

Architecture, by definition, has visibility. The fascist regime's constant tearing down and building up of Rome hardly went unnoticed by residents and visitors throughout this period. In addition, many of the new structures and new spaces offered public functions that pulled people into them. Schools, train stations, ancient monuments, and sports facilities attracted the public, be they students, athletes, or tourists.

Post offices offered another example of public buildings that the citizens of Rome used regularly. Post offices in Italy not only took care of the mail but were also centers for payment of taxes and bills, and other transactions, which made them an integral part of Italian life. The Ministry of Transportation and Com-

munication sponsored a contest for the design of four new post offices in out-
lying neighborhoods undergoing significant growth in the 1930s. The four were
on the Via Marmorata, the Via Taranto, Piazza Bologna, and Viale Mazzini.

Mario De Renzi and Adalberto Libera won the competition for the Aven-
tine/Testaccio neighborhood. On October 28, 1935, Mussolini presided at the
opening of the new post office on the Via Marmorata, facing the Pyramid of
Cestius and the Porta San Paolo. These same architects had designed the bold
façade of the Exhibit of the Fascist Revolution that opened in 1932. The Aven-
tine post office demonstrated that modern architecture still found favor in the
Duce's eyes. The U-shaped building had a columned portico on the front. In the
eyes of architectural historians, it has maintained its place as an example of a "ra-
tionalist masterpiece."[24] A renovation completed several years ago restored the
portico, which stretches seventy-eight meters and leads into the large concourse
that one critic called "one of the most original spaces constructed in Rome in
the 1930s."[25]

The Piazza Bologna and the Nomentana neighborhood emerged as a newly
developed area northwest of the Termini train station and the new university
campus.[26] Mario Ridolfi and Mario Fagiolo won the competition to design this

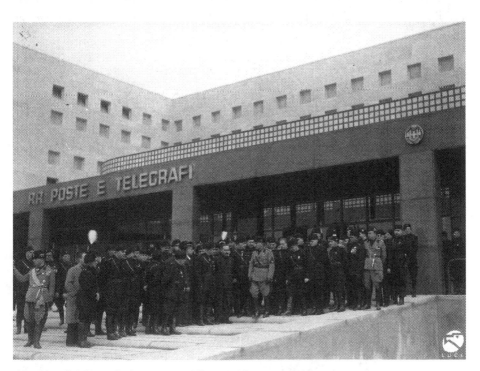

4.2 Mussolini Opens the Aventine Post Office, Via Marmorata, 1935

post office. The freestanding building had curved surfaces with a large over-hanging roof to mark the main entrance. Its modern, rationalist elements underscored the regime's desire to display its own modernity as well as those of the postal and telegraphic communications functions of the building.[27]

Giuseppe Samonà designed the post office at the corner of the Via Taranto and the Via Pozzuoli in the Appio neighborhood southeast of the Lateran and the Porta San Giovanni al Laterano, near the Piazza Re di Roma. Samonà had a more restricted site with which to work. He used a compact design with a curved surface at the main entrance facing the corner and with a liberal use of glass on the lateral sides of the building. The fourth new post office arose on the Viale Mazzini in the new and rapidly developing Milvio neighborhood around the Piazza Mazzini. Designed by Armando Titta, it had a curved shape to conform to the corner space it occupied. It also opened in 1935.[28]

Although not a product of this competition, Angiolo Mazzoni's 1934 post office at Ostia Lido is another example of strikingly modern design. Mazzoni came to Rome in 1924 and worked for a time in Piacentini's studio. In his subsequent career he came under a number of influences, from neofuturism to the monumental style of the late 1930s. The post office at Ostia Lido featured a round, colonnaded portico with a fountain at the center that led into the curved public space. The building took the shape of a question mark, with a tower at the base.[29]

VIA DELLA CONCILIAZIONE

When the new post offices opened in October 1935, Italy had just invaded Ethiopia. Mussolini had gone against the advice of his generals and other advisors in his insistence on war. Initially the campaign did not fare particularly well, but with more troops, airplanes, and the secret use of poison gas plus a new commander, General Badoglio, Italy prevailed. Addis Abeba fell and Mussolini declared that "Ethiopia is Italian!" Then on the evening of May 9, 1936, Mussolini declared to the "oceanic" throng in the Piazza Venezia that Italy again had an empire: "Italy finally has its empire. A fascist empire. . . . An empire of civilization and of humanity for all the populations of Ethiopia. This is in the tradition of Rome, that, after having conquered, it associates the people with its destiny. . . . The Italian people have created with its blood the empire. Make it fruitful with your labor and defend it against anyone with your arms."[30] It would not be long before the fifth map went up on the Via dell'Impero showing the new fascist empire, next to the four depicting the growth of the Roman Empire.

Despite the cost of the war and the cost of intervention in Spain over the next three years, the fascist transformation of Rome continued. The messages in exhibits, demolition, and construction now had more overtly imperial themes, linking fascism's domestic revolution to its emergence as a major European power. The sanctions imposed by the League of Nations during the Ethiopian conflict caused resentment in Italy that Mussolini exploited by portraying Italy as a victim of hypocritical foreign powers led by England. He looked to Hitler's Germany for support. In 1936, Mussolini coined the phrase that Rome and Berlin had formed a new "axis" around which Europe would revolve. Italy would subsequently withdraw from the League in 1937.

Mussolini, an avowed atheist and anticleric in his earlier socialist days, recognized the importance of Rome as the center of Catholicism. The Rome of the emperors and then of the popes represented "civilization," and fascism now shared in that legacy. The conquest of Ethiopia would bring civilization to a barbaric land—despite that land's significance as one of the oldest Christian communities in the world.

In practical terms, Mussolini had come to power in part because he promised to help rather than hinder the church. The Vatican had refused to recognize the new state of Italy when it seized the papal states and then took Rome from the pope in 1870. One of Mussolini's greatest achievements, and one he took full advantage of for the prestige it brought his regime, was reconciliation with the papacy. Soon after becoming prime minister in 1922, Mussolini began overtures to the Vatican. Pope Pius XI (1922–1939) was receptive. The upshot was the Lateran Accords in 1929, in which Mussolini's government made a financial settlement with the church, recognized the Vatican as an independent state, and signed a concordat spelling out the special place of the Catholic Church in Italian life. Italians welcomed the reconciliation. Internationally, the agreements gave great prestige to Mussolini and his government. Here was another example of fascism's ability to solve even the most difficult issues facing Italy.

In 1936, Mussolini announced plans for a new street to commemorate the Lateran Accords of 1929. The fascist government was not the first to consider a new approach to St. Peter's, but once again it got the credit for accomplishing the task. The plan called for the demolition of the neighborhood immediately in front of the basilica and the construction of a broad avenue running from the Tiber to Bernini's colonnaded piazza in front of Christendom's largest church. Although generally a supporter of the regime's demolitions, Gustavo Giovannoni (1853–1947), the distinguished architectural historian, opposed the project, but he did not stop Mussolini from going ahead with it.[31]

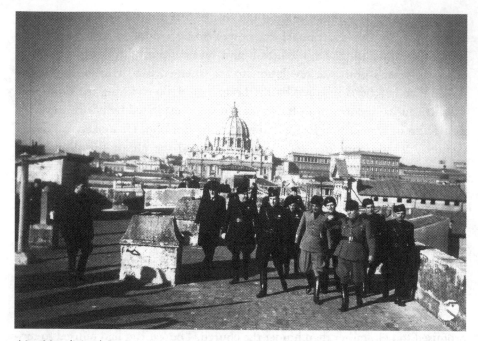

4.3 Mussolini and Giuseppe Bottai at inauguration of the project for the Via della Conciliazione, 1936

The Duce did the honors on October 28, 1936, as he wielded the ax, the *piccone,* which launched the project. His entourage that day included Giuseppe Bottai, the only major fascist party official to serve as governor of Rome, a post he held from 1935 to 1937. The major portion of the work was completed by 1938, and the broad new Via della Conciliazione appeared in the official guidebooks. There were finishing touches after the war in time for the Holy Year of 1950, and the new street served the fascist regime well as a symbol of its new relationship with the Vatican.

Another project begun during Bottai's time as governor was the construction of the new Corso Risorgimento, initiated on April 21, 1936. It ran from the Corso Vittorio Emanuele in front of the Church of San Andrea della Valle to the side of the Piazza Navona. It replaced the Via Sediari and the Via Sapienza, site of the older university building. The widening and straightening of this street meant the demolition of a number of buildings and the construction of several new ones. The most prominent of the latter sat directly across from the church and had a small piazza in front of it. The building housed insurance offices and apartments, and the project had the backing of the National Insurance Association, or INA. The fountain that graces this space today was

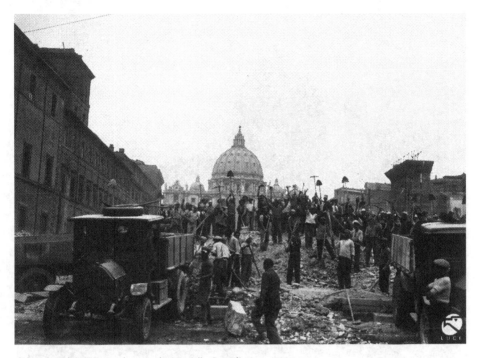

4.4 Mussolini visits workers on the Via della Conciliazione, 1937

added in 1958 and came from the area demolished to open up the construction of the Via della Conciliazione. The building's Latin phrases speak of the glory of the new fascist empire.[32]

This project included the one fascist incursion into the Piazza Navona. At the north end at the curve, a new building went in that retained the façade on the piazza side but was a new presence on the outside facing the widened Via Zanardelli. The new fascist building exposed remnants of the original stadium of Domitian and is today open for tourists to descend to the original level.[33]

AUGUSTUS AND ROMANITÀ

When Mussolini spoke from his balcony on the Palazzo Venezia and declared the new fascist empire on May 9, 1936, he shouted to the crowd, "Are you worthy of it?" The crowd, of course, roared back "Yes!" Clearly the Duce enjoyed his imperial role, but it was King Victor Emmanuel III, as head of the Italian state, who assumed the title Emperor of Ethiopia. Nevertheless, no one present for that speech and those that followed could miss the point that Mussolini

4.5 Demolition of the north curve on the Piazza Navona, 1937

played the role of the new Augustus. The next phase of Mussolini's Rome saw the emergence of a self-consciously imperial city.

Mussolini had already set in motion two new projects to glorify Augustus: the "liberation" of the mausoleum of Augustus through demolition and construction, and the exhibit to celebrate the two-thousandth anniversary of Augustus's birth, to take place in 1937. He launched the first project on October 22, 1934, just a week before closing the Exhibit of the Fascist Revolution. Surrounded by officials and photographers, the Duce swung the now-familiar *piccone* to begin demolition of the buildings that penned in the circular tomb of Augustus. He declared: "The work of isolating the Augusteo, which today I initiate and that must be finished within three years for the bimillenium of Augustus, has a triple utility: that of history and beauty, that of traffic, that of hygiene. . . . A fourth and not final use: with these works of demolition and of construction of new buildings gives work for three years to numerous workers of every sort. And now I give the word to the pickax."[34]

The pickax, the *piccone,* symbolized Mussolini's efforts to lead "this new political risorgimento."[35] Every blow of the pickax was a blow against the errors, abuses, inertia, and passivity of the past. With every swing of the *piccone* Mussolini demonstrated to Italians that work was honorable and necessary. The beginning of this new project in 1934 came just at the closing of the highly successful Exhibit of the Fascist Revolution and the opening up of the Circus Maximus, all part of twelve years of dynamic development under fascism and its leader.

The ambitious project to open up Augustus's tomb resulted in the creation of the vast Piazza Augusto Imperatore adjacent to the Tiber. The architect Vittorio Morpurgo designed the buildings, with their massive façades and Latin inscriptions, for the piazza. Antonio Muñoz supervised the restoration of the mausoleum, and the work proceeded rapidly in time for the September 1937 celebration of Augustus's birth, although the construction of the new buildings was not completed until 1941. The west end of the piazza, close to the Tiber, was the spot chosen for the Altar of Peace, the Ara Pacis. It was housed in a simple glass rectangle, and completed in 1938.[36]

One commentator believes that "the Piazza Augusto Imperatore has proved both an aesthetic and urbanistic failure."[37] Notwithstanding that opinion, shared by other architectural and urban historians, the piazza embodied fascist messages in the imperial, warlike style of the late 1930s. It included a mix of Roman, Christian, and fascist themes. The largest building on the north side provided office space for the national social security administration, which financed the project. The Latin inscription at the far end of the building referred

to the "extraction of the mausoleum from the shadow of the centuries," the reconstruction of the Ara Pacis, and the emergence of new streets, buildings, and churches in place of the former congestion. Two winged victories holding the fasces flanked the inscription. Above were depictions of various kinds of work on either side of the central panel, which featured the river Tiber holding up Romulus and Remus with the she-wolf beneath. The same façade included further illustrations of Roman and fascist military prowess. At one end were depictions of ancient military artifacts such as helmets, shields, bows, and arrows. At the opposite end were modern weapons and motifs.[38]

The frieze over the long building on the east side of the piazza depicted scenes of work and family. "Motifs of the Tellus relief—the goddess with the full breasts holding healthy babies in her lap, the grazing sheep and lazing cow, the plans and fruits and flowers—are given here a contemporary reading, interspersed with related neo-Augustan concerns, in forty-two near life-size figures on either side of the Mussolini aphorism on the immortality of the Italian people."[39]

Ironically, the message of peace permeated the piazza. The Emperor Augustus established the Pax Romana, and his Ara Pacis, or Altar of Peace, would be the chief attraction along with the mausoleum. The building containing the Illyrian College, Collegio degli Illirici, housed a seminary for Croats and had mosaic panels on the top story celebrating Christ as Prince of Peace, PRINCIPIS PACIS. Mussolini continued to claim that he sought peace, yet as the piazza neared completion in 1940, he would take Italy into the war on the side of Hitler's Germany.

Another figure of peace in this piazza was Pope Pius XI, who had signed the Lateran Accords with Mussolini's government and died during the construction of the piazza. One of the plaques on the piazza's church of San Carlo commemorated Pius, who, as Achille Ratti, celebrated his first mass in this church in 1879. Another plaque recorded the 1929 agreement between Italy and the Vatican, describing Pius as an "advocate of concord among peoples," who restored Italy to God and God to Italy.[40] Two life-sized statues of Saints Carlo and Ambrogio were erected in 1940.

The Piazza Augusto Imperatore exuded fascist propaganda. It served no other purposes, unlike other regime-sponsored complexes: sports at the Foro Mussolini, education at the Città Universitaria, or the international exhibition planned for 1942. It was bound to the politics of its day in a way that makes it something of a historical relic today: interesting but distant. Spiro Kostof came to this conclusion in his study of the piazza: "Its aim as political art had been to use relics of the Augustan age to lend authority to Fascist achievement. The contest, at least in the visual sense, was never really joined. The Fascist side of the balance is too weak: what we are conscious of is the Augustan substance.

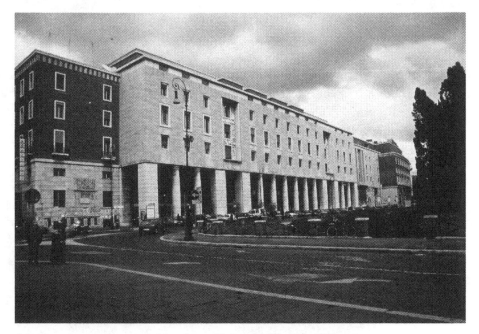

4.6 Piazza Augusto Imperatore, Mausoleum of Augustus on the right, 2000

Our opinion of Augustus is not affected by the association with Mussolini, and our opinion of Mussolini is not enhanced. The Duce yields to the emperor and is lost. The Piazzale, in the end remains a colossal mistake."[41]

Nevertheless, at the time, the regime claimed credit for again accomplishing a project that "liberated" the mausoleum, demolished unhealthy housing, improved traffic, and provided jobs. The immediate benefits for Mussolini's and fascism's image were clear enough, and if anyone missed them, the regime never hesitated to issue reminders. The transformation of Rome fit into the regime's desire to "go toward the people" and to forge a consensus among Italians to support fascist Italy.

Mussolini opened the second Augustan project on September 23, 1937: the Exhibition of Augustus and Romanness, the Mostra Augustea della Romanità. This exhibit took advantage of the Palazzo delle Esposizioni on the Via Nazionale, which had worked so well for the Exhibit of the Fascist Revolution from 1932 to 1934. The Palazzo once again had a new façade for the occasion. The exhibit consisted of reproductions and models of imperial Roman artifacts, and proved popular in attracting visitors. A centerpiece was the large model of imperial Rome at the time of Constantine's reign, built on a scale of 1:250. Subsequent to the closing of the exhibit, this model, or *plastico,* along with all the

artifacts of the exhibit, went to the new area of Rome called EUR and the Museum of Roman Civilization, where they reside to this day.

Professor Giulio Giglio of the University of Rome organized the exhibit. This glorification of imperial Rome featured the life and conquests of Augustus, the Roman army, law, and other institutions. It also contained a section titled "Fascismo e Romanità." The regime devoted great energy to advertising the exhibit, organizing group visits, and offering reduced train fares to Rome, all efforts used for the first Exhibit of the Fascist Revolution from 1932 to 1934. Over the entrance to the exhibit were inscribed Mussolini's words: "Italians, you must ensure that the glories of the past are surpassed by the glories of the future." At the opening, a symbolic gesture: the presentation of a live eagle to Mussolini, underscored the passing on of the imperial tradition.[42]

Romantic notions of *romanità* abounded. An ideal fatherland brought equality for all peoples and a sense of social community based on Roman thought, politics, art, law, language, and religion. Christianity was the spiritual force that also represented *romanità*. A universal culture and civilization permeated *romanità*, so that the exhibit conveyed a message for all humanity.[43]

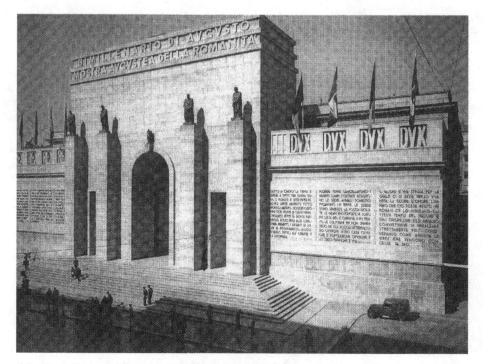

4.7 Mostra Augustea della Romanità, Via Nazionale, 1937

The Augustan Exhibit also clearly bore an imperial stamp in its conception and execution, in contrast with the dynamism and innovation evident in the 1932 Exhibit of the Fascist Revolution. In Marla Stone's judgment, its inauguration "offered clues to the regime's new cultural tastes and priorities."[44] The government required party members to attend, and members of youth organizations were to appear in uniform. The opening events emphasized the heroic early days of the fascist movement: "The highly choreographed inauguration stressed hierarchy and militarism, as opposed to the earlier exhibition's emphasis upon a broad cross section of the nation and its use of the inauguration to depict the exhibition as a pan-Italian event. In contrast to the festive, almost carnivalesque, atmosphere of the opening day of the 1932 Mostra [della Rivoluzione Fascista], the 1937 exhibition revolved around regimentation and military choreography."[45]

The fascist presentation of the new Mostra Augustea emphasized the direct connection between Rome's glorious past and the possibilities of the present. The parallel between the Roman Empire of antiquity and the modern Italian Empire created by fascism was obvious. The glorification of Augustus as the founder of the ancient empire pointed the audience toward Mussolini as the founder of the new empire. However, the model of ancient Rome re-created the Rome of Constantine, not Augustus. It showed Rome at its imperial height and opened the way to include Roman Christianity as part of the Roman legacy.[46]

The exhibit provided a tour through the history of Rome from its origins to its fall. It featured both the physical monuments of Rome and its empire, and the cultural achievements of art, letters, music, medicine, and more. Economic life, fashions, sports, and religion all had their place. The main floor traced the physical expansion of Rome from its early days to the height of the empire under Caesar and Augustus. Adjacent rooms were dedicated to the army, the navy, the magistracy, and the law. Next came the advent of Christianity, followed by the legacy of the Roman imperial ideal, and finally the resurgence of empire in a "united and victorious Italy, through the work of the Duce and Fascism."[47] Mussolini had decided that this great exhibition in honor of Augustus would be in the same location as the triumphant Exhibition of the Fascist Revolution of 1932 to 1934.

SECOND MOSTRA DELLA RIVOLUZIONE FASCISTA

On the same September day, Mussolini also opened a new version of the Exhibit of the Fascist Revolution. This second version appeared in the National Gallery

of Modern Art in the large Villa Borghese park. The Duce intended to make the exhibit, along with an archive containing documents and artifacts of fascist history, permanent. It would be a shrine dedicated to the fascist movement and party. The architect Cesare Bazzani designed a new façade for the gallery, and Mussolini led the entourage of party officials and members of the youth organizations.

This second version of the exhibit reproduced much of the first version, but within a rather sterile design, compared with the dynamic style of the original. Evident was the didacticism of the rooms, with their flat surfaces and many documents and photographs in panels that required visitors to read and view them at close range. One fascist account noted that the new version had abandoned the more "decorative" approach of the original in favor of a certain "austerity and simplicity of lines."[48] The same account stated that the heart of the exhibit was the heroic period of *arditismo* and *squadrismo,* when the squads of fascists evoked the shock troops of World War I, the *arditi,* and made fascism a mass movement that ultimately propelled it into power.[49]

This exhibit attracted far fewer visitors than had the first version. The relatively remote location in the Villa Borghese made it difficult to find, as various officials complained. In addition, the regime had other showpieces, such as the Augustan Exhibit and several exhibits in the Circus Maximus, which it featured and fully supported. The Exhibit of the Fascist Revolution was only one of many exhibits, but it is important in demonstrating basic messages of fascism of the late 1930s.

The layout of the rooms initially copied the first version.[50] Officials then decided to revise and update the exhibit, closing it for that purpose on November 20, 1938. When it reopened on March 23, 1939, the twentieth anniversary of the founding of the fascist movement, the sequence of rooms was rearranged and new rooms with new subjects had been added.[51]

The room, for example, dedicated to the fascist organizations for Italians living abroad, the Fasci all'Estero, moved from the end of the exhibit to the front. The new rooms found space for the accomplishments of the regime since 1922: the reconciliation with the Vatican in 1929, the conquest of Ethiopia and the declaration of the fascist empire, the struggle of Italian "volunteers" fighting for Franco and against Bolshevism in the Spanish Civil War, the Duce's words and deeds, and the scientific achievements of Guglielmo Marconi.

A more ominous theme was the threat of the Masons and the Jews. Italian fascism, unlike German Nazism, had no racial doctrines or anti-Semitism before 1938, and many Italian Jews supported the regime as a part of their support for the Italian nationalism that had given them citizenship and civil rights when Italy was unified. Mussolini changed all that in 1938 with new racial laws that

put Jews at a severe disadvantage. Hence the revised exhibit now showed the Jews as a threat to Italy. There is no evidence that these changes attracted any more visitors. One report at the end of 1939 indicated that attendance had dwindled to eighty a day, sometimes as few as ten. The report urged rerouting bus lines, making a greater effort to advertise the exhibit, bringing all party groups visiting Rome to the exhibit, and making annual visits of school groups obligatory.[52] The exhibit finally closed in April 1941.

Immediately after opening the Augustan Exhibit and the second Exhibit of the Fascist Revolution, Mussolini further cemented his relationship with Hitler by visiting the Führer in Berlin from September 25 to 29, 1937, with a stop in Munich on the way. Banner headlines in the fascist press hailed this historic visit both before and during its unfolding. The first announcement portrayed the planned visit as a "decisive event for the history of Europe."[53] Hitler would reciprocate with his visit to Rome the following May.

CIRCUS MAXIMUS EXHIBITS

Prominent among Rome's fascist spectacles in the late 1930s were the exhibits placed in the Circus Maximus from 1937 to 1939. They combined an outdoor-indoor presentation; the ample space of the Circus Maximus invited visitors to stroll throughout the grounds and then enter specific buildings in order to view the exhibits inside. The buildings, temporary by definition, provided the designers both employment and an opportunity for some experimentation. The central location gave visitors easy access. "The government newsreels, produced by the Istituto Luce, emphasized the exhibitions, the preparations surrounding them, their inauguration, the visits of prominent guests, and other aspects of interest. By law these newsreels were shown before and after feature films."[54]

The regime thus had an excellent location to present some of its major political, social, and economic policies and practices to the public in what has been called "a fascist theme park."[55] The first exhibit ran from June 20 to September 1937. The Exhibit of Summer Camps and Assistance to Children, Mostra delle Colonie Estive e dell'Assistenza all'Infanzia, featured aspects of the regime's program for raising a healthy and thoroughly fascist youth. The architectural team of Adalberto Libera and Mario De Renzi supervised the exhibit's overall design as well as some of the major buildings. The artist Giovanni Guerrini produced the paintings. Giuseppe Pagano praised the results as proof that such exhibitions could be done with style and art. The project had "unity of style, great clarity, and expository liveliness."[56]

To participate in the opening of the exhibition, sixty thousand of the Donne fasciste, members of the fascist organization for women, converged on Rome. They came in special trains on the weekend of the opening and were accommodated in schools fitted out with beds and cots for the occasion. In addition, members of the fascist youth organization for girls, le Giovani fasciste, and of the rural housewives, le Massaie rurale, joined in the festivities.[57] The women were thus out in force for the first show in the Circus Maximus and they would be there for the last, when seventy thousand rallied at the closing of the fourth and final one in 1939.[58] These displays of fascist women underscored the fact that although women in fascist Italy were primarily wives and mothers, they also participated in mass organizations, contributing to a totalitarian mobilization of the entire population. There may have lurked here a contradiction or incoherence in trying both to domesticate and mobilize women at the same time, as historian Victoria De Grazia suggests in her study of women in fascist Italy.[59]

The stated purposes of the exhibition were to present every important aspect of the government's programs for mothers, infants, and youth. Every point of view gained expression, from "the more generally human to the social, from the artistic to the educational, from hygienic to sporting and military."[60] Throughout the summer of 1937 it would serve as a center to draw in large crowds of citizens, especially women and young people, giving them a sense of the lively topics so important to Italy's present and future and in preparing the fathers and mothers of tomorrow. One fascist source claimed that 2 million visitors saw the exhibition.[61] Recently Marla Stone concluded, "attendance at the Fascist Party exhibition remained high through the end of the 1930s: the Mostra delle colonie estive attracted over 500,000 visitors, the Mostra tessile nazionale had an audience of 600,000, and the Mostra autarchica del minerale brought in 1,091,435 people."[62]

To make the site attractive, gardens were planted with thousands of flowers and plants. The twelve pavilions occupied about half the space of 56,000 square meters that stretched the length of the Circus Maximus, 600 meters. The pavilions featured various programs and policies of the regime including summer camps, sun-therapy camps, the Italian youth groups abroad (Italiani all'Estero), commercial technology and training (Mercelogia), welfare for children (Assistenza all'Infanzia), a model school, the youth organization (Opera Balilla), the fascist university organization, the Gruppo Universitario Fascista (GUF), and the major state agency of maternity and children's benefits, the Opera Nazionale Maternità ed Infanzia (ONMI). The result was another fascist city, in this case one that would prove ephemeral: "The entire organization of the exhibition followed the life-path of the individual taken care of by the Fascist regime, from

4.8 Mostra delle Colonie Estive, Circus Maximus, 1937

birth (OMNI . . .) to the completion of schooling (GUF . . .). Libera and De Renzi planned the pavilions for child welfare, the schools, the summer camps, and ones at the end—the Merchandizing Pavilion, the convention hall, and the offices—alternating their designs with contributions of other architects."[63]

In addition to Libera and De Renzi, three other architects contributed to the exhibition. Ettore Rossi designed the second pavilion, the large ONMI building. Franco Petrucci did the Fasci all'Estero building, which was the seventh pavilion, and Luigi Moretti the eighth pavilion for the Balilla. The overall effect carried the eye along an extended horizontal line of buildings of the same height, punctuated by recesses and towers. The fascist party presented the whole as architecture in the proper service of politics, for the "goal of this show is . . . to present to the genuine people, and not to the intellectual classes, the results of the work of Fascism in some important sectors of the national life: an exposition then of ideas, statistical data, of results reached and by methods employed to reach them."[64]

It was no wonder that the use of modern and rationalist design in this highly visible exhibition won Pagano's enthusiastic endorsement. He saw this exhibit as in the spirit of the Mostra della Rivoluzione Fascista and a series of exhibits in other major cities that "represented the art of our time" and educated

the aesthetic sense of the masses. He optimistically concluded, incorrectly, as it would turn out, that "there exists a generation of Italian artists who have entered, by the direct will of the Duce, into the representative life of fascist art."[65]

The second show was the Exhibition of National Textiles, which featured the economic importance of Italy's textile industry. It took place from November 1937 to March 1938. The opening day on November 18 marked the anniversary of the League of Nations sanctions during the Ethiopian war. A major theme of the exhibit was Italy's ability to attain self-sufficiency in the production of textiles.[66] One of the messages inscribed in the exhibit declared that "We have realized the imperative of the Duce toward the people [*verso il popolo*]. Our fibers have given to the Italian people the opportunity to be clothed in dignity at modest cost."[67]

The Dopolavoro Exhibition, Mostra dell'Opera Nazionale Dopolavoro (OND), occupied the Circus Maximus during the summer of 1938, from May to August. The Dopolovoro (literally "after work") provided leisure-time activities such as sports, travel, theater, cinema, festivals, and other entertainment. Its political aim was to draw workers, peasants, and salaried employees closer to the fascist regime.[68] It had a popular quality in two senses: 1) it provided popular entertainment and activity, and 2) it aimed to win over the *popolo* to fascism and away from any lingering attachment to other now-forbidden political persuasions, be they socialist, communist, or liberal. "The Opera Nazionale Dopolavoro has been among the primary fascist institutions in favor of that popular education that is one of the strongholds of the regime's policies. . . . That the Dopolavoro is a political institution is, fascistically speaking, not only conceivable but logical; everything that has its origin in the Regime has 'political' content in how it enters into the larger picture of a national purpose; and, so, it appears exquisitely political today, after more than ten years of existence."[69]

The exhibit featured the full range of activities provided by the Dopolavoro: sports, radio, cinema, theater, music, popular festivals, and traditions. The fascist party ran these programs for "educational and moral purpose."[70] One pavilion, devoted to "Popolaresca," contained a full range of popular Italian festivals. Indeed, the exhibit included an entire "rustic village." There was an outdoor swimming pool and a pavilion dedicated to sporting activities. A group of artists, including the futurist painter Enrico Prampolini, contributed the paintings and murals. Another pavilion showed the OND social and hygienic services. The "Organization" pavilion gave statistics and photographic documentation of the Dopolavoro "of the Empire, Libya, the Armed Forces and Abroad."[71] Overall this exhibition illustrated the combination of entertainment and propaganda evident in each of the four shows in the Circus Maximus, as

Marla Stone has noted: "At the exhibitions, the spectator could be simultaneously fun-loving, traveling, patriotic, and Fascist."[72]

On November 18, 1938, again using the anniversary of the League of Nations sanctions, Mussolini inaugurated the fourth exhibit in the Circus Maximus, the Autarchic Exhibition of Italian Minerals, the Mostra Autarchica del Minerale Italiano. It remained open until May 1939 and attracted a million visitors.[73] In the narrow sense, it celebrated the economic self-sufficiency sought and achieved by fascist Italy, but in a wider sense it "represented a history of Italy armed in order to indicate the ineluctability of wars. This was the direct and disquieting message of the exhibition."[74] Indeed this show glorified the imperialism and militarism meant to convince Italians that Italy was now a great nation destined for war and conquest.

The show was composed of twenty-three pavilions that covered a surface of 35,000 square meters. Another 24,000 meters contained piazzas, streets, and gardens. The directors and designers included Cipriano Efisio Oppo for artistic direction, Luigi Mancini for technical direction, with Mario De Renzi, Giovanni Guerrini, Mario Paniconi, and Giulio Pediconi in charge of artistic and architectural planning.[75]

A major message of this exhibit argued that Italy had no choice but to pursue economic autarchy if it wished to be a great and respected power pursuing an independent foreign policy. The sanctions imposed on Italy during the Ethiopian war "with brutality and cynicism without equal" demonstrated vividly the way in which other powers had and could victimize Italy. Mussolini had won the "Battle for Grain" to gain self-sufficiency in wheat production, and now he would lead the nation into a more comprehensive battle to obtain as much self-sufficiency as possible in materials such as gas, coal, steel, and other metals needed in a modern economy and for modern warfare. "The Regime has put [autarchy] on the front line among the most urgent solutions to face when it has proclaimed Italian independence in foreign policy. Because an independent foreign policy, a prime element of greatness, becomes almost impossible when there exists economic dependence of raw materials."[76]

The twenty-three pavilions contained thirty-nine sections that covered a wide range of materials and products. Metals and minerals were prominent, but building materials, such as marble, granite, and other stones, mineral water, salt, ingredients for cement, and sulfur had their places. One section reproduced a marble quarry and another, appropriately underground, a coal mine. And there was a photograph of the Duce in miner's garb.

The buildings flanked the grand Boulevard of Pavilions (Viale Padiglioni), which ran the full length of the Circus Maximus. From the entrance at the foot

of this street, the visitor saw at the far end the square tower rising forty-one me-
ters with a huge imperial eagle affixed to the façade with "AUTARCHIA" em-
blazoned across the top. A little farther along he or she could read the phrase
beneath the eagle's talons: "MUSSOLINI HA SEMPRE RAGIONI" ("MUS-
SOLINI IS ALWAYS RIGHT").

The meaning of pursuing an independent foreign policy to achieve "great-
ness" found ample illustration in the Pavilion of Arms, the Padiglione delle
Armi, designed by Mario De Renzi. It was one of the largest pavilions, located
at the far end of the exhibit next to the tower with its eagle. In other words, it
brought the visitor to the culmination of the exhibit and its ultimate meaning.
The building had displays of arms from the past, but they gave pride of place to
modern arms for the army, navy, and air force.[77]

The four exhibits in the Circus Maximus had their origins and inspiration
in the highly successful Exhibit of the Fascist Revolution in 1932. As Herman
Finer pointed out (see chapter 2), this exhibit brought thousands of Italians to
Rome to witness the wonderful works of fascism and the newly emerging Mus-
solini's Rome. The Circus Maximus exhibits differed, however, from that dy-
namic and innovative show celebrating the tenth anniversary of the March on
Rome. These large, open-air exhibits celebrated the accomplishments and poli-
cies of fascist Italy. They presented ideal "cities" that all Italians regardless of class
or regional background could enjoy while experiencing pride and a sense of na-
tional unity.

> Held in Rome, the shows drew crowds to the national capital. The Roman lo-
> cation played a critical ideological role in reinforcing the idea of a Fascist-en-
> abled national unity—a national unity grounded both in the present and in
> the historic past. For many of those whom the regime bused, trained, or
> trucked to Rome, these events represented their first introduction to the Ital-
> ian nation. The regime used the Roman location "at the heart of the nation"
> to stress Fascism's connection to ancient Rome and to elevate Rome as the spir-
> itual, national home of all Italians.[78]

THE AGRO PONTINO AND THE NEW TOWNS

Outside of Rome, but very much part of Mussolini's Rome in fascist planning
and propaganda, were the Pontine Marshes. Writer and art critic Ugo Ojetti de-
clared in 1941 that one could not write about Mussolini's Rome without speak-
ing of the redemption of the Agro Pontino.[79] Early in his rule of Italy, Mussolini
made the reclamation of this area a top priority. Here the regime would redeem

thousands of acres for use as farmland and as the site of new towns. Ultimately five new towns appeared in the 1930s: Littoria (today's Latina), Sabaudia, Pomezia, Pontinia, and Aprilia. These towns offered examples of fascist architecture and town planning that the regime presented reflective of the changes taking place within the city proper.

The Pontine Marshes lay south and southwest of Rome, in the area stretching down to Anzio. For centuries, various schemes promised to drain this unhealthy wasteland and turn it to productive uses, but the fascist regime made it a priority and began work in the 1920s. Once it accomplished the major work of draining and controlling the water, it took the next step of turning the area into farmland. Then came the new towns. In the 1930s, government propaganda used the area to show fascism's achievements. Mussolini visited numerous times, always being mindful of what we today call "photo ops." On several occasions the Duce joined peasants at harvest time to thresh wheat. Here was the man of the people, tanned and stripped to the waist, participating in the "Battle of Grain" to make Italy self-sufficient in wheat.

The transformation of the Agro Pontino through reclamation, or *bonifica,* became a metaphor for the fascist transformation and redemption of the nation:

4.9 Mussolini visits the work in the Agro Pontino, 1931

Initially, the term [*bonifica*] referred to the conversion of swampland into arable soil and New Towns along the Latium coast and in Sicily and Sardegna. Yet land reclamation merely constituted the most concrete manifestation of the fascists' desire to purify the nation of all social and cultural pathology. The campaigns for agricultural reclamation (*bonifica agricola*), human reclamation (*bonifica umana*), and cultural reclamation (*bonifica della cultura*) together with the anti-Jewish laws, are seen here as different facets and phases of a comprehensive project to combat degeneration and radically renew Italian society by "pulling up the bad weeds and cleaning up the soil."[80]

Mussolini reminded Italians repeatedly that the fascist revolution aimed to reclaim, redeem, transform, improve, modernize, and strengthen Italy. He had promised in 1928 to "redeem the earth; and with the earth man; and with men, the race."[81] This idea came to permeate fascist efforts at change, including the transformation of Rome. As Mussolini's Rome emerged in the 1930s, it too qualified as *bonifica,* consistent with the dramatic reclamation of the Pontine Marshes.

The vast project of reclaiming the marshes served important propaganda purposes for the regime at home and abroad. It gave the impression of embarking on a "revolutionary project, a project in keeping with both the Fascist creation of a new civilization and a revolt against urban society."[82] The August 1934 issue of the *National Geographic Magazine* carried a flattering presentation of the work to date written by Italian Senator Gelasio Caetani. Caetani reported that 14,000 men were at work in the region and that by October 28, 1935, "all the stagnant waters of this region should be drained off to the sea, malaria should be eradicated, 4,000 farmhouses built and populated with as many peasant families drawn from the crowded agricultural provinces of the north."[83]

The regime used the National Institution for Combatants, the Opera Nazionale per I Combattenti (ONC), as the agency for the work in the Agro Pontino. Founded in 1917 to assist veterans, it "floundered along for several years until under the aegis of the Fascist party in 1926 it changed from an agency that gave modest assistance to the immediate claims of the demobilized soldiers to the first large state structure for the agrarian transformation undertaken by the Fascist regime."[84] The ONC financed the work through loans from Italy's oldest bank, the Monte dei Paschi di Siena, and funds from the Consorzio delle Opere Pubblico, a state agency.

Five new towns came out of the Pontine project. From Rome, moving south and southwest, the towns and their inaugural dates were: Pomezia (October 28, 1939), Aprilia (October 29, 1937), Littoria (December 18, 1932), Pontinia (December 18, 1935) and Sabaudia (April 15, 1934). From the smallest, Pon-

tinia, to the largest, Littoria, each one manifested in its plan and organization the regime's ideas and ideals. All the essential buildings appeared: the town hall, the church, the post office, the fascist party headquarters, the youth building, and other government and party facilities. The new towns of the Agro Pontino departed from the more traditional Italian pattern of a main piazza with both the major civic and religious buildings, in establishing the main piazza for civic and party buildings and the church in a secondary piazza, "a telling indication of the PNF's [Partito Nazionale Fascista] expectations about the role the church should play in Italy's future."[85]

In addition to but smaller than the towns were the villages or *borghi*. Each *borgo* contained a chapel, medical dispensary, general store, offices, an elementary school, and a post office. In one of the first built, Borgo Vodice, a monument to the war dead related to the new colonists from northern Italy stood behind the church. Beyond the *borghi* were the individual farms.[86]

Construction on the largest of the new towns, Littoria (now Latina) began in April 1932, and Mussolini attended the official groundbreaking in June.[87] He returned to preside over the inauguration of Littoria on December 18, 1932. The Duce proclaimed to the crowd assembled for the occasion: "Today is a great day for the Revolution of the Black Shirts, it is a happy day for the Agro Pontino, a glorious day in the history of the Nation. What was in vain attempted during 25 centuries, today we have translated into a living reality." Furthermore, he declared that Italians no longer had to seek work and land beyond the Alps or beyond the ocean, for opportunities here were less than half an hour from Rome. "It is here that we have conquered a new province. It is here that we have conducted and will conduct true and proper operations of war. This is the war that we prefer."[88]

Mussolini made subsequent visits at the annual celebration of the city's anniversary, when he could also present awards to local officials and farmers for their accomplishments. On December 18, 1934, Littoria became the capital city for the new province of Littoria. By 1941, the city had a population of 19,500 and the province 30,000.[89] Today's Latina has approximately 100,000 inhabitants.[90]

As a new place arising on new ground, Littoria manifested fascist ideas of town planning carried out *de novo* without any physical or historical barriers or obstructions. The main Piazza Littorio was located on the main axis running through the town. The town hall, the *palazzo municipio,* dominated this square, and Mussolini addressed the crowds from its balcony. Streets then radiated out from the piazza, today the Piazza del Popolo, to other centers of activity. The Piazza XXIII Marzo, Piazza March 23, commemorated the founding of the fascist movement on March 23, 1919, and is today the Piazza della Libertà. Two blocks

4.10 Town Hall, Littoria (now Latina), 2003

away was the Piazza San Marco, with the town's main church. Two blocks be-
yond the church there arose the massive Palazzo M built in the shape of an *M*
to honor Mussolini. A few steps away lay the Viale XXI Aprile, part of a ring
road around the city.

This Viale XXI Aprile defined the core of the fascist city. Within or on it
stood all the principal buildings mentioned previously. By the late 1930s, the
core also included a train station, post office, palace of justice, police station,
and various buildings for state and party agencies such as the ONC, the ONMI,
the fascist militia, the fascist youth, and the sports stadium. "As the capital of
the new province, Littoria was completely outfitted with the national and local
institutions necessary for the administration of the town and the province—
town hall and municipal offices, or commune; Casa del Fascio; post office; cara-
binieri headquarters; Dopolavoro; GIL; militia barracks; as well as churches,
schools, hospital, cinema, and sports facilities."[91]

Sabaudia had a plan similar to Littoria's but on a smaller scale. It was sur-
rounded on three sides by water and quickly developed as both a center for
local agricultural life and for vacationers. The road to Rome and Littoria
formed the major axis in the town, culminating in the Piazza della Rivoluzione,
today the Piazza di Comune. This major piazza was just south of the intersec-

tion with the other axial road that went west to Terracina. The fascist party's Casa del Fascio shared the space on the Piazza della Rivoluzione, along with the movie theater, market, and hotel. A short distance away and clearly visible from the main piazza was the secondary piazza, which was dominated by the church of the Annunciation.

Diane Ghirardo has noted that in Sabaudia, as in most of the other new towns, there was a striking absence of "one of the most cherished institutions of Italian life—the *osteria,* or bar. The omission of a place for casual group gatherings could only be deliberate."[92] The regime did not want to encourage informal meetings that might turn political in nature.

Sabaudia's name derived from the Savoyard dynasty of Piedmont, which became the ruling dynasty of the newly unified kingdom of Italy in 1861. Hence, King Victor Emmanuel III and Queen Elena inaugurated the new city on April 15, 1934, as the inscription on the town hall still notes. Mussolini made his first visit later that year on September 22, speaking from the balcony overlooking the Piazza della Rivoluzione.

Then, as now, Sabaudia gained considerable recognition for the modern style of its architecture. Giuseppe Pagano held it up as a favorable example of modern architecture at work for the fascist state. Its design and construction coincided with the period in the early 1930s when Mussolini still favored those architects who could design buildings to show that fascist Italy was modern and revolutionary. As a fascist publication put it, "Mussolini himself opportunely intervened in the debate [over style] in favor of modern rationalism, especially [regarding] those buildings which reflected the new social functions of the Fascist state, such as youth clubs, health centers and Fascist organizations."[93] The debate had erupted in 1934 when conservative fascists criticized the plans for Sabaudia, the new university, and the Florence train station as in an international style and even "bolshevik" in conception, but Mussolini defended, for the moment, "rational and functional architecture" as in keeping with the spirit of ancient Rome's greatest monuments.[94]

The regime opened Pontinia, Aprilia, and Pomezia with similar fanfare. Every new town demonstrated, in Mussolini's words, that "our will is methodical, tenacious, indomitable." Of the five towns, Littoria and Sabaudia figured most prominently in propaganda. Littoria's size and status as a provincial capital gave it prominence of place. Sabaudia's population of five thousand made it a distant second to Littoria, but the town attracted great attention for its architectural importance and its potential as a seaside resort town, functions beyond its original purpose as a center for agriculture, which was the basic purpose of all the new towns. Diane Ghirardo noted that "in urban

arrangement, the subsequent New Towns are patterned more after Sabaudia than after Littoria, so its urban arrangements warrant a closer look."[95]

The bold effort of reclamation, *bonifica,* was not without problems—problems not reported by the regime to the public. The majority of early colonists came from the Venetian countryside, and some came either unwillingly or enticed by promises they later saw as unfulfilled. Farmers worked as sharecroppers without title to the land. The quality, furnishings, and sanitation of the farmhouses brought complaints, and there were even work stoppages in a country where strikes were now illegal. "Mussolini saw the dismal state into which many farms and even the canals and infrastructure had fallen by 1938," and when his prefect from Rome visited Pomezia in 1940, he "noted a heavy feeling of misery everywhere; some houses lacked furniture, including beds, and everywhere colonists complained that they lacked shoes, clothes, or linens."[96]

The Agro Pontino lay in the path of bitter fighting during World War II as the Allies fought to break out from the Anzio beachhead in 1944 and move toward Rome. Littoria suffered some damage from aerial bombardment before the Anzio landing and more damage during the fighting until the Germans abandoned the city on May 25. Aprilia stood in a direct line with Anzio and thus suffered some of the heaviest fighting. The town passed back and forth between German and Allied control, as the opposing forces struggled for domination of the area and the adjacent Mussolini Canal. When the Allies finally occupied the town on June 2, it was completely destroyed. The Allied armies at Anzio and Monte Cassino made their breakout at the end of May and early June, occupying all of the Agro Pontino before pushing on to liberate Rome on June 4, 1944. Both Aprilia and Littoria, now Latina, underwent rebuilding after the war, but only Latina still has its principal buildings from the 1930s.[97]

The fascist regime waged a largely successful campaign during the 1930s against the malaria that had constantly plagued the area. Although the fascists never eliminated malaria, they succeeded in drastically cutting the number of cases to a fraction of what they had been before the reclamation of the marshes began. During the war, the Germans tried their hand at biological warfare by destroying the pumping stations and flooding the area before their retreat, hoping that the consequent increase in malaria would cause confusion and delay among the Allied troops. The military results were inconsequential, but this unfortunate tactic did bring about a dramatic increase in malaria from 1944 to 1946.[98] Thus one of the positive achievements of Mussolini's government disappeared with the national disaster that overtook Italy as a result of joining forces with Nazi Germany.

Five

POPULATION, NEIGHBORHOODS, AND HOUSING

POPULATION

Mussolini believed that the transformation of Italy into a great and imperial power depended on a growing population and the central role of the family. Demographic policy, the "Battle of Births," provided the road to revolution, fascist style: Italy must be prolific in order to assert itself among the nations of Europe and beyond. He declared: "The birth rate is not simply an index of the progressive power of the nation; it is not simply, as Spengler suggests, 'Italy's only weapon'; it is also an index of vitality and the will to pass on this vitality over the centuries. If we do not succeed in reversing this trend, all that the Fascist revolution has accomplished and will accomplish in the future will be perfectly useless, as at a certain point in time fields, schools, barracks, ships, and workshops will be empty."[1]

The necessity of large families dictated fascist policies to women and children. Women should play the roles of wife and mother. Financial incentives included benefits for families with more than six children. Schools, medical care, and camps kept children alive and healthy. Single males paid a bachelor's tax to encourage them to marry and start families. That tax helped finance the state agency that provided the benefits for mothers and their children, the National Agency for the Protection of Motherhood and Infancy, the Opera Nazionale per la Protezione della Maternità e dell'Infanzia, or ONMI.

The regime took great pride in the work of ONMI and other youth and health programs. Italy's drive for power and empire could here take the form of benefits for mothers and children. It is no surprise that a major exhibit appeared in the newly cleared Circus Maximus in 1937, devoted to summer camps and assistance to youth, La Mostra delle Colonie Estive e dell'Assistenza all'Infanzia. The progressive architect Giuseppe Pagano hailed this effort for both its design and content:

> Sunday June 20: the National Exhibit of Summer Camps and Assistance to Childhood has been opened by the Duce in Rome. The political-moral and so-cial echo of this exposition, unique of its kind, that demonstrates the interest of the fascist State in the health of children, has passed naturally to the fore-front. Such is the value of the content and so much interest is there in ac-knowledging a work so complex and complete, which is that of protecting and increasing the race, that every artistic evaluation relative to the "form" of the exposition must necessarily pass to second place compared to "content."[2]

Two years later, the new building for ONMI, designed by Cesare Valli opened in Trastevere in a prominent location on the Lungotevere Ripa overlooking the Tiber.[3]

These policies led also to the glorification of "ruralization" and control of migration to the cities. Rural families produced more children than urban fam-ilies. Fascist surveillance worked more easily and efficiently in the countryside, whereas migration to cities and urban crowding, it was feared, might lead to so-cial unrest.

These ambitious policies for population growth and control fell far short of their goals. Marriage and birth rates improved somewhat, but not in the dra-matic way Mussolini expected. In addition, migration to cities continued—nowhere more markedly than Rome. Migration, not more babies, doubled Rome's population during fascist rule. The nearly 700,000 inhabitants of Rome in 1921 grew to 1,415,000 by 1941. Between 1931 and 1936 annual popula-tion growth was 4.3 percent, with an immigration of 34,000 people each year.[4] By 1938, the government estimated an annual population increase of 50,000. Therefore it had to come as close as possible to building new housing for that number and to create new streets and other basic services such as water, sewers, lighting, and gas.[5]

The magnetic force attracting migration to Rome put pressure on the regime to provide more housing for all classes. Mussolini's Rome included the construction of new neighborhoods to accommodate people moving from other parts of Italy to the capital as well as housing for established Roman residents

5.1 ONMI Building, Trastevere, 2000

displaced by the regime's demolition projects. The pressures of growth required the regime to meet, in Mussolini's words, "the problems of necessity," such as housing, schools, churches, and hospitals.

NEIGHBORHOODS AND HOUSING

Fascist housing in Rome and elsewhere in Italy formed a part of the complex of policies and achievements that included new streets, modern buildings such as train stations and post offices, the liberation of ancient monuments, and the re-configuration of urban spaces. Mussolini appeared in newspapers and newsreels as the driving force of Rome's transformation, symbolizing the dynamic energy of the fascist revolution. He was that combination of revolutionary hero and government leader whose "shrewd awareness of the need to win the loyalty of the masses led him to direct much of his efforts toward them in the public realm of Italian cities."[6]

BORGATE

The first and least expensive type of housing was the *borgate,* which was con-structed in outlying areas to house people displaced by the demolition of

neighborhoods in the center.[7] The first use of the term *borgata* appeared in
1924 for Acilia, fifteen kilometers from Rome, built for the residents displaced
by the clearance of areas on both sides of the Victor Emmanuel Monument. By
1940, the Governatorato boasted of Acilia's fine accommodations and social
services, including a building for the rural housewives' organization, La Casa
delle Massai Rurali.[8] The regime planned to make the *borgate* part of the ru-
ralization effort and sometimes spoke of them as *borgate rurali*.[9] Efforts, how-
ever, to transform working class urban dwellers into farmers proved a difficult
if not impossible task.[10]

"*Borgata* is a subspecies of *borgo:* a piece of a city in the middle of the coun-
tryside that is really neither one nor the other."[11] Other borgate followed: San
Basilio, Pietralata, Tufello, Val Melaina, Prenestina, Quarticciolo, Primavalle,
Gordiani, Tor Marancio, Tiburtino III, and Trullo.[12] Initially construction was
shoddy, and such services as private water and electricity were lacking. By the
1930s the quality improved as the housing became part of the system of public
housing, or *case popolari*.[13]

In theory, the *borgate* offered residents new lives that brought them out
of cramped, unhealthy conditions to lower-density housing with fresh air and
basic social services. These improved conditions should provide a more fe-
cund environment to encourage more child-begetting, or so the regime
hoped and expected.[14] Mussolini boasted to a *New York Times* reporter that
"in directing the population toward the hills and the sea we are clearing away
all the unwholesome hovels, purging Rome, letting in air, light and sun,"
which meant health for the nation.[15] The new conditions would give space,
air, gardens, fresh drinking water, and other benefits that a "fraternal and pa-
ternal fascism [offered] to the humble," creating an environment in which
children could "flower."[16]

In practice, the inhabitants of the *borgate* suffered many disadvantages,
most notably living far from jobs in the city, with no easy means of transporta-
tion to them and in conditions that undercut fascist claims about the quality of
life. Carla Capponi, later a major figure in the Roman resistance, gave a stark
picture of life: "I slept at Gordiani, which was the worst *borgata* of all. It was
made up of shanties, with four families in each—wide open, I mean, and in the
entrance you could see beds lying on the ground, perhaps on boards, or noth-
ing, on packed earth or concrete, and there they would lay mattresses and the
children all heaped on top."[17]

One of the largest of the *borgate* was Primavalle, located several miles out-
side the city center. Its first housing provided dormitory accommodations for
the homeless. The initial project had six hundred beds with separate facilities for

men and women. Officials boasted of the showers, laundry, and medical aid available.[18] It subsequently grew into a working-class town for people displaced by the demolitions in the historic center. The new residents came primarily from the areas demolished to open up the Tomb of Augustus, to create the Via della Conciliazione, and to widen the Corso Risorgimento, parallel to the Piazza Navona. Many of these transplanted Romans came from the working class and leaned to the left in their politics. The regime could much more easily keep an eye on them in the isolation of their new *borgata*.[19] Its location several miles northwest of the Vatican effectively cut it off from easy access to the city. Primavalle and other *borgate* thus harbored displaced and disgruntled populations among whom antigovernment sentiment was common. In postwar Rome these areas became largely left-wing and antifascist in politics.[20]

One Primavalle resident recalled his family's transfer to the *borgata:* "I still remember when the trucks came, with the Fascists who loaded us up with those few rags we had; my mother screaming and us kids, on the trucks, thought it was a holiday. It was a long journey that seemed endless. They made us get off at a place that was a few scattered little buildings and mud all over. They said the name of the place was Primavalle."[21]

By the late 1930s the *borgate* ideally included all the necessary social and educational facilities. The Tiburtina *borgata,* east of the city center, housed six thousand workers. By the end of the decade, it had a school with thirty-two classrooms; an open-air school, or *scuola all'aperto,* with six outdoor pavilions; a gym; a party headquarters or Casa del Fascio; and a swimming pool. These facilities had cost 3,800,000 lire and employed eight hundred workers for the fifty days it took to construct them.[22]

CASE POPOLARI

The next level of housing was the *case popolari,* the public housing that the national government began before the fascist regime. The rapid growth of Rome as Italy's capital after 1870 required working-class housing. New construction in the Testaccio neighborhood provided some, while a more ambitious project arose on the little Aventine Hill around the medieval church of San Saba. The Istituto Case Popolari (ICP) built an entire neighborhood around a central piazza that provided space for open-air market stalls and small shops. Work began before World War I and was completed immediately thereafter.[23] Mussolini's government took over the ICP and quickly expanded its scope through an ambitious program of public housing.[24]

The new fascist regime also inherited the work recently initiated just south of the Aurelian Wall in Garbatella and continued developing the neighborhood in the 1920s and 1930s. Garbatella represented the takeover and then the gradual transformation of a planned working-class neighborhood. Unlike that of the *borgate,* Garbatella's placement put it very much within the planned expansion of the central city as a suburb for workers. The plan in the mid-1930s to develop what became EUR enhanced Garbatella's location as Rome now expanded to the south, promising new road and rail facilities.

The original, prefascist plan for Garbatella featured winding streets designed to look more natural than a geometric grid. It embodied an English-garden approach to urban planning.[25] Plans included a variety of housing patterns with ten different types, from single-family houses to multi-family apartments, with the streets converging on several major piazzas. Facing the Piazza Michele da Carbonara were several large buildings that included housing for those temporarily displaced by demolition and awaiting permanent housing. Innocenzo Sabbatini designed several of these suburban hotels, or *alberghi suburbani,* in the late 1920s, the most visible being the bright red Albergo Rosso, between the Piazza Carbonara and the Piazza Eugenio Biffi.[26] Sabbatini sought in this "hotel for the evicted" and several of his other buildings to find new ways of providing public housing in large buildings, in some cases providing communal dining halls as in this one.

The more obviously fascist imprint on Garbatella took shape during the 1930s. Apartment complexes appeared that had similarities with public housing under construction in other areas of the city. For example, architect Giorgio Guidi designed a curved apartment building constructed in 1935 as *case popolari* on the Via Luigi Orlando in collaboration with the engineer Innocenzo Costantini. The building incorporated the latest construction techniques and provided twenty-seven apartments of two or three rooms each, plus kitchen and alcove. The design "realized a solution most economical for the exploitation of the habitable area."[27]

The largest space in Garbatella was the Piazza Domenico Sauli. This piazza furnished another example of the more monumental fascist style emerging in the 1930s. The clear intent was to create a massive square containing major centers of civic life as defined by the fascist regime. Giovanni Brunetto designed the massive school built in 1930 and named for the recently deceased fascist leader Michele Bianchi that dominated the piazza on the south side. On the opposite north side were businesses and stores in the characteristic brick and travertine materials of the 1930s.

Set in the middle of the piazza was the church of San Francesco Severio, typical in design of many of Rome's churches from the period. Inside the church

5.2 Albergo Rosso, Garbatella, 1999

today one finds a dramatic painting of Pope Pius XII with outstretched arms be-
fore a crowd of Roman citizens. It is based on a photograph from 1943 when
Pius visited bomb-damaged areas of the city. It was a dark time for Rome, given
Mussolini's ouster from office and the Allied invasion of Sicily and then main-
land Italy. The king abandoned the city to seek safety behind Allied lines in the
south. The mural captures the drama of Pius XII reasserting leadership in the
city at the time of fascism's demise, Italy's defeat, and the beginning of the armed
resistance.

Case popolari sites appeared in neighborhoods throughout the city. In some
instances, they were scarcely distinguishable on the exterior from more expen-
sive, middle-class housing, *case convenzionate,* although apartments inside were
more modest in size. Innocenzo Sabbatini's innovative design for an ICP project
on the Via della Lega Lombarda in the Nomentana quarter in 1930 offered one
example. The triangular building had layered, stepping-stone stories.[28]

Case popolari projects continued throughout the 1930s, often becoming
larger and embodying more sophisticated concepts of urban planning. The
complex on the Via Donna Olimpia on the Janiculum Hill demonstrated
these trends. The project included housing for nearly three hundred families
in a series of buildings of eight stories each. The plan included a church, a
school, and other services such as those offered by the ONMI. Mussolini at-
tended the opening in 1939 with lavish attention from the press. The regime
boasted of its success in planning: "In the field of high density public hous-
ing, the example is given precisely of how much better it can be done when

there is the coordination of training based on long experience with the healthy economy and the rigorous directives of autarchy."[29]

Once again, the recollections of a resident convey a different picture of life in the new housing project. Goffredo Cappelletti, born in 1930, told an interviewer in 1997:

> I lived in Donna Olimpia. They build these big projects, the [so-called] skyscrapers, and in my way of thinking these projects were not conceived in order to give a home to working people. They were conceived in order to concentrate the people who were adverse to Fascism in strategic places, where they could be controlled easily. This is my opinion. Because my father owned his own house [near] the Colosseum, where I was born, and practically he was expelled when they were making via dell'Impero in '30, and they gave him a place in these projects.[30]

CASE CONVENZIONATE

The need for housing increased more rapidly than the ability of the government to meet it through such public housing. A different approach emerged by the 1930s, in which the Roman Governatorato worked in partnership with quasi-public and private firms to provide large numbers of new apartments, known as *case convenzionate,* for Rome's rapidly growing population. This new program led to the construction of buildings in already populated neighborhoods and, quite dramatically, in completely new neighborhoods.

In 1928, the government lifted rent restrictions imposed in 1917. Rents immediately surged, and many families faced eviction. This development coincided with the influx of newcomers to the city. A new law created "conventional housing," or the *case convenzionate,* by providing financial incentives to banks, insurance companies, manufacturers, real estate companies, and construction firms for apartments built with the understanding that rents would be affordable for the working- and middle classes. The law provided also for fixed rents for five years. Thus thousands of families could now afford new apartments, and the firms building them were guaranteed a steady return on their investment.[31]

Governor Prince Ludovico Boncompagni Ludovisi supervised the first projects that would meet the housing "crisis" facing the rapidly growing city. Although the Governatorato stayed out of the building business, it exercised control in return for subsidies and guarantees. In particular, it had to approve of the tenants assigned to the *case convenzionate* through its Office of Social Assistance, the Ufficio di Assistenza Sociale.[32] Potential tenants had to respond to a

5.3　Case popolari on the Via Donna Olimpia, 1938

set of questions. The decisions on who gained admission endeavored to avoid "any appearance of arbitrariness and favoritism," and used five criteria to assess applicants: (1) disabled from the war or the fascist revolution; (2) large families; (3) veterans and decorated veterans of the war; (4) workers and pensioners of the Governatorato; and (5) those evicted by judicial authority for reasons other than failure to pay rent or questions of "morality." [33]

The Società Generale Immobiliare, SGI, became one of the major firms in this type of housing. With its origins in the nineteenth century, the SGI had developed into a major construction and real estate business in Rome and "under Fascism financed the clearances in the city centre. In 1935 the Vatican took control of SGI (25 percent of shares) using part of the money it had acquired from the Italian government as negotiated in the Lateran Pact of 1929."[34] Another major provider of funds for the *case convenzionate* was the national insurance giant Istituto Nazionale Assicurazioni (INA). These and other firms produced the apartments that the Governatorato then allocated to families. The combination of private financing and public control of residents thus gave the fascist regime another layer of housing above the *borgate* and the *case popolari* that provided means for the development of new neighborhoods in Rome.

The law of 1928 and regulations led to an upsurge in building. Both the SGI and the INA took part in the construction of *case convenzionate* in a number of quarters of the city such as Flaminio, Prenestino, Nomentana, and Appio. One report on activity in 1930 showed that new apartments could accommodate nearly two thousand families. Thus the regime demonstrated once again its ability to meet the needs of the growing city, claiming "another victory of the Regime and its Head, less apparent, because more complex and scattered, but no less profound and salutary than others."[35]

The apartments typically had up to three rooms and a kitchen. A few had four rooms and a very few five rooms, the latter no doubt for those families responding successfully to the challenge to produce more children. The family depicted in the 1977 Italian film *Una Giornata Particolare (A Special Day)* lived in such an apartment on the Viale XXI Aprile. Sophia Loren portrayed the mother of six children and thinking of a seventh to qualify for the special subsidy from the government. Her husband worked for the regime and thus received special consideration for the apartment as a government employee.[36]

The apartment in the film was part of the largest single project of the *case convenzionate* type. Located at 21–29 Viale XXI Aprile, it consisted of two large buildings with 442 apartments, 70 stores, a parking garage, and a cinema that is today a supermarket. Mario De Renzi designed the complex whose buildings reached eight to ten floors in height, real "high risers" by traditional Roman standards but not unusual in this new type of housing.

The Viale XXI Aprile extended out from the Piazza Bologna, where one of the regime's four major post offices was completed in 1935. In fact, the whole neighborhood radiating out on all sides from the Piazza Bologna arose in the 1930s. It remains today as one of the most extensive areas of Rome produced during the fascist period. The *case convenzionate* type of apartment building dominates the neighborhood. A walk through its streets provides a clear view of what Mussolini's Rome furnished for its citizens of the "middling sort."

The *case convenzionate* also appeared prominently in the Flamino, Prenestino, Via Taranto, Corso Trieste, and Piazza Mazzini neighborhoods. Prenestino was also the location of a film *Roma Città Aperta (Rome Open City)*, director Roberto Rossellini's neorealist masterpiece about Roman life under Nazi occupation. The apartment scenes take place in a large *casa convenzionate* on Via Montecuccoli, off the Via Prenestina.[37]

The fascist regime also administered the Istituto per le Case dei Dipendenti del Governatorato di Roma, known as INCIS, which had its origins in 1920 to provide housing for city employees. This type of housing resembled in design and quality the *case convenzionate* and some of the *case popolari*. Mario De

5.4 Case convenzionate, Viale XXI Aprile, 2000

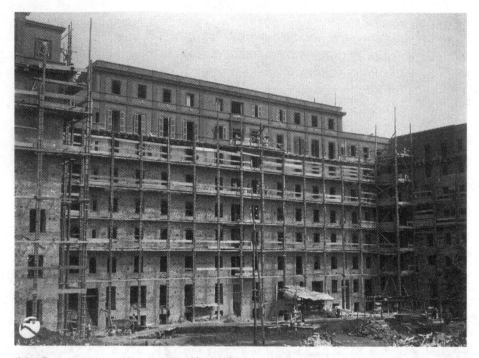

5.5 Case convenzionate, Prenestino neighborhood, 1930

Renzi, for example, designed the building on Via Andrea Doria, 1–27, which opened in 1930, adjacent to recently constructed *case popolari*.[38] This area, the Prati neighborhood in the shadow of St. Peter's, bordered the Trionfale Quarter, which also expanded markedly in the 1920s and early 1930s. Included in the latter neighborhood expansion were Innocenzo Sabbatini's *casa popolari* at Via Trionfale, 120–126, opened in 1925, and the Governatorato's large office building and parking garage, the Autoparco Centrale della Pubblica Sicurezza, in 1930 at the corner of Via Trionfale and the Via Andrea Dorea.[39]

Another large INCIS project went up just outside the Aurelian Wall between the Porta Latina and the Piazza di Porta Metronia, not far from the Lateran. Once again, the new housing would replace what the regime saw as old and decrepit housing hastily built early in the century during the decadent days of Liberal Italy. Mussolini appeared on site in May 1938 to inaugurate construction.[40] The complex included a middle school on the Viale Metronio, surrounded by the new apartment buildings.

Other projects appeared in the Via Taranto and Piazza Mazzini neighborhoods.[41] In fact, the four new post offices sponsored by the government illustrated both its support of innovative architecture and its planned expansion of

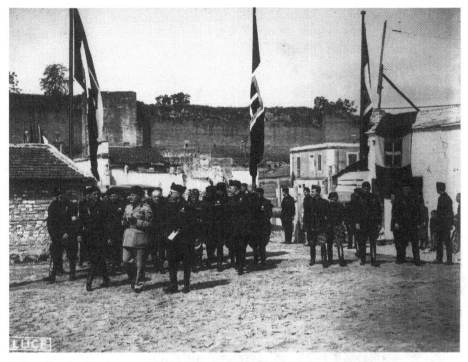

5.6 Mussolini at the cornerstone laying for the INCIS housing at the Porta Metronia, 1938

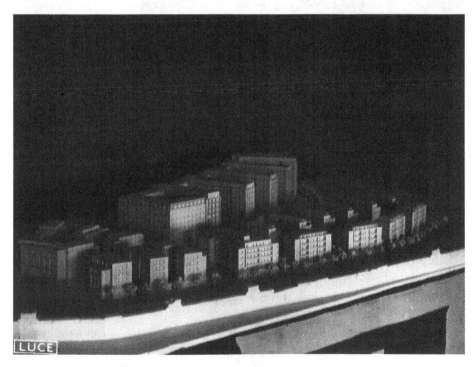

5.7 Model for the INCIS housing at Porta Metronia, 1938

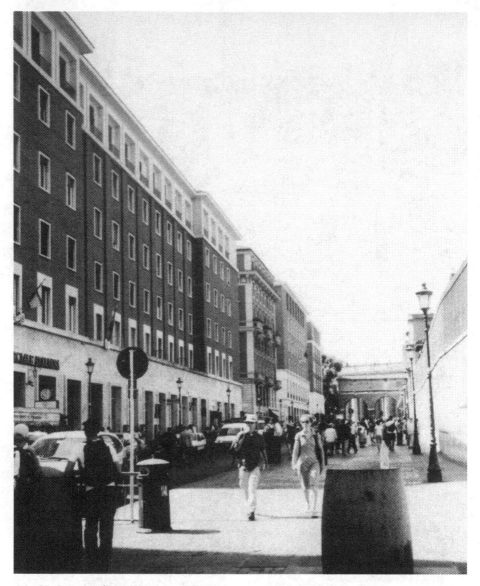

5.8 Via Porta Angelica, 2003

neighborhoods. Each of the locations—Via Taranto, Viale Mazzini, Via Mar-
morata, and Piazza Bologna—was central to the development of a new area of
the city.[42]

The development of the Via Porta Angelica between Bernini's colonnade in
front of St. Peter's and the Piazza Risorgimento served as another dramatic ex-
ample of new construction in an old neighborhood. The four-block area con-

stituted part of the urban reclamation analogous to the land reclamation of the Pontine Marshes. In this case, it was "building reclamation," or *bonifica edilizia.* This work followed from the project under way to construct the Via della Conciliazione. It would redeem the neighborhood by getting rid of a "picturesque and characteristic area of old Rome, but [now] in such a condition of indecorous and miserable decadence as to be no longer tolerable."[43]

The Società Generale Immobiliare expropriated the land in collaboration with the Governatorato. After demolition of the existing structures, building began on the four blocks of the Via Porta Angelica. The ground floor of each building accommodated offices and stores, but the upper five stories supplied apartments of three to six rooms. Altogether the four buildings contained 160 apartments. Construction took place in 1940 and 1941.[44]

HIGH-PRICED HOUSING: PALAZZINE AND VILLINI

The upper level of housing in the period carried the names of *palazzini* and *villini.* As the names imply, these were apartments suggestive of the level of a palazzo or a villa. They appeared in more modest-sized buildings that were free-standing, often with gardens and shrubs enhancing the appearance. Usually *villini* were two to three stories and *palazzine,* three to five.[45] While such buildings could appear in spaces within the historic center, they became particularly conspicuous in new neighborhoods just beyond the historic center. Their occupants thus enjoyed both the prestige and comfort of the best new housing in Rome and the convenience of proximity to its center. This type of housing, sometimes described as *signorili,* or "lordly," dominated both the Aventine Hill and Parioli neighborhoods.

AVENTINE HILL

The villas and apartment houses of the Aventine Hill are almost completely the products of the fascist and immediate postwar years. The Aventine lay within the historic center defined by the third-century Aurelian Wall, but by the twentieth century it had little residential housing. Churches, monasteries, convents, and the Knights of Malta accounted for most of its buildings. The fascist transformation of the historic center from the Victor Emmanuel Monument to the Circus Maximus and around to the Colosseum and back included the Aventine.

The new Via Circo Massimo ran along the Aventine slope overlooking the Circus Maximus, and the new Via del Mare connected the hill with the Piazza Venezia.

The Aventine, one of ancient Rome's seven hills, was convenient to downtown Rome and now lay within the area under intense development by the fascist regime. At one point, Mussolini considered building the fascist party headquarters on the Viale Aventino before it was finally decided to construct it at the Foro Mussolini. Apartments sprang up in the late 1920s that began the trend toward residential development. The additions in the mid-1930s took on the look of similar construction at that time, with the brick walls and travertine-bordered windows now found throughout the city.[46]

The Via San Alberto Magno, just south of Santa Sabina, has a solid wall of apartments from the 1930s. In the middle building there are three arches to accommodate both auto and pedestrian traffic. Beyond the arches opened a view down the Via di S. Domenico, with similar apartment buildings on both sides of the street. Nearby at the Piazza Santa Prisca, the Via di Terme Deciane offers a similar view. These apartments offered suitable accommodations for middle- and upper-middle-class Romans, including fascist officials.

The trattoria Castel dei Cesari, just above the church of Santa Prisca, provided a dramatic view across the Circus Maximus to the Palatine. When Mussolini received the property as a gift, he turned it over to the Balilla. The youth organization rebuilt it as one of its principal facilities in the historic center. Plans went ahead for placing Mazzini's statue between it and the Circus Maximus on the new (1934) Piazzale Romolo e Remo, although that did not take place until after the war. Antonio Muñoz completed the restoration project for the church of Santa Sabina in 1936–1937, and the park adjacent to the church was also developed at this time.[47] The park, known as the Parco Savello or Orange Grove Park, includes a panoramic view across the river to Trastevere and up the river to the dome of St. Peter's.

The attraction of the Aventine neighborhood was further enhanced by the work accomplished around the Porta San Paolo. Another new park, the Parco Cestio, appeared behind Libera's post office, which faced the Via Marmorata. The park site was the same one proposed in 1937 for the fascist party headquarters, the Palazzo del Littorio. The regime sponsored a design competition for the latter but decided subsequently to locate the building at the Foro Mussolini.[48] There were rail connections nearby to the Lido, and the new Ostiense station opened in 1938. Apartment buildings went up on the Viale Aventino after it reopened in 1934 from the Porta San Paolo to the Circus Maximus. The broad Viale Ostiense stretched south of Porta San Paolo, to Garbatella. It un-

derwent extensive development, especially with *case convenzionate*.[49] The whole area, from the Aventine south, developed out of Mussolini's plan to extend Rome to the sea beginning with the Via del Mare project.

The Via Marmorata runs from the Porta San Paolo to the Tiber, with the Aventine Hill on the right and the Testaccio neighborhood to the left. It underwent significant development during the fascist period, both before and after the Piano Regolatore of 1931. A new fire station appeared in 1929 directly across the street from the site used six years later for the new post office. Apartment buildings of the *case popolari* type went up in Testaccio. One of the most striking examples faced the Via Marmorata in the block between the Via Luigi Vanvitelli and the Via Giovanni Branca. Architects Innocenzo Sabbatini and Innocenzo Costantini designed two apartment buildings completed in 1930.[50] The street was widened at the point where it reached the Tiber at the Piazza dell' Emporio, with new brick embankments opposite the Fontana delle Anfore, built in 1925.[51]

These neighborhoods arose outside the historic center and thus out of sight for journalists and tourists visiting Mussolini's Rome, but they housed thousands of new Romans and were visible to thousands more who lived and worked in the city. The sheer volume of construction undergirded the image of Mussolini the *costruttore*, who guided the building of a Rome worthy of the new and imperial Italy. Rome and its dynamic growth symbolized an Italy that the regime likened to a vast shipyard, or *cantiere*, of constant construction.

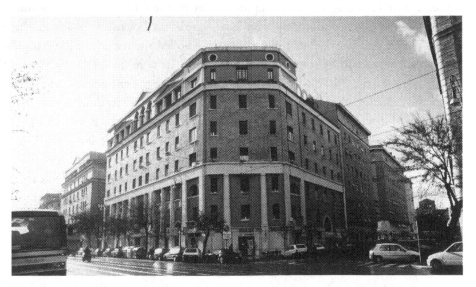

5.9 Case popolari, Via Marmorata, Testaccio neighborhood, 2000

Mussolini regularly appeared as the leader of the effort, the *capocantiere,* in newsreels and newspaper photos.[52]

PARIOLI

The Parioli neighborhood occupies the area north of the Piazza del Popolo and the Porta Flaminia, adjacent to the Villa Borghese park. The Tiber defines its borders to the west and north, the Villa Glori to the northeast, and the large Villa Adda park to the east. This area provided ample space for sports facilities and the Campo Dux of the regime's youth groups. The higher ground of Monte Parioli provided the space for the higher-end housing of the 1930s that defines the neighborhood to this day.

The Viale Maresciallo Pilsudski ran from the Via Flaminia, past the Stadium of the National Fascist Party, up to the Villa Glori. The stadium had opened in 1911 to commemorate fifty years of Italian unity and then underwent expansion by Marcello Piacentini to become the Stadio del PNF, with a capacity of 30,000 spectators. The Villa Glori held a monument to those Romans who fell in World War I. At the summit of the street, where it reaches the Villa Glori, the Governatorato constructed a monument to Josef Pilsudksi (1867–1935) with a bust of the Polish leader mounted on a column dedicated on December 19, 1937: "Next to the main entrance to this Roman Park of Remembrance, where four streets open and one of them descends to the Tiber, at the celebrated fonte of the Acqua Acetosa, there has been raised in a dignified way by the Governatorato of Rome a great bust of the Condottierio who has restored to Poland its place in the world."[53] Pilsudski was Poland's national hero who led the rebirth of the nation after World War I and defeated the Bolshevik Red Army in the 1919–1920 war.

Just beyond the Pilsudksi monument and opposite the entrance to the Villa Glori, the immense church of the Cuore Immacolato di Maria, designed by Armando Brasini and completed in 1923, dominated the Piazza Euclide.[54] The broad Viale Parioli snaked from there, south to the Piazza Ungheria, which contained another fascist-era church, dedicated to San Roberto Bellarmino. The street running from the Piazza Ungheria back to the Via Flaminia was dedicated to the martyrs of fascism, the Viale dei Martiri Fascisti. This new street brought "a notable contribution to dispersing city traffic" and would improve the flow of traffic in the Parioli and Flaminio areas.[55] After World War II it gained a new name, Bruno Buozzi, after the antifascist and socialist leader executed by the Germans in 1944.[56] Within the borders of these streets—Flaminia, Pilsudski, Parioli, and Martiri Fascisti—arose the new Parioli district.

The architects Mario Paniconi and Giulio Pediconi were celebrated for their modern apartment house overlooking the stadium of the fascist party, the Stadio del PNF.[57] Its location on the Via Cavalier d'Arpino gave its occupants a sweeping view of the whole area. The architects employed materials in accordance with the regime's drive for autarchy, which meant limiting the use of imported metal in the building's construction. The building contained only two ample apartments and represented the most expensive and prestigious housing available in Rome, the *villini*. "Demolished in the Sixties, the villino Pantanella testified to an architectonic research very close to the lexicon of European rationalism and in particular to the work of Le Corbusier."[58]

Mario Ridolfi designed the *palazzina* at Via S.Valentino, 21, completed in 1936 and containing three large apartments. His design provided ample light and space carefully planned for functionality.[59] Ridolfi collaborated on this project and also on a *palazzina* of similar size and design at 39 Viale di Villa Massimo, near the Piazza Bologna, with Wolfgang Frankl. Both buildings are notable examples of modernist, rationalist domestic architecture.[60]

Back in Parioli, the long and winding Via Archimede was the site of many more expensive apartments in modern buildings. Gino Franzi's *palazzina* of six floors opened in 1930, with the upper five floors each containing one apartment, and "considered one of the first 'modern' apartment houses built in Rome."[61] Nearby, a five- story *palazzina* appeared in 1936 designed by Mario Tufaroli Luciano. It too had one apartment on each floor.[62] Another example was at the corner of the Via Guidubaldo del Monte by architect Luigi Piccinato, opened in 1939. The design took full advantage of the location to give maximum light and panoramic views. In fact, this and many of the apartments in the area featured balconies for precisely that reason.[63] These buildings also frequently provided garage space for private automobiles. Collectively they demonstrate that the modern architectural style favored by Pagano remained important for the highest-priced housing in fascist Rome.

EXAMPLES IN OTHER NEIGHBORHOODS

Similar housing appeared on both sides of the Parioli district. The area to the west, between the Via Flaminia and the Tiber, developed at the same time. Gino Franzi produced a building of five stories, with two apartments on each floor, on the Via Maria Adelaide. Each apartment had a living room, dining room, study, three bedrooms, and servants' quarters.[64] Other examples lined the Lungotevere Flaminia. A rather large complex of five buildings containing *palazzine*

by Angelo Di Castro was completed in 1937.[65] A corner building of seven stories, also on the Lungotevere Flaminia, was designed by Ugo Luccichenti and completed in 1939.[66] Mario De Renzi and Giorgio Calza Bini collaborated on the striking Palazzina Furmanmik on the corner of Via Canina, which today houses the offices of the Diners Club.[67]

On the eastern border of Parioli between the Piazza Ungheria and the Villa Ada park was another area developed with the more expensive housing of *palazzine*. The Via Panama runs alongside the Villa Ada, and the Via Bruxelles runs parallel to the Via Panama one block away. Andrea Busiri Vici designed the four-story apartment house on the Via Bruxelles, completed in 1935. The below-ground garage provided eight parking spaces, one for each apartment. The outdoor terraces wrapped around the three sides of the building.[68] Mario Tufaroli Luciano completed two projects on the Via Panama. The first, completed by 1936, had five stories, with eight apartments on each floor. Although more modest than some other examples, each apartment had seven rooms with a separate service entrance and staircase and a projecting terrace.[69] The second project contained two five-story buildings. The design of each was different, but the ground floors and the similar sizes and shapes tie the two together.[70] Mario De Renzi also designed a *palazzina* on the Via Panama by the Piazza Cuba in 1929.[71]

The broad Corso Trieste lay just to the south of this neighborhood on the way to the Via Nomentana. It developed in the 1930s as another fashionable area with substantial housing and public buildings. Pietro Aschieri designed the six-story *palazzina* on the corner of the Piazza Trasimeno and the Corso Trieste, which opened in 1931.[72] The Corso Trieste was also the location of one of the period's largest schools, the Liceo Giulio Cesare, designed by Cesare Valle, which opened in 1937.[73]

These new residential neighborhoods also required new parish churches. For example, in the Piazza Ugheria, the church of San Roberto Bellarmino was designed by Clemente Busiri Vici and completed in 1933.[74] Another notable public building in this area dominated the Via Romania: the Caserma Mussolini, completed in 1935.[75] This building occupies a triangular lot with curved walls and a tower at the apex of the triangle. The design and brick construction were similar to the post office at the Palazzo Bologna.

The more expensive housing of the *palazzine* and *villini* also appeared in neighborhoods with mixed housing, especially *case convenzionate*, but also *case popolari*. The area near the Lateran and just outside the Aurelian Wall near the Porta Latina, Porta Metronia, and Porta San Giovanni offers a good example. In 1936, the architect Mario Paniconi's Casa Ceradini included twelve spacious

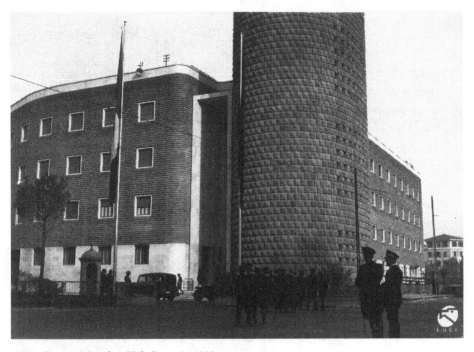

5.10 Caserma Mussolini, Viale Romania, 1938

apartments with balconies. The apartment building stood at the foot of the new fascist street, Via Amba Aradam, on the Piazzale Metronia, adjacent to the more modest complex of INCIS housing, noted previously, that would appear a few years later.[76] The new neighborhood school had opened in 1932 on the Via Vetulonia, just beyond the Porta Latina.[77]

Beyond the Villa Ada and the Via Salaria, adjacent to the Via Nomentana, was the area of Monte Sacro. Its development began early in the century but accelerated during the fascist period. The regime built a major complex of sports and fitness facilities for the Gioventù Italiana del Littorio in 1935. Gaetano Minnucci designed the project, which included a pool, a gym, locker rooms, a solarium, a theater, and a school for home economics.[78]

The expansion of Rome south of the center led to Ostia on the sea. It too underwent major housing expansion in the 1930s. The Società Immobiliare Tirrenna sponsored a competition to spur housing development that envisaged a group of fifteen buildings. Adalberto Libera ended up designing four of the *villini* included in this group.[79] Ostia also boasted a strikingly designed post office by Angiolo Mazzoni.[80]

CHURCHES AND HOSPITALS

As we noted in touring these new neighborhoods, new churches as well as new housing went up. The Lateran Accords of 1929 did not prevent tensions between the fascist regime and the church, but they opened the way for Mussolini to show the people that his regime recognized Catholicism as Italy's official religion. One way was in the provision for new parish churches. The number of parishes in the city during the 1930s rose from 64 to 103.[81] In some instances, special recognition went to new churches deemed particularly noteworthy for their style. The church of Christ the King, Cristo Re, on the Viale Mazzini, designed by Marcello Piacentini and completed in 1934, was one of them. Its red brick construction and its twin towers embodied a modern religious building that "continues the tradition of monumentality proper to Rome."[82] Another indication of government support for local churches was the restorations by Muñoz of such ancient churches as Santa Sabina, Santa Balbina, and San Giorgio al Velabro.

The regime boasted of its efforts to improve the health of the nation. Social services, slum clearance, schools, camps, youth programs, and benefits for mothers and infants all played their roles. Major programs were designed to reduce tuberculosis and malaria. Clinics opened in new neighborhoods, and the *borgate* and several hospitals arose. The two largest and most often featured by the government were the Ospedale Littorio and the Sanitorio Carlo Forlanini, adjacent to each other on Monteverde, just south of the Janiculum.[83]

This survey of housing types and neighborhoods underscores the rapid expansion of the city and its population during fascism's two decades of rule. The sheer volume of Rome's growth played an integral part in Mussolini's attempt to show that the fascist revolution could indeed work miracles. Here was proof of fascism's ability to be modern while reinventing the glorious past of the Roman Empire. The theme of Mussolini as builder of the new Rome played a central role in fascist propaganda right up to the end. Here it is in a German publication written in 1942 but not published until August 1943, after the coup that toppled Mussolini and put him under arrest:

> Only someone, after having known Rome before the advent of fascism to power, seeing it today after twenty years of the Regime, can value what the Duce has done for Rome in this period. The city now is extended externally in a surprising measure and has reached the greatness of the capital of the first empire under Augustus: in 1870, when Rome became capital of Italy, it had only 226,000 inhabitants. In 1922, when Mussolini accomplished the March

on Rome, it counted around 700,000 people. In one decade of the fascist regime the population had grown almost as much as in the fifty years preceding. In 1932 it passed one million inhabitants, and in 1942 it boasted 1,450,000. With that Mussolini has clearly doubled, in scarcely twenty years of work, the number of inhabitants of Rome. Naturally this incredible development must bring with it a decisive change in the image of the city.[84]

Six

AXIS AND EMPIRE

Mussolini's fascist revolution promised the Italian people two major changes: First, Italians would achieve internal unity, experience a new identity as Italians, and fulfill the promise of the Risorgimento to overcome the traditional divisions in the name of the new national community; and second, Italy would become a powerful nation capable of gaining the respect of other great powers and creating a new sphere of interest—a place in the sun—worthy of the Roman imperial tradition. The themes and messages integral to Mussolini's transformation of Rome spoke to both these goals. The regime brought Italians from every corner of the land to see the new city emerging and to experience for themselves the pride and strength of being Italian. Fascism produced results. Visitors could see it in the new streets and buildings, in the new vistas opened by wide streets and boulevards, and in the ancient monuments now liberated and integrated into the Roman landscape. In the constant parades, events, and ceremonies, the Duce beckoned Italians to play their part in the new Italy now poised to make its mark in Europe, the Mediterranean, and the world.

Rome would continue to play a central role in Mussolini's definition of his regime, his empire, and his fascist revolution. Giuseppe Bottai declared in 1938, "The revival of the grandeur of Rome is the highest aspiration of Italian poets, who, from Dante, to Leopardi, and D'Annunzio, have prophesied the triumphal events of the Empire, in which—thanks to Il Duce—our generation can play a leading role."[1]

CONSENSUS AND PROPAGANDA

Gauging the effect of all these efforts, including the impact of Mussolini's Rome, is difficult for historians. Renzo De Felice argued the case in the 1970s that Mussolini had achieved a certain consensus between his government and the people, particularly from 1929 to 1936. The degree and nature of the consensus continue to generate debate, but it does appear clear that Mussolini faced almost no resistance to his rule and that most Italians willingly went along, some enthusiastically, others indifferently. Rome's transformation, its use as the center of national attention, and its impact on the populace as a symbol of fascist achievement were certainly real and unavoidable.

Mussolini's dilemma by the early 1930s was in determining where to go next. What, in fact, would the fascist revolution achieve? How would it deliver on its promises to produce a new generation of Italians and hence a new Italy? Corporatism promised a new economic and social order, but was it anything more than a new state bureaucracy? After all the speeches, parades, ribbon-cutting ceremonies, festivals, sports, and games, how much was really different? Fascism appeared dynamic, but could it ever settle down and bring economic prosperity and social cohesion? Answers were not forthcoming. In particular, it is not clear that Mussolini had long-range plans for Italy, although he was acutely aware of the short-term political consequences of his policies. Therefore, his policies kept changing to attract and maintain public support. Mussolini's fascist rule seemed to possess dynamism and energy that manifested itself as a restlessness bordering on incoherence.

Whatever messages the fascist regime wished to convey, it continued to seek more effective ways to convey them. The example of Nazi Germany's propaganda techniques had an impact, as did the formation of the Rome-Berlin Axis from 1936 on. Italy and Germany collaborated in helping Franco's forces during the Spanish Civil War from 1936 to 1939. The other side in the Spanish struggle increasingly defined itself as "antifascist," thus producing the idea of a struggle against a generic fascism that included Mussolini, Hitler, Franco, and anyone who sympathized with them. In a sense, it seemed logical to fascists and antifascists alike that Mussolini's regime, like Hitler's, would develop the tools of totalitarian control over education, cultural organizations, and the media. These were the strands coming together to form the "fabric of consensus" in fascist Italy.[2]

The fascist state press office underwent reorganization in 1934 under the direction of Mussolini's son-in-law, Count Galeazzo Ciano. By 1937, it had be-

come the Ministry of Popular Culture, nicknamed Minculpop, and had under its control radio, film, newspapers, tourism, music, and theater. When Ciano became foreign minister in 1936, Dino Alfieri took over command.[3] The ministry occupied an older building on the Via Veneto diagonally across from the Ministry of Corporations and near the Ambassador Hotel.

Those years saw new buildings appear in Rome that had important roles in the drive to control popular ideas and attitudes. The most spectacular new complex was the Cinecittà, the Cinema City, on the Via Tuscolana, six miles southeast of the historic center. It opened on April 28, 1937, and covered 600,000 square meters in an undeveloped area. It contained all the facilities to produce movies for the public, with room for expansion.[4] A new law in 1938 restricted the importation of foreign films, which led to a significant reduction of American films in Italy. Known as the Alfieri law, it opened the way for increased production of Italian movies.[5] Indeed, the number of films produced each year rose from an average of thirty to over one hundred by 1941. Luigi Freddi, director of the film division of Minculpop, boasted that "the new national film production is acquiring an international reputation and meaning because it expresses our time in history, which is truly Italian and Fascist."[6]

The L'Unione Cinematografica Educativa began in 1923 and by 1925 had become the state-controlled Istituto Luce. It took most of the official photographs for the regime and produced the newsreels, the *cinegiornali,* that were required viewing in all movie theaters in the country. Its new building opened on November 10, 1937 adjacent to Cinecittà and across from the Centro Sperimentale di Cinematografico.[7] The latter, founded in 1935, had the express purpose of producing films for the popular market that conveyed fascist political messages. As its director Luigi Chiarini put it, the films produced by the young Italians attracted to the center "were to contribute to the 'great work of human reclamation' [*bonifica umana*] that the regime had undertaken."[8]

ETHIOPIA AND THE ROME-BERLIN AXIS

Mussolini continued to believe that Italy could be a great nation and that the fascist revolution could fulfill itself only through war and conquest, for war brought human achievement to its highest level. "Better to live one day as a lion than a thousand years as a sheep" went the slogan. He chose Ethiopia as the object of conquest. Italy had suffered a humiliating defeat there in 1896, along with the shame of a European army losing to native troops. Now a fascist Italy could return for vengeance and conquest. The war would forge greater national

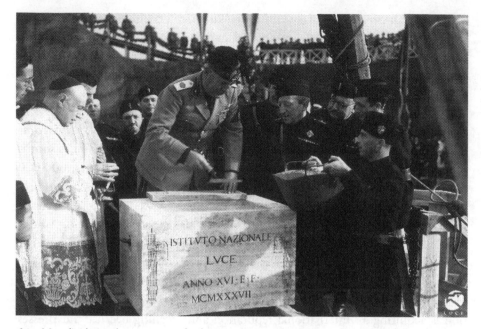

6.1 Mussolini laying the cornerstone for the Istituto Luce, 1937

unity and allow Italy to found a new empire. Against the counsel of advisers, both civilian and military, he went ahead. The gamble paid off, and by May 1936, Italy had its empire.

Here certainly was the turning point for Mussolini's Italy. The British-led opposition of the League of Nations in the form of economic sanctions caused great resentment in Italy. Mussolini played the point for all it was worth in his propaganda. Who were the British, with their worldwide empire, to deny the Italians their rightful place in the sun? Against such cynical opposition, Italians rallied to the cause and sacrificed to gain their victory.

When the league imposed sanctions on November 18, 1935, Mussolini declared that it was a day history would recall as a "date of shame." Resistance to the sanctions became a new rallying cry, as flags unfurled and rallies gathered throughout the country. The most dramatic and public response came on December 18 as a Day of the Wedding Ring, or Giornata della Fede, *fede* meaning both "faith" and "wedding ring." Led by the queen and accompanied by members of the royal family, Roman women gathered on the altar of the fatherland to donate their gold wedding rings to the cause of the war.[9]

Italy decided it could do without the League and withdrew on December 11, 1937. Italy could also manage without the British and their friends. Ger-

many alone of the great powers stood ready to help. The ideological affinity between fascism and Nazism now resulted in a diplomatic and military alliance. In 1931, before coming to power, Hitler had predicted a special relationship with fascism: "The spiritual relations existing on so many points between the fundamental ideas and principles of Fascism and those of the National Socialist Movement under my direction allow me to live with the inner hope that after the victory of my movement in Germany—in which I believe with unshakable faith—there will one day ensue between Fascist Italy and National Socialist Germany relations of the same kind for the good of the two great nations."[10]

HITLER COMES TO ROME

Mussolini's trip to Germany in September 1937 was hailed as an historic event for Italy and evidence of its great power status. One headline in *Il Popolo d'Italia* proclaimed the Duce's visit a "decisive event for the history of Europe."[11] At the great rally in Berlin, Mussolini spoke to the crowd, estimated at 800,000, in German, although some commentators said the listeners could not understand him between his poor accent and the pouring rain. "Mussolini did, however, return home proclaiming that he was now more sure than ever that 'the future of Europe will be fascist.'"[12] Not surprisingly, Mussolini invited the Führer to come to Italy and to Rome.

Hitler's trip to Italy in May 1938 came just two months after the Anschluss, uniting Austria to Germany. His journey included Rome, Florence, and Naples. Hitler's interest in art made it mandatory that he view the great artistic and architectural achievements of the Renaissance in Rome. Mussolini took him to Naples to review the Italian navy. Nevertheless, it was Rome, the Rome of Mussolini, which was the centerpiece of Hitler's visit.

Hitler arrived in Rome on May 3 after a train ride through the Brenner Pass and down the spine of Italy, where thousands of Italians were assembled along the way to cheer and wave flags. His train pulled into the Ostiense station, just beyond the Porta San Paolo; the station was built for the occasion and brilliantly illuminated for the evening arrival. The German eagle and swastika were prominently displayed throughout the station.

Architect Roberto Narducci had designed the new station. Its grand proportions accorded with the new imperial atmosphere of Rome. Inside the main pavilion, two murals celebrated the achievements of the two movements, one for Nazism and one for fascism. The first represented the Germany of Hitler as the successor of Frederick II and of Bismarck, while the second mural of Mussolini's

Italy emphasized the ongoing victory march of fascism. Outside the main doors, mosaics, including a map of the Roman Empire, decorated the pavement.[13] "The map is framed by a Roman triumphal arch and the figure of a victorious Augustus with the imperial eagle," which was "designed to make a clear statement about Fascist pride in the idea of empire and in the importance, as they saw it, of linking the 'vitality of the Italian people' with the greatness of ancient Rome."[14] Pagano's *Casabella* praised the advanced techniques used in the station's roof as well as the speed and efficiency of construction.[15]

Beyond the new station's style and techniques of construction, Ostiense represented Mussolini's desire to have his own new grand point of entry for Hitler and subsequent high-profile visitors. It signified yet again the reshaping of Rome to suit the purposes of fascism. The Ostiense station "will permit illustrious guests to make an entrance into Rome within the impressive area of [new] construction: the Via Imperiale, the Via dei Trionfi and Via dell'Impero, thus being carried immediately into contact with the major monuments of Imperial Romanità" that were part of Rome's development toward the sea.[16]

King Victor Emmanuel, Mussolini, and top fascist officials greeted Hitler and his entourage on the train platform. The newsreel of the event captures the many fascist salutes, except for the king, who used the traditional military version. The principals strutted about bowing, raising their arms, and putting on quite a show. The scene invited parody, which was exactly what it got in Charlie Chaplin's 1940 movie, *The Great Dictator,* with Chaplin as Hitler and Jack Oakie as Mussolini.

The motorcade made its way from the station onto the new Viale Adolfo Hitler, up the Viale Aventino, renamed that year the Viale Africa, past the Circus Maximus, up the Via Trionfi past the Arch of Constantine and the Colosseum, then down the Via dell'Impero to the Piazza Venezia and, finally, to the royal palace on the Quirinal Hill. This route took Hitler right through the heart of the historic center newly transformed by Mussolini. It was, in the words of the *New York Times,* "a spectacle to remember." "For Chancellor Adolf Hitler's arrival a whole section of Rome, stretching across the city, had been transformed. Along the three-mile route that he traveled from the new railroad station built for him to the King's palace, ruins of the past were floodlighted to enclose a modern phantasy of white pillars and gilded symbols of fascism and nazism. There were illuminated fountains, huge pylons spouting flames and everywhere flags without end—banners of Germany, of Italy and of Rome."[17]

Protocol required that the king, as head of state, host Hitler, also head of state, upon his arrival. The head of government, Benito Mussolini left the station by private car for home,[18] just one more annoyance of having to defer to

the monarch. Protocol having been satisfied, Mussolini then accompanied Hitler for the remainder of his visit.

American seminarian Philip Hannan stayed indoors during Hitler's visit "to avoid being one of the rabble welcoming Hitler." Nevertheless, he and his friends had definite opinions about the reaction of Romans to the Führer: "The people are definitely 'griped' at the huge outlay of money for [Hitler's] welcome. So whenever Hitler and Mussolini appear, they get a hand, but everybody knows that it is for Mussolini; the first time that Hitler rode into Rome he was accompanied by the King—Mussolini was not with him—and all the people yelled the old, familiar, 'Duce, Duce.' There was no individual yelling for Hitler."[19]

On May 6 the great parade in Hitler's honor took place. Hitler, Goebbels, Hess, von Ribbentrop, and other Nazi officials joined the king and queen, Mussolini, Ciano, and other fascist leaders on the flag-draped reviewing stand on the Via dei Trionfi. The parade took two hours, as youth, military, and party units marched by. Many of the military units used the goosestep, recently introduced by Mussolini and called the Roman step, *passo romano.* "Perhaps 50,000 persons watched the review. Hitler, when he appeared with the King, was received with cordial, but not overwhelming cheers and much of the cheering was for the King. But when Mussolini joined them there was a roar that completely drowned out the previous mild acclaim."[20]

Following the parade and lunch at the German Embassy, Hitler visited the Augustan Exhibit on the Via Nazionale, "illustrating the various phases of the political, economic and social life of the Roman Empire." The day ended with an open-air concert at the Villa Borghese Park given in Hitler's honor, with 100,000 people in attendance.[21]

It had been a very special day for Rome, and the two leaders who were drawing their two nations ever more closely together. Two days later, Hitler and Mussolini reviewed youth and athletic groups at the Foro Mussolini. Here was fascist Rome, Mussolini's Rome, on display to impress the Führer of Nazi Germany. The fascist regime boasted of a Rome bedecked with flags, Roma *pavesata,* which demonstrated the "consensus that surrounds and that sustains the totalitarian regimes, when they are solidly founded on social justice, on quiet and hard-working discipline." The peoples of Italy and Germany stood united by two ideologies that in their different ways "tended toward a single end, the defense and empowerment of the civilization of Europe and the world."[22]

As previously mentioned, Ettore Scola's 1977 film *Una Giornata Particolare,* released for English-speaking audiences as *A Special Day,* dramatically captures this moment in the history of Mussolini's Italy. It opens with newsreel shots of

Hitler's train greeted by great crowds as it moves through Italy, the arrival at the Ostiense station, a ceremony at the Victor Emmanuel Monument, and the motorcade to the Quirinal Palace.

The rest of the film takes place in an apartment complex recently built on the Viale XXI Aprile for state employees.[23] Sophia Loren plays the wife of a minor fascist official and the mother of their six children. Early that morning, she rouses the family so that her husband and the children can put on their various fascist uniforms and go to the big parade in honor of Hitler. They and nearly all the residents of the apartment complex flood the courtyard and stream out for the special day. Left behind, Sophia Loren, as Antoinetta, has an encounter with a radio commentator, played by Marcello Mastroianni. The only other person around is the snooping concierge, who sits in the courtyard with the radio blaring the account of the parade. While portraying that day, the film artfully explores the weight of fascism's repression and conformity, particularly for women, homosexuals, and "deviants" of any kind.

The day after the parade, Mussolini hosted Hitler at a rally before 35,000 people at the Stadio Olimpico in the Foro Mussolini. The occasion allowed the Duce to show off both the *foro* and the latest techniques of dramatic lighting that the Nazis favored in their own rallies in Germany. The show included massed formations of uniformed members of the Gioventù Italiana del Littorio forming a huge *M* and then a swastika in the Olympic Stadium.[24]

TERMINI STATION

The Ostiense station was but one example of the many train stations constructed by the fascist regime. The passenger train, after all, symbolized modern, fast travel, and rail networks had played a key role in bringing economic and political unity to many nations. "Mussolini made the trains run on time" summed up the fascist claim that the Duce's government had made modern efficiency part of the new Italy. Train stations, by definition, had no traditional architectural style, so a variety of styles competed for contracts. The Santa Maria Novella station in Florence, opened in 1935, had been a victory for a modern, rationalist approach that Giuseppe Pagano applauded.

The regime also initiated a plan, E'42, for linking the historic center from the Termini train station to the Lido and a new section now known as EUR, for the Esposizione Universale di Roma, originally scheduled for 1942 in celebration of the twentieth anniversary of the March on Rome. The line from EUR to the Ostiense station would be above ground. From Ostiense to Termini it would

go underground and follow a route from the Piramide, the Viale Aventino, the Coliseum, San Pietro in Vincoli, and the Via Cavour.[25] The new rail line would accommodate the anticipated influx of visitors and tourists in 1942 and would continue to serve beyond that date because the universal exposition was not designed to be a temporary world's fair but a new city with a permanent role in the development of Rome. The plan called for two stations in the EUR section.[26] Some construction began, but the war soon interrupted the work. The line completed after the war is now the Linea B of Rome's metro system.

In Rome, the main station, Stazione Termini, awaited a decision for the design of a new and expanded version of the original. The Piano Regolatore of 1931 called for changing the location of the main train station and development of the city in northerly and easterly directions. Mussolini's decision to develop toward the south with the E'42 project changed all that. Once the Duce decided on the "placement of the World Exposition of 1942 and the development of Rome toward the Sea," he then called for the rebuilding rather than the relocating of Termini. According to the regime, this decision was "the most important in many centuries to be adopted in regard to the future of Rome."[27] The construction of the Ostiense station in 1938 fit into the new plan to develop toward the south and the sea. The next step was the transformation of the main terminal.

The origins of the Termini Station go back to the papal Rome of Pius IX. Work began in 1867 and proceeded at a slow pace. It came to a halt in September 1870, with the seizure of Rome from Pius by the new Italian state. Work began again in 1871 and was finished in 1873.[28] Subsequently there were various plans put forward to develop a new series of railway stations to fit the development and growth of the city. After World War I, it appeared likely that Termini would be relocated to Porta Maggiore. The assumption behind such thinking was that Rome would expand toward the north and the east. The Piano Regolatore then foresaw two new stations, one north and the other south, with Termini becoming "an underground transit" station,[29] but all planning now shifted to rebuilding Termini as the centerpiece of the city's rail system.

Angiolo Mazzoni won the commission to design the new station. He held the position of head of the architectural section of the Italian state railway system, the Ferrovie dello Stato.[30] Mazzoni had designed a number of railroad stations for the regime throughout Italy, including Montecatini, Messina, Siena, and Littoria (now Latina), as well as post offices in Ostia, Sabaudia, Littoria, and Palermo. His first design in 1936 featured a long horizontal structure with ample use of glass set on pillars over an open atrium that led out to the Piazza Cinquecento. This interesting and rather subtle approach did not, however, win

favor, for it became clear that Termini would have to function as a gateway to Mussolini's new imperial Rome. Mazzoni's second plan in 1938 won acceptance. The glass disappeared, and the open atrium now had an imperial character constructed with Carrara marble stretching more than two hundred meters in length and supported by columns of eighteen meters each.[31]

Construction of the new station came to a halt in 1942 before work had begun on Mazzoni's columned portico. Between 1939 and 1942 considerable work was accomplished on the arcaded sides of the station on the Via Marsala and Viale Principe di Piemonte according to Mazzoni's design.[32] The plan included moving the entrance to the station about two hundred meters to expand the size of the Piazza dei Cinquecento. The adjacent streets grew wider as well.

These changes improved the flow of traffic, but the driving force came from Mussolini's imperial vision of fascist Rome. He wanted fascist Rome to have large spaces, giving the impression of power and authority. Mussolini made the decision to design an exit from the station onto this new grand space. In Mazzoni's plan, the entrance had been situated around the corner on the Viale Principe di Piemonte, today's Via Giovanni Giolitti. Mussolini had in mind the effect on travelers as they came out of the station onto this "Piazza grandiose."[33]

The Piazza dei Cinquecento commemorated the five hundred soldiers who fell at the battle of Dogali in 1887, an Italian setback in its initial campaign to conquer Ethiopia. The nearby monument dates from 1924.[34] The streets and piazzas nearby bore names recalling the events and battles of the Risorgimento, unification, and the new Italy: Via Nazionale, Via Cavour, and Via Marsala, the seacoast town in Sicily where Garibaldi landed with his one thousand volunteers, an event also recalled by the Via dei Mille (Street of the Thousand). Via Solferino and Via San Martino were named after two of the principal battles leading to the declaration of the kingdom of Italy in 1861. The construction of the new Termini station and the reconfiguration of the piazza and the streets constituted another self-conscious effort of the regime to tie fascism to Italian nationalism and to articulate fascism's fulfillment of the Risorgimento and unification.

Termini lay close to the new University City. Therefore it was important to connect the two with good streets that conveyed clear fascist messages. For example, the Via Solferino connected the Piazza dei Cinquecento to the Piazza Independenza. The latter had undergone its own reconstruction, which gave it an unmistakable fascist stamp. Several of the office and apartment buildings in the piazza arose during the mid-1930s. The most striking fascist construction was the building on the southwest corner, opened on April 21, 1938, as the House

of the Marshals of Italy, La Casa dei Marescialli d'Italia.[35] Its survival to this day serves as a remarkable testament to Mussolini's Rome. Over each window on the second floor the helmeted face of the Duce looks out over the square. Although Italy had two Marshals of Italy, King Victor Emmanuel III and Mussolini, it is the visage of the latter that decorates the building. [36]

Beyond the Duce's countenance on the Via San Martino della Battaglia was the rather plain but unmistakably fascist Istituto Magistrale Alfredo Oriani. Oriani (1852–1909) wrote novels with nationalist themes and rhetoric favored by Mussolini. When Allied troops raided Mussolini's headquarters on Lake Garda the day after he was shot in April 1945, they found among his private papers the manuscript of an unpublished novel of Oriani's.[37] The Via San Martino della Battaglia led to the Viale Castro Pretorio to the Air Force Ministry, the Ministero Aeronautica, and the university. Roberto Marino designed the Air Ministry, which opened in 1931. Its style is similar to the Ministry of the Navy, Ministero della Marina, built on the Tiber in 1929. These two ministries contrasted markedly with Marcello Piacentini's more grandiose and "fascist" style Ministry of Corporations on the Via Veneto, opened on November 30, 1932.

The reconstruction of Termini and its reaffirmation as Rome's central train station thus deviated from the Piano Regolatore of 1931 but followed logically from Mussolini's decision to develop Rome to the south and the sea. The planners boasted that the new location offered the perfect balance for the city's development: "The zone chosen, immediately outside the limits of the 1931 Town Plan of the City and already grazed by the urban expansion, lies about seven chilometres from Piazza Venezia, at about the same distance from this as the Mussolini Forum, and in this it represents the obvious balancing by the expansion of Rome on the seaward side."[38]

EUR

Key to Mussolini's new plan for the city was the development of yet another fascist "city" celebrating the Ventennale, or twentieth anniversary of the March on Rome, in 1942. The E'42 project for the Esposizione Universale di Roma (EUR) would build a truly fascist complex of buildings and spaces that would not disappear like the exhibitions in the Circus Maximus or such international shows as New York's World's Fair of 1939–40. From the beginning, the intention was to create a new quarter of Rome consistent with fascist Rome's new status as the center of the new Italy's new fascist empire.

6.2 La Casa dei Marescialli d'Italia (now the Consiglio Superiore della Magistratura), Piazza
Independenza, 2000

Piacentini's monthly publication *Architettura* spelled out the ideas animating the new project in a 1938 special edition that included text in English, German, and French as well as Italian. Mussolini, of course, took full credit for the original conception of EUR:

The idea of holding a General International Exhibition (that is, Universal, representative of all peoples and interests) in Rome in the year 1942 was not conceived by the Duce in June 1936, when, as it is known, the official request was made, but in the Spring of 1935-XIII E[ra] F[ascista], when the Abyssinian War was at its height, sanctions weighed upon Italy, and the future was very uncertain in the minds of many but not in that of the Duce. "It is in a letter dated June 23rd, 1935-XIII," *writes H. E. Giuseppe Bottai, Minister of National Education,* "that the Duce gives the order to obtain a concrete international adherence to his idea. Victory in Abyssinia, the affirmation of the Italian will in the world, the Foundation of an Empire, are all certainties for him, so that he is able to anticipate the celebration of them with mathematical security."[39]

The articles in this special edition went on to explain how the planners considered various areas of the city but concluded that only an open area that allowed for a wholly new start would be sufficient. "The sensation of the renewed Italian spirit could only be given by an organism created and realized as a whole, with a plan and vision of its own." The zone to the south, known as the Tre Fontane, offered the best site for this ambitious plan. "From its birth it is essentially *permanent* in character, in contrast to all other world exhibitions, which have been ephemeral in character and have disappeared after the manifestation had attained its end."[40]

Mussolini appointed Senator Vittorio Cini president of the E'42 corporation, and Marcello Piacentini chief architect. Piacentini included Giuseppe Pagano in his original group. Pagano expected a result similar to that of the Città Universitaria, which would favor his approach to modern architecture and avoid the monumentality he opposed, but he suffered a disappointment. Piacentini held a much stronger position in EUR's development than he had in planning the university complex. The first plan, Plan A, for EUR did have Pagano's participation and approval, but that plan was set aside for Plan B, which was much less satisfactory, from his point of view.

Piacentini supported an eclectic approach that allowed for the traditional and academic styles that linked the modern with Italy's and Rome's past. That approach included the more monumental direction that Pagano then criticized in vain in the pages of his architectural review, *Casabella.*[41] Pagano complained in a 1938 article that such monumentality risked losing contact with reality and falling into rhetorical and academic conventions that took art down rather than

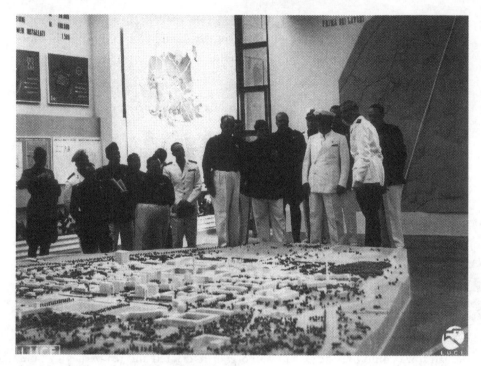

6.3 Mussolini views the model for E'42 (EUR), 1938

up.[42] By 1941 he openly attacked Piacentini and his followers in an article enti-
tled "Can we save ourselves from false traditions and monumental obsessions?"[43]

Despite this setback for Pagano and his sympathizers, Mussolini's support
for Piacentini did not mean that the regime explicitly repudiated any particular
style. Nevertheless, Pagano's dream of receiving the Duce's definitive support for
the modern style never became a reality. EUR demonstrated the regime's latest
version of aesthetic pluralism. Pagano's *Casabella* continued publishing articles
critical of the final plan for EUR, while Piacentini's *Architettura* faithfully re-
ported favorably on all the projects of the regime, including EUR.

Among the first buildings constructed was the Palazzo della Civiltà Italiana,
soon nicknamed the "Colosseo Quadrato," the "Square Colosseum," because of
its six stories of arches. The architects were Giovanni Guerrini, Ernesto La
Padula, and Mario Romano.[44] It remains to this day as the signature building
for EUR. The inscription running across the top of the building celebrated "A
People of Poets, Artists, Saints, Thinkers, Scientists, Sailors, Explorers." It stands
at one end of an axis with the Palace of Congresses (Palazzo dei Congressi) at
the other. Adalberto Libera designed the latter, completed only after the war,

HISTORIC CENTER AND E'42 (EUR)

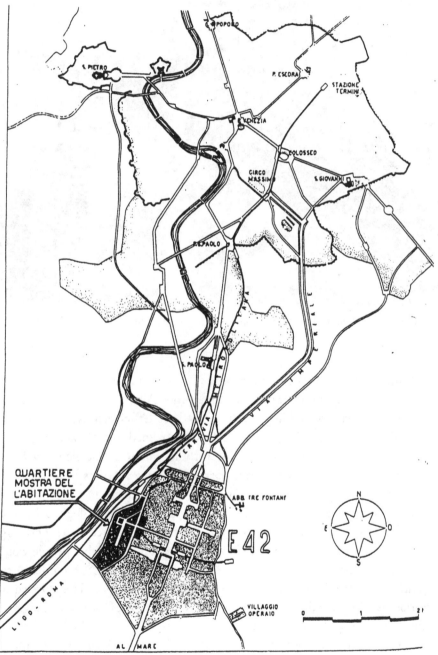

LA ZONA OVE STA SORGENDO L'E 42 CON I SUOI COLLEGAMENTI CON LA CITTA'

From *Capitolium,* 1939, p. 374

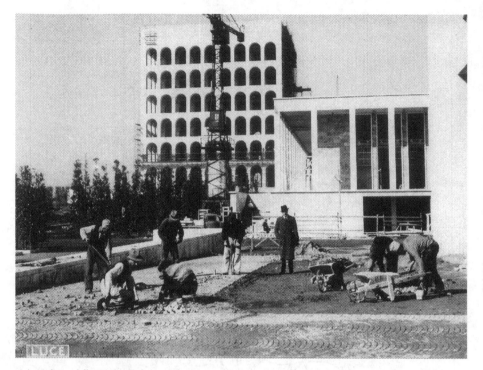

6.4 Palazzo della Civiltà Italiano, (The "Square Coliseum"), EUR, 1940

which today finds constant use for large meetings and exhibits. Artist Achille Funi painted a large mural for the atrium entitled All Roads Lead to Rome.[45]

The headquarters building, the Palazzo degli Uffici dell'Esposizione Universale di Roma, designed by Gaetano Minucci, opened in 1937 and stood next to the Square Colosseum. The building included many of the elements found throughout Mussolini's Rome: clean horizontal lines, columns in an arcade, a statement chiseled prominently on one side, mosaics in front, fountains and a statue of a large muscular athlete at the far end. The Palazzo degli Uffici provided the quasi-independent corporation with ample office space and large meeting rooms. Minnucci stated that he designed a building that people would recognize as "a palazzo of Rome, in the time of Mussolini."[46] A model of the original plan, Plan A, remains today just inside the entrance. The chiseled inscription over the arcade facing the fountains and mosaics speaks of the glories of the Third Rome, la Terza Roma.

The covered entrance to the *L*-shaped building contained a large sculpted tablet of travertine marble by Publio Morbiducci. It portrayed the history of the building of Rome, beginning at the top and working its way down to the door.

The viewer saw Romulus and Remus at the top and various scenes of Roman history, such as the Roman Empire, the papacy and St. Peter's, Garibaldi and unification, culminating in Mussolini's Rome, symbolized by the Duce on a horse with his arm outstretched in the fascist salute. This remarkable piece survives to this day as a example of fascist *romanità* with Mussolini the triumphant embodiment of Roman and Italian history.[47]

Other state buildings constructed before the war included the National Social Security building and several museums, including the Museum of Folk Art and Traditions and the Museum of Prehistoric Ethnography. The largest of the museums was the Museum of Roman Civilization, il Museo della Civiltà Romana. The items in the museum came from the exhibit celebrating the bimillenium of the Emperor Augustus, la Mostra Augustea della Romanità, held in 1937 and 1938 in the Palazzo delle Esposizioni on the Via Nazionale. The pieces of the collection were reconstructions and copies of Roman art and architecture throughout the Empire. A large model, or *plastico,* on a scale of 1:250, depicted Rome during the reign of the Emperor Constantine. The museum and the collection remain open today. The *plastico* is periodically revised according the latest historical and archeological information. Photographers regularly use this fascist artifact to shoot pictures featured in tourist books showing what Rome looked like at the height of the Empire.

Another large columned building, just south of the Museo della Civiltà Romana, housed offices of the Italian army and today is the Archivio Centrale dello Stato, which contains the main historical collections of the Italian government, especially documents pertaining to modern Italy, including the fascist period. The building faces the long axis of the Viale Europa, culminating with the church of Saints Peter and Paul at the highest point of the zone. The centrally designed church is modest in size but with a relatively large and imposing dome easily visible for some distance.

The open space and the broad axial avenues of EUR were precisely what made it so different from the historic center. It exudes an architectural message of authority and power. The construction completed before the war represented only a fragment of what the regime had in mind. Plans called for an amphitheater, cinema, and additional museums. Nevertheless, the original buildings remain as primary historical artifacts of fascism's projected image.

The original Plan A included a large arch, spanning the avenue that connected the historic center to the new zone, at the entrance of EUR. Designed by Adalberto Libera, it bore a striking resemblance to the one now standing in St. Louis, Missouri. The technical challenge of building the arch proved too great for the 1930s, and the planners eliminated it.[48]

THE VIALE AFRICA AND THE VIA IMPERIALE

The Viale Aventino ran from the Via Marmorata to the Circus Maximus and the Piazza di Porta Capena. The Governatorato widened it in 1934, and by 1938 new office and apartment buildings appeared. In 1938, the renaming of the Viale Aventino as the Viale Africa fit in with the regime's wish to make this entire area a tribute to the new fascist empire. In 1939, Mussolini opened the new Cestio Park (Parco Cestio), named for the Piramide Cestio, behind the Aventine post office, at the Porta San Paolo.[49] The space at the apex of the tri-angular park became the Piazza Albania to commemorate the incorporation of Albania into Mussolini's empire in 1939. An equestrian statue to the fifteenth-century Albanian warrior hero Giorgio Scanderberg was designed by Romano Romanelli and unveiled by Mussolini in 1940 in the new piazza adjacent to the tram line. The monument thus took its place in "a zone exceedingly suggestive and important" for Mussolini's Rome.[50]

The broad new street planned to connect the historic center with the new zone was the Via Imperiale. It began at the Circus Maximus, and continued past the Baths of Caracalla, through the third-century Aurelian Wall, to EUR and the sea. The point of departure was at the intersection of the Circus Maximus, the Via dei Trionfi, and the Viale Africa. It would be the "greatest road of Rome and of Italy and, if taking into account the historic area it goes through, the greatest street in the world."[51]

In 1939, the regime held a contest for designing a new Ministry of Italian Africa. The winning design by a team of architects and engineers was announced in 1938, and construction began August 31. The location at this key intersec-tion trumpeted the new fascist empire and its connection to "the complex mon-uments recalling the imperial pomp [*fasti*] [of Rome]."[52] The entrance faced the new Via Imperiale and looked directly at the Obelisk of Axum, installed at the Piazza di Porta Capena. Taken from Ethiopia in March 1937 and shipped to Rome, it assumed its new place in October as part of the celebrations of the fif-teenth anniversary of the March on Rome. The sixteen-hundred-year-old obelisk soared eighty feet into the sky and weighed about two hundred tons. The completion of the Ministero dell'Africa Italiana came only after the war. In 1950, it became and remains today the headquarters of the United Nations Food and Agricultural Organization (FAO).

On October 28, 1938, Mussolini opened the first stretch of the Via Imper-iale, which extended to the Baths of Caracalla and through four arches cut into the Aurelian Wall a kilometer away. The new street would facilitate the plans to

develop Rome to the south and sea. Right up to the outbreak of the war, the regime looked forward to a great influx of visitors for E'42. In order to provide proper fascist hospitality, the Via Imperiale would provide hotels, campsites, restaurants, and other facilities for those arriving by car and bus.

The first stretch of the Via Imperiale replaced the Parco Porta Capena, or Passeggiata Archeologica, created between 1911 and 1913.[53] Guido Baccelli was the driving force behind this project. Baccelli (1830–1916) came from a prominent Roman family and gained a national reputation as a doctor, minister of public instruction, and an amateur archaeologist. Mussolini backed a successful campaign to erect a monument in his honor, which was unveiled in 1931 on the Piazza Salerno in the Nomentana quarter.[54] The work on the Via Imperiale in 1938 required repositioning the street named for him, which now intersected with the Viale Giotto on the little Aventine and snaked down the slope, past the Campo Sportivo Guardabassi, to the Via Imperiale.[55]

A new airport at Magliana for both sea- and land-based aircraft would provide access to EUR for air travelers, and the proposed metro would bring visitors from the center of Rome. In February 1937, the *New York Times* reported that "Mussolini Starts Work On Italy's First Subway," with the expectation that it would be ready by 1941 to serve "the thousands of visitors Rome hopes to attract at that time for its world exposition. Five thousand workers will be employed on the project."[56] Once there, visitors to EUR would find everything from the latest technology in cinema, radio, and television, to entertainment for children. Above all, these thousands of visitors and tourists would experience the new Rome of Mussolini.[57] The multilane Via Imperiale assumed its current name, Via Cristoforo Colombo, in 1948.

VIA XXIII MARZO AND THE VIA NOMENTANA

The metro, the Via Imperiale, and the E'42 projects, vast and expensive as they were, did not stop the regime from making important changes in Rome itself. Demolition and new construction continued. In 1940, to celebrate the twenty-first anniversary of the founding of the fascist movement on March 23, 1919, Mussolini inaugurated work on the new Via XXIII Marzo, today the Via Bissolati, which began at the Piazza San Bernardo on the Via XX Settembre, between the churches of Santa Sussanna and Santa Maria della Vittoria, and would end at the Ministry of Corporations on the Via Veneto, opened in 1932. Once again, many buildings fell to the *piccone* as demolition cleared the way for new streets and massive new buildings.[58]

This project took place within the city's center but in a neighborhood largely built in the nineteenth century, after unification. The Via XX Settembre ends at the Porta Pia of the Aurelian Wall and then continues as the Via Nomentana. The street's name commemorated the seizure of Rome by Italian troops who overwhelmed papal forces at the Porta Pia on September 20, 1870. The fascist addition came in 1932 in the form of the large monument to the Bersaglieri troops who stormed into Rome on that historic occasion. The architect Italo Mancini designed and sculptor Publio Morbiducci executed the monument of the running Bersagliere. The Historical Museum of the Bersaglieri, the Museo Storico dei Bersaglieri, opened there at the same time as did the monument.

In the decades following 1870, construction of new apartments and government buildings created the Nomentana neighborhood that symbolized the newly unified nation and the new historical role for Rome as Italy's capital, the third Rome. The neighborhood also became the home of Mussolini and his family. Several blocks beyond the Porta Pia on the Via Nomentana stood the Villa Torlonia, built in the nineteenth century. The Torlonia family offered Mussolini the villa for his family residence. Here the Duce, his wife Rachele, and their five children lived during the years of the regime. Many photographs of the period depicted Mussolini as family man, husband, and father on the grounds of the villa. In 1930, it was the site of the wedding reception of his oldest child, Etta, and her husband Galeazzo Ciano, son and heir of Count Constanzo Ciano, an early supporter of Mussolini. The young Ciano went on to hold several positions in his father-in-law's government, culminating in his appointment as minister of foreign affairs in 1936 at the age of thirty-three.[59] The ample grounds surrounding the villa provided the backdrop for numerous photographs of the Duce playing tennis, riding his horse, playing with lion cubs, and engaging in other activities demonstrating his strength, courage, and physical prowess.

The Governatorato opened a park across the street from the Villa Torlonia on April 21, 1934. Creating parks was a continual activity of the fascist regime. It provided Romans with green spaces that would encourage outdoor activities in keeping with the emphasis on fresh air as a vital part of good health. In this case, the city acquired the run-down Villa Paganini Alberoni, which it then repaired, transforming the grounds into a public park. Shortly after the opening, it added a monument to soldiers from the neighborhood fallen in the Great War.[60]

What better way, then, for Mussolini to put his fascist movement on the same level as the Risorgimento, Italian unification, and mark Rome as the new capital than to have March 23 commemorated adjacent to September 20? In-

deed, the regime made the claim that thanks to its efforts, "Rome has become the true capital of Italy that the great [leaders] of our Risorgimento had dreamed."[61] When the Duce inaugurated the new Via XXIII Marzo on the twenty-first anniversary of the fascist movement, he took another step in Rome's transformation "according to the by now famous Mussolinian distinction, as a work of necessity."[62]

The new street, according to the regime, vastly improved the flow of traffic from the area of the Termini Station across the city to the Prati district near the Vatican and the area of the Via Flaminia. The Piano Regolatore of 1931 called for such a street in this area for cross-town traffic. Of course, the project also created "12,000 work days" for laborers. This modern construction of "necessity" also managed to preserve historic pieces of Rome, such as some ruins of the old Servian Wall, and thus associate twenty-five centuries of history with the "new imposing Mussolinian Rome [that] will be by their contrast a testimony to the continuity of the City through time."[63]

The Via XXIII Marzo began on the Via XX Settembre between the churches of Santa Susanna and Santa Maria della Vittoria, home of Bernini's famous Saint Teresa in Ecstasy. The street pattern just to the north of Santa Maria della Vittoria remained unchanged, but several notable buildings arose in the late 1930s in that neighborhood. The Montecatini chemical company's Rome offices stood on the corner of the Via Salandra and the Via Flavia. The triangular-shaped building incorporated a number of sculptured reliefs. In the rear, a fragment of the Servian Wall stood exposed in a space under the building. Across the street was the new Ministry of Agriculture.

The Via XXIII Marzo itself ran over to the Via Veneto. Branching off to the left was another new street, the Via Regina Elena, now the Via Barberini, which went to the Piazza Barberini. Both streets were lined with new buildings. The FIAT building at the Largo Santa Susanna has an unmistakably fascist look, although it was completed after the war. The new buildings beyond that point, with their windows, brickwork, and occasional arcades, bore the familiar marks of office and apartment buildings of the late 1930s. The National Institute of Insurance building, the Palazzo dell'Istituto Nazionale delle Assicurzioni (INA) on the Via XXIII Marzo, dates from 1928, and Marcello Piacentini's Banco del Lavoro was built in 1934.[64]

These buildings had more floors, usually six or seven, than typically found in buildings in the historic center. Thus the number and size of these buildings stand out in this neighborhood that remains today as an obviously fascist-era area within the Aurelian Wall. The red brick of most of these imposing buildings mimicked the brickwork of ancient Rome. The windows were framed by

travertine, and arcades were often located on the top floor. Piacentini used an-
cient Roman models to create a fascist and Italian modernism at variance with
Pagano's rational, functional modernism, which lacked any clearly traditional
Italian models. These buildings exemplified the triumph of a nationalist over an
internationalist style. The style typified fascist buildings throughout the city.

The Via Regina Elena led into the Piazza Barberini at the foot of the Via
Veneto. Bernini's fountain in the piazza faced the Hotel Bristol, dating from the
late nineteenth century, a period despised by the fascists as a time of decadence
and fragmentation in the nation. The new work provided the opportunity to de-
molish the hotel in favor of a new Bristol in the same style dominating the new
fascist-era neighborhood. Just up the street from the Piazza Barberini on the
sloping Via delle Quattro Fontane was the historic corner of the Quattro
Fontane at the intersection with the Via XX Settembre. Borromeo's quintessen-
tially Baroque church of San Carlo alle Quattro Fontane faced the Via XX Set-
tembre on the southeast corner. Even in this most Baroque of places in Rome
there appeared a major building of the fascist era. In 1937 Vittorio Morpurgo
designed the building diagonally across the street from San Carlo. He incorpo-
rated Renaissance elements in the two portals, one on the Via XX Settembre and
the other on the slope of the Via Quattro Fontane.[65]

MOSTRA DELLA RIVOLUZIONE FASCISTA
1942–1943

Even after Italy's entry into the war on June 10, 1940, the fascist transformation
of the Eternal City continued. Gradually the need to mobilize the war effort led
to the cessation of construction on such major projects as the Via della Concil-
iazione, EUR, the Termini Station, the metro line and the Fascist Party head-
quarters at the Foro Mussolini. By 1942, virtually all work had stopped. Yet one
project went forward that offers one last glimpse into fascist self-perception and
Mussolini's attempt to define his fascist revolution. Considerable effort and ex-
pense went into mounting the third and final version of the Mostra della Rivo-
luzione Fascista (MRF).

The first and second versions had appeared from 1932 to 1934 and from
1937 to 1940. As with the earlier versions, the exhibit embodied the messages
Mussolini and his regime wished to send forth about the historical significance
of fascism, the nature of its revolution, and the role of Rome and *romanità*.

The final version of the Exhibition of the Fascist Revolution opened on Oc-
tober 28, 1942 in the National Gallery of Modern Art, la Galleria Nazionale

dell'Arte Moderna.[66] It celebrated the twentieth anniversary of the regime. The war prevented Rome's sponsorship of the Esposizione Unviversale di Roma, but it did not stop this exhibition's celebration of the anniversary and its meaning for history. In fact, the exhibit offered an opportunity to convince the public that fascist Italy would achieve victory.

Although occupying the same space as the 1937 version, this new exhibit had quite a different design. The second version had been a rather unimaginative recycling of the original 1932 show with some additions, whereas this final version had a fresh design. Rooms took various shapes and forms, many with curved and rounded spaces rather than flat walls, and the rooms possessed greater coherence of design elements. There were, for example, strong horizontal and vertical lines in some rooms, while others had circular or semicircular shapes, and in many, black and white contrasts stood out with added emphasis from strong, and no doubt expensive, illumination.

The messages of the 1942 exhibition emerged clearly enough. The war dominated, and all pieces suggested the theme that Italy would yet win the war. "We Will Win," "*Vinceremo,*" was the military slogan reiterated in the show. Of particular interest, beyond the emphasis on victory, were the new rooms and the messages conveyed in them. Wartime conditions made travel to Rome nearly impossible for most Italians, so the visitors were mostly residents of Rome and Lazio as well as a smattering of foreign dignitaries, given the tour by party officials.

All the rooms were new in design if not in content. For example, the first large space beyond the atrium was dedicated to Mussolini. It had the strong horizontal lines in a black and white motif that characterized most of the rooms. Along the walls, brightly lit *M*-shaped display cases carried Mussolini's messages. The following rooms, which covered the same subjects as earlier versions, such as World War I, the threat of bolshevism, the Fascist Party, *Il Popolo d'Italia,* the fascist squads, the fascist fallen, and the March on Rome, had similar new configurations. The room on the squads had white walls with black horizontal strips running across and stark white death's head skulls repeated with them. It housed a huge painting romanticizing the *squadristi* carrying their trademark club, the *manganello,* going about their mission of saving Italy from chaos and subversion.

The second half of the exhibit not only had new design motifs but a number of new rooms as well. Here Romans saw, for the last time, fascism's definition of itself and its place in history. The final section, called the "second time," *il secondo tempo,* introduced the new rooms that both explained the significance of fascism and encouraged the belief that fascism must triumph in the current struggle against bolshevism and the plutocratic powers. Fascism at war meant an

emphasis on fascism as revolutionary and totalitarian.[67] In retrospect, the self-delusion of the regime is clear enough, but considerable time, talent, and treasure went into the design and execution of the final Mostra della Rivoluzione Fascista.

Several rooms celebrated the new institutions and accomplishments of the regime. One displayed flags, banners, and weapons taken from the enemy in combat, while another tried to explain the reasons for the current war. Anti-Semitism had great prominence. It had first appeared in the revised version of the second exhibit in 1938. Now it emerged in full-blown form. The room dedicated to Judaism and Masonry, l'Ebraismo e la Massoneria, vividly depicted the Jewish menace in photographs, caricatures, and slogans. That menace was, of course, linked to the bolshevik threat as well. In case anyone had missed the point, the racial theme was incorporated into the new room on cinema and films.

La Sala del Cinema had a particular fascination for Americans because it juxtaposed still shots of American and a few English films on one side of the room with shots of Italian films on the opposite wall. Gary Cooper, David Niven, Broderick Crawford, Spencer Tracy, Fred MacMurray, Dick Powell, Ruby Keeler, and other Hollywood stars of the 1930s found themselves playing newly assigned roles in a fascist propaganda script. What the eighteen promotional stills had in common was military men—soldiers and sailors—looking silly, looking anything but warlike. To the Roman audience, such fools and clowns could not be taken seriously. Certainly these buffoons could not win a war in combat with the brave and resolute fascist heroes facing them from the other side.

Dick Powell in a West Point uniform faced Ruby Keeler in a white drum-majorette outfit holding a rifle. The shot came from the 1934 musical *Flirtation Walk,* (Warner Brothers), which was "set mainly in West Point Academy and focused on the tentative, naïve romance" between Powell and Keeler.[68] Spencer Tracy lay flat on his stomach, in army uniform, with a rifle under him and looking thoroughly confused on a firing range. The film, *They Gave Him a Gun* (MGM, 1934), had Tracy playing a young weakling who got drafted, learned how to use a gun, became a wartime hero, and then returned to civilian life as a gangster. Another photo showed Virginia Bruce tweaking the chin of a smirking Raymond Walburn, decked out in his dress-white naval uniform as Captain Dinghy in the 1936 musical *Born to Dance.* Captain Dinghy's benign and bemused expression showed not a trace of the bellicose spirit it takes to win wars.[69]

The room may well strike us today as laughable, but less amusing are the dark racial themes present. A large photograph showed dejected, defeated black

French colonial troops captured by the Germans in the French defeat of 1940. It bore the title "Grande Illusione," no doubt an ironic reference to the famous film. At the far end of the room, a large panel featured four rows of five photographs each. The first and third rows showed Roman faces of antiquity and under each a photograph of a modern Italian who resembled the Roman face above it. The room thus offered a visual presentation of the regime's 1938 racial laws emphasizing a newly discovered purity in the Italian "race," descended from the Romans and now under threat from Jews, blacks, and other inferiors. It also fit the contemporaneous campaign to ban foreign films and the influence of Hollywood on Italian cinema. American films, according to the official view, emerged from a Jewish "ideology."[70]

The exhibit closed with a large circular room dedicated to the "Current War" with the slogan *Vinceremo* running all the way around the circle. On the way out, visitors went through a small gallery dedicated to fascist war heroes. Although attendance was modest, it was greater than the second version of the exhibition. The Tourist Information Office in Rome claimed that seventy thousand visitors came in the first twenty days.[71] *Il Popolo d'Italia* stated that about one thousand visitors a day attended.[72] We cannot corroborate the numbers issued by the regime and its controlled press; nevertheless, newspaper accounts report a steady stream of school and party groups brought to the exhibit. It is also conceivable that wartime Rome offered few diversions and that a free exhibit housed in the midst of the Borghese Gardens would draw regular visitors.

This third version of the exhibit was intended to be permanent. When it opened in October 1942, Italians might still hope for a victorious conclusion of the war, but such hopes were dashed by defeats at El Alamein and Stalingrad. On the night of July 24–25, 1943, dissident fascists in league with the king ousted Mussolini, and the new government under Marshal Badoglio sought a way out of the war. The Mostra would close its doors amidst the fall of fascism and the defeat of Italy. Mussolini's Rome now entered its final and most bitter phase. The dream of national unity and imperial power gave way to the nightmare of defeat, the humiliation of occupation, and the loss of and search for a new national identity.

Seven

WAR AND RESISTANCE

The construction boom in Rome and the surrounding Agro Pontino slowed and then came to a halt after Italy's entrance into the war on June 10, 1940. Italy had signed its Pact of Steel with Germany in May 1939, which completed the diplomatic and military alliance of the Axis powers. Mussolini had boasted throughout the 1930s of Italy's growing military strength and the "eight million bayonets" that represented the armed strength of the nation. In fact, Italy had nowhere near that number of men in the armed services, and the military rhetoric of the Duce far exceeded his limited military resources.[1] In an unusual admission, Mussolini told Hitler in 1939 that he would need three years to prepare Italy for war. Hitler had other plans and would not wait for his Italian partner. Following his August agreement with Stalin, Hitler had a free hand to invade Poland on September 1, 1939. Mussolini remained on the sidelines and declared Italy a "non-belligerent."

The German blitzkrieg in May and June of 1940 ended the "phony war" and brought France a humiliating defeat. Mussolini decided that it was worth a few thousand Italian casualties to join Hitler's conquest of France. From his balcony overlooking the Piazza Venezia, he announced the declaration of war on June 10. Newsreels showed the cheering throng's response, although one American resident of Rome later wrote that the crowd was sullen and silent. He reported that the original soundtrack "was so devoid of sound when the populace should have been cheering that a friend of mine, in that business, told me personally that he dubbed in the sound of cheering from the recent Olympic tryouts and used those cheers to make the proper sounds on the newsreel of the

Duce's declaration of war."[2] On the outer edges of the piazza, where it was difficult to hear the Duce, a *New York Times* reporter found "a surprisingly light-hearted attitude, in some cases, toward the grave news [Mussolini] was going to impart. Those who heard him well, however, responded with enthusiasm."[3] President Roosevelt denounced Italy's move: "[T]he hand that held the dagger has struck it into the back of its neighbor."

The regime claimed that fascism had prepared the nation for this fateful hour. Indeed, war would somehow fulfill fascist Italy's destiny. "We will win because twenty years of Fascism has prepared us magnificently in spirit and in arms, because of our past glories and greatness, from Rome to the Risorgimento," and because Mussolini has endowed Italians with the impulse to win though his daily example.[4]

Italy's entry into the war did not stop the work on transforming Rome. Efforts continued for the next two years. Some new housing reached completion, and such projects as the Via della Conciliazione and the Termini Station continued. Plans also included additional bridges to span the Tiber, both at its northern and southern ends. The Ponte Principe Amedeo Savoia Aosta replaced the Bridge of the Florentines, the Ponte dei Fiorentini. It spanned the river at the end of the Via Giulia at the church of the Florentines, San Giovanni dei Fiorentini, connecting to the new tunnel, the Galleria Amedeo Savoia Aosta, which carried traffic underneath the Janiculum Hill. The work on these projects began in 1939 and was completed in 1942.[5] The next bridge planned at the farthest point on the river would "create a monumental access to Rome of the North," in accordance with the Piano Regolatore of 1931. This bridge, dedicated to the March on Rome, the Ponte XXVIII Ottobre, had a greater capacity than the ancient Milvian Bridge nearby. Thus it could carry traffic from the Flaminio and Parioli neighborhood across to the area of the Foro Mussolini and the ancient Via Cassia, an important artery traveling northeast out of the city. Completed after the war, this last fascist bridge is today the Ponte Flaminio.[6]

The grandest project under way was, of course, the EUR section. Even though the regime had to set aside plans for the 1942 exposition, the construction site remained active in keeping with the plan to create a permanent new city for Rome. Planning for EUR included two new bridges in the southern portion of the Tiber. The first would cross the river from the Via Galvani in Testaccio. The Via Galvani linked directly to the Viale Aventino, renamed by the regime the Viale Africa, and thus to the historic center. The new bridge, the Ponte Africa, would thus allow a flow of traffic to cross the Tiber into the Portuense neighborhood and continue down to EUR. Farther down the river, a

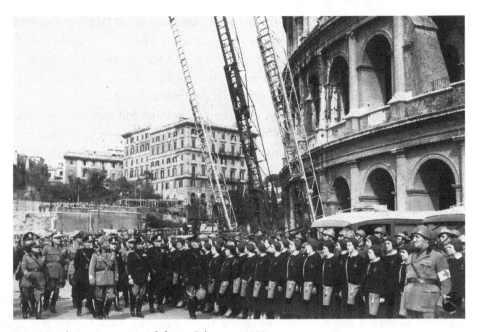

7.1 Mussolini reviews antiaircraft forces, Colosseum, 1939

second bridge, the Ponte San Paolo, would cross near St. Paul's Outside the Walls and also provide access to EUR. Construction on a final bridge crossing from EUR to the Magliana district had already begun and was completed after the war.[7]

Work on EUR inspired a new version of the master plan for the city. The 1931 Piano Regolatore did not include plans for EUR, and this new zone constituted a radical shift away from it. The de facto revision of Rome's development called forth the revised plan of 1942, the Variante Generale del Piano Regolatore.[8]

Marcello Piacentini led the new commission appointed in 1941. Gustavo Giovannoni and Cipriano Efisio Oppo were also appointed, and several others subsequently joined the group. The result of the commission's work the next year laid out for the first time a definitive direction for Rome's development. The city's orientation would now point south toward the new EUR and the sea. What had previously been only one of the directions of fascist Rome's development now became its main direction.

The Variante called for the further development of the area between the historic center and the sea. Garbatella, Magliana, and Ardeatinia all became zones for expansion. More facilities and more infrastructure would be required. For

example, an airport at Magliana, the metropolitan railway, and the Via Imperiale would provide for various modes of transportation. The Via Imperiale would also have hotels, tourist facilities, new housing, and various public buildings.[9] The plan forecast a doubling of Rome's population from 1.5 to 3 million, with 800,000 concentrated in the area from EUR to the sea.[10]

These grandiose plans soon ran into the realities unfolding in the war. The Italian military failures of World War II are well known: The invasion of Greece in October 1940 soon turned into a disaster saved only by German intervention. The initial advances of Italian troops into Egypt invited a devastating counterattack from a smaller British army that prompted Hitler to send Rommel and his Afrika Korps to the scene. Mussolini insisted on sending an Italian army to fight alongside the Germans after the invasion of Russia in June 1941. Fascist propaganda and German-Italian successes kept alive the hope of eventual victory well into 1942, but then the battles of El Alamein and Stalingrad turned the tide. The Italian Eighth Army of 250,000 men disintegrated in the bitter Russian winter of 1942–43. In North Africa, the Italian and German armies surrendered to British and American forces in May 1943.

In the first phase of the war, Rome had to tighten its belt and slow down construction projects. Even so, Mussolini continued to use the city and especially its new sites for speeches, parades, and ceremonies as part of the war effort. For nearly three years of war the emerging fascist city provided sites to support the war effort and the regime's message of ultimate victory: "Vinceremo"—"We Will Win." For example, on March 28, 1942, the Via del Mare hosted a parade with the awarding of medals as part of the regime's annual Air Force Day. The temporary rostrum where Mussolini presided over the ceremonies stood directly in front of the church of Santa Maria in Cosmedin, facing the two ancient temples on the Piazza Bocca della Verità. The new street, now lined with fascist office buildings on both sides, made it an appropriately fascist site for the occasion.[11]

Work on the Casa Littoria at the Foro Mussolini had completely stopped by 1942, but the Stadio dei Marmi adjacent to it continued to find use for rallies and sports exhibitions. On April 21, a major gymnastic competition took place before a standing-room-only crowd. The empty spaces at the *foro* provided soils to grow wheat as a new battle for grain to feed Italy during the war. In June, Balilla members harvested the precious grain.[12]

Building of the new Rome now came to a complete halt as military reverses brought the regime to the brink of crisis. Work sites closed, the demolitions for the Via della Conciliazione stopped, and the vast site of EUR grew silent. The Variante of 1942 never got beyond the planning stage, a stage properly summed

up as follows: "A considerable amount of time was used for the construction of a grandiose model representing the future Rome. The model was then destroyed in the events of 1943. Thus today very little today remains of the project given that the report was never published."[13]

For Rome, the second phase of the war began with the Allied invasion of Sicily on July 10, 1943. War had come to the Italian homeland. At the same time, Allied planes began bombing Italian cities, including Rome. The historic center was spared, but the first raid caused heavy damage in the San Lorenzo district surrounding the basilica of San Lorenzo and adjacent to the university. The war had come to Mussolini's Rome. Pope Pius XII, not Mussolini, visited the damaged neighborhood and its stunned residents.

The crisis of Mussolini's regime was at hand. Mussolini convened the Fascist Grand Council for the first time in several years for what turned out to be its last meeting. Its members gathered in the Palazzo Venezia on the night of July 24–25. They took hours and did not finish until dawn. The resolution approved by Mussolini's fascist colleagues amounted to a vote of no confidence in the Duce, although it is not clear that he realized how perilous his position was. Even his son-in-law Ciano voted against him, an act that would lead to his execution as a traitor in January 1944. Only when Mussolini went to his weekly meeting with King Victor Emmanuel III on the morning of July 25 did he learn that the king was dismissing him as head of government. Military police placed Mussolini under arrest. The king appointed the military conqueror of Ethiopia, Marshal Pietro Badoglio, as the new prime minister. Badoglio announced rather ambiguously, "The war continues."

The new government undertook secret negotiations with the Allies and reached agreement for an armistice. When the public announcement came on September 8, Romans took to the streets to celebrate what they thought was the end of the war. The climactic scene of Bernardo Bertolucci's film *The Conformist* portrays vividly the nighttime parade through the streets culminating in a scene at one of the ancient monuments "liberated" by the Duce: the Theater of Marcellus. Mussolini was now the object of scorn as the crowds pulled down his statues and pictures while destroying other symbols of the fascist regime. These Romans did not realize that the worst phase of the war for them would now begin. Soon Mussolini's Rome would become Hitler's Rome for nine agonizing months.

The Germans had feared an Italian attempt to exit from the war. When armistice was announced, German troops moved toward key positions and thousands more descended on the Italian peninsula. Hitler could not let fascism collapse and thus allow Italy to fall unopposed to the Allies. On September 12,

a small German force of gliders, led by Otto Skorzeny, rescued Mussolini from his mountain resort prison in the Abruzzi region and flew him to Germany.

Mussolini immediately became the leader of the newly constituted Italian Social Republic, or Repubblica Sociale Italiana (RSI), nicknamed the "Salò Republic" because of its headquarters in the small town of Salò on Lake Garda in northern Italy. The king and Badoglio fled to the Allies, who had invaded the southern mainland. Winston Churchill had argued for the invasion of Italy as a way to hit Germany in the "soft underbelly" of Axis Europe. To the contrary, the Italian campaign turned into a slow and difficult one, as the Allies fought up the mountainous peninsula that provided the Germans with ideal defensive positions. The Romans had looked forward to a quick Allied entrance into their city, but suffered instead a harsh German occupation for nine months.

The American General Maxwell Taylor parachuted into Rome the night of September 7–8, 1943, to make advance preparations for Allied paratroops to land and seize Rome's airports. He found Badoglio and the Italian generals he met quite unprepared to offer clear and decisive support. Taylor canceled the operation only hours before it was to begin. This daring plan carried great risks even if circumstances had been favorable, but it also might have caught the Germans by surprise and forced them to withdraw north of Rome.[14]

As German troops moved into the city in the days immediately following the armistice announcement of September 8, 1943, no clear orders went to the Italian army units as to what they should do next. Fear, uncertainty, and lack of direction ruled the day. Fascism had collapsed. Now it seemed that the Italian nation had also collapsed. Rome stood open and vulnerable to the advancing German columns.

The Italian armed resistance to the German occupation began in an area striking for its juxtaposition of ancient Rome with Mussolini's Rome. Civilians joined Italian troops at the third-century Porta San Paolo and first-century B.C. pyramid of Caius Cestius to face the Germans. The nineteenth-century Protestant Cemetery was there, adjacent to the pyramid. Libera's Aventine post office, which had opened in 1935, stood across the street. In fact, the streets and park just beyond, the Parco Cestio, were all developed during the fascist period. "The battle at Porta San Paolo, which initiated the last stand for the defense of Rome, began the next morning, September 10, and would continue all day. The fierce combat and the heroism of an improbable band of patriots around the pyramid would recast the image of that first-century B.C. Egyptianate tomb into the birthplace of the resistance, but most of the rest of Rome awoke in ignorance of what was taking place inside and around their city."[15]

An American nun, Mother Mary Saint Luke, published her diary of occupied Rome at the end of the war under the pseudonym Jane Scrivener. She gave a vivid account of the bloodshed and chaos of that day. Italian troops struggled to oppose the Germans without leadership from their officers and with shortages of equipment and ammunition. Beyond the Porta San Paolo, conflicts between Germans and Italians took place at sites throughout the city. "A ferocious encounter took place near the Ministry of the Interior in Via Agostino Depretis, with Fascists and Germans inside, Italians attacking from the street. Near the Circus Maximus a platoon of Germans took advantage of the newly constructed tunnel for the underground railway, dived into it and emerged at the Coliseum [*sic*], only to find resolute Italians at the other end, awaiting them with hand grenades and revolvers."[16]

The inevitability of the German occupation was never in doubt. German troops gained the upper hand throughout the city, and columns of troops continued to enter the city. Some of them "in rather straggling formation, marched down the Via dei Trionfi, past the Arch of Constantine and down the Via del Impero to Piazza Venezia, where machine guns had been barking all afternoon."[17] Ironically, German troops had taken the same parade route as the Italian military and youth formations on that "special day" in May 1938 when Mussolini welcomed Hitler to Rome.

Mussolini's Rome was now Hitler's Rome. Many Italians fell in those fateful September days, but their valiant efforts were no match for German armed might. Nevertheless, the fighting represented the first attempt of some Italians to redeem their honor by resistance, and that resistance would continue until Rome's liberation on June 4, 1944. Today the area of the Porta San Paolo, which includes the pyramid and the post office, is a shrine to the resistance. Numerous plaques commemorate those who fell. The fascist park behind the post office is now the Parco della Resistenza del 8 Settembre. Flanking it on the north side is the Largo Manlio Gelsomini, named for a doctor and Italian army officer who fought in the resistance until captured and then executed at the Fosse Ardeatine in March 1944. Plaques on the Aurelian Wall by the pyramid are dedicated to the city's liberation on June 4, 1944. The British war cemetery down the street from the pyramid and the Protestant Cemetery is the final resting place for several hundred troops who died in the Italian campaign. This piece of fascist Rome now bears the stamp of war, resistance and antifascism imposed after the war.

The nine months from armistice and resistance to liberation formed the most bitter and difficult time of the war for the Romans. They had to live under constant surveillance by German and Italian fascist forces, food was scarce, and

the longed-for liberation by Allied forces became stalled during the long winter months. The Germans maintained their defensive line at Monte Cassino. The Allied attempt to outflank them by the landing at Anzio on January 22 met a determined German attempt to push the Americans back into the sea. Bitter fighting continued at Anzio and in the Agro Pontino. The effort failed to bring the quick conquest of Rome.

Rome's synagogue overlooks the Tiber just a short distance from the Piazza Venezia and the Victor Emmanuel Monument. The Jews of Rome had felt a profound gratitude toward Victor Emmanuel II for seizing Rome from the pope and making it the capital of the newly unified Italy in 1870. The new kingdom of Italy made Jews citizens with the same legal status as all other Italian citizens and abolished the papal ghetto. The ghetto survived as a Jewish neighborhood, but it was voluntary, not compulsory. The Jews built their synagogue there and opened it in 1904. Not surprisingly, Jews supported the new Italy and took pride in their role as citizens of the nation. Subsequently, many had supported the fascist regime, and some joined the Fascist Party.[18]

Italian fascism fostered an extreme nationalism that promised to unite Italians and make the nation a strong and respected power. Unlike Hitler's National Socialism, it initially harbored no racial or anti-Semitic teaching and policies. When Hitler first came to power in 1933, Mussolini scoffed at the racial theories of the Nazis, but five years later he changed his policy. Hoping to curry German favor and to strengthen the sense of Italian identity, he introduced racial laws that severely curtailed the rights of Italian Jews in every aspect of life.[19] The treatment of Jews from 1938 to 1943 was severe and caused considerable hardship. German occupation in 1943 brought to Rome the brutal policies of the Nazis, now bent on exterminating European Jewry.

The new reality came home in the brutal and tragic roundup in the ghetto on October 16, 1943. The raid was preceded by the extortion of fifty kilograms of gold from the Jewish community by Lieutenant Colonel Herbert Kappler, head of the German SS in Rome. Having made the payment within the two-day deadline, the residents of the ghetto justifiably believed that they would now enjoy a measure of security. Kappler himself favored using Jews as laborers, but orders from on high demanded the roundup of Rome's Jews and their deportation to Auschwitz.[20]

The German raid on the ghetto began in the early hours of the Sabbath on October 16. Mother Mary Saint Luke wrote, "The S.S. are doing exactly what one expected, and at 4:30 A.M. began to round up the Jews in their own houses. The Rabbi did not destroy his registers, and they know where every Jew lives. And this, after the promise made when they produced the ransom. . . . Some

Jews escaped, others were herded into open lorries in the rain, and we know nothing about their destination. It is a nameless horror."[21]

The raid netted more than twelve hundred people, including nine hundred women and children. Some two hundred non-Jews arrested by mistake gained release. Two days later the Jews "were crammed into freight cars and transported to Auschwitz. Within a week, all but 149 men and 47 women had been gassed and burned in the camp's crematoria. Of the 196 admitted to the camp, seventeen returned after the war. They included sixteen men and one woman."[22]

During the occupation the German High Command established its headquarters in the Hotel Excelsior on the Via Veneto. Their Italian fascist allies moved their headquarters into the Ministry of Corporations across the street. A curfew was imposed. German and Italian police patrolled the city day and night. Roman citizens and religious houses hid Jews and escaped Allied prisoners. Romans continued to hope for liberation, but the months dragged through the winter, with little change in the fighting to the south.

The most dramatic incident during this period came on March 23, 1944, when the resistance planted a bomb in a trashcan on the Via Rasella, just down the street from the Palazzo Barberini and just a block away from the Piazza Barberini, at the foot of the Via Veneto. The clandestine forces of the resistance chose the Via Rasella as the perfect place to attack the SS police battalion that marched up the street on patrol every afternoon. They hoped that such a bold attack might spark general resistance to the German and fascist forces, but tragically, it only resulted in the brutal massacre of Italian citizens in reprisal.

German-speaking Italians from the South Tyrol made up the SS police battalion. Hitler had purposely avoided incorporating these Germans into his greater Reich after the Austrian Anschluss. He gladly paid that price for the alliance with Mussolini. With Italy now out of the war, he acted quickly to incorporate the area into Germany and bring its men into the German armed forces.

The Via Rasella provided the place. The date March 23 provided the occasion, for it was the fascists' day to celebrate the twenty-fifth anniversary of their movement, nearby in the party headquarters on the Via Veneto. The resistance operatives knew that the police patrol would march up the Via Rasella toward the Palazzo Barberini on the Via delle Quattro Fontane at 2:00 P.M. They packed forty pounds of dynamite into a municipal trashcan. Rosario Bentivegna, medical student and future historian of the resistance, donned the uniform of a Roman sanitation worker and with his broom pushed the can to its assigned place at number 156, the Palazzo Tittoni. Perhaps the fact that Mussolini had

lived in a small apartment in the palazzo in the 1920s before moving to the Villa Torlonia with his family gave the resistance added reason to choose this place.

The members of the Eleventh Company of the Bozen SS Regiment inexplicably failed to show up at the appointed time. An hour passed and still no patrol appeared. Bentivegna and his colleagues in the area grew nervous and thought of aborting the operation. Then at 3:45 the troops appeared, marching up the Via Rasella singing. Bentivegna ignited the fuse and headed up the street to meet his partner in the operation, Carla Capponi. The celebrating fascists in the Ministry of Corporations six hundred feet away felt the tremendous explosion that tore into the police.[23]

> The rigid shaft of German troops snapped like a breaking walking stick. Two dozen men were blown apart. They fell in puddles of blood. The rubbish cart and the steel case inside it disappeared. Shrapnel whistled through the street. It pinged on German helmets and sliced and chopped through human flesh. Dying and wounded men fell to the ground. They lay groaning among parts of arms and legs, in many cases their own. They were immediately drenched in a rain of slivers and sheets of glass. Hunks of concrete were chopped from as high as thirty feet out of the façades of the buildings across the street from Palazzo Tittoni. An armored truck that had been escorting the column was demolished. A hole of about thirty cubic feet was blown out of a stone wall. Water began to gush from it, washing down the graded street, mixing dust with steel and blood.[24]

Thirty-three soldiers died on the spot or within the next day. The only remnant today of what took place are the bullet holes in the building at the corner of the Via Rasella and the Via Boccaccio. SS Commander Herbert Kappler received orders from Berlin to retaliate by executing ten Italians for every dead German. The SS rounded up hostages, many already in prison, and took them to the southern outskirts of the city near several of Rome's most important catacombs. There in the Ardeatine caves, the Fosse Ardeatine, they shot 335 men of all backgrounds and ages, the youngest being fifteen-year-old Michele Di Veroli, a resident of the ghetto and one of 77 Jews executed that day. When the Germans finished, they blew up the entrances to the caves to bury their victims and cover up their work.

Some of the victims of the Fosse Ardeatina massacre came from the Gestapo prison at 145–155 Via Tasso, around the corner from the tram line on the Viale Manzoni and not far from the Colosseum. The building belonged to Prince Francesco Ruspoli, who rented it to the German embassy. Eventually, it came under Kappler's command and became notorious as a prison and interrogation center.[25] The Germans partitioned the apartments into small cells, especially for

those prisoners suspected of resistance activities. The graffiti messages left by the prisoners bear eloquent testimony to their desire to redeem Italian honor and patriotism by resisting the Germans and their Italian fascist allies.[26]

After the war, the infamous site became the Museum of the Liberation of Rome, the Museo della Liberazione di Roma. It remains open today as a shrine to the resistance. One of the prisoners was Arrigo Paladini. He had served in the Italian army on the Russian front, where he witnessed Nazi atrocities and recorded his experiences in his war diary. Paladini was among the few thousand Italian troops to survive the bitter defeats of 1942–43. He returned home and finished his university degree. After the armistice of September 8, he refused the call to fight for Mussolini's new Salò Republic and entered the resistance. During his subsequent imprisonment in the Via Tasso, he scratched into the wall, "È facile saper vivere, Grande saper morire ("It is easy to know how to live, Heroic to know how to die").[27]

A variant of that classical message found a larger audience in the film *Roma Città Aperta* (*Rome Open City*), Roberto Rossellini's 1945 neo-realist film honoring Rome's people and their resistance to the Nazi-fascist tyranny. The film established a new view of Rome and her ordinary citizens. Mussolini's Rome, with its images of Romans packed into the Piazza Venezia to cheer the Duce, now became the gritty Rome of survival and resistance. Rossellini's masterpiece forged on a popular level the postwar historiographical stance that Mussolini's brutal dictatorship had never won the hearts and minds of Italians and that when given the opportunity, ordinary, working-class people like the Romans in the film found ways to resist their oppressors.

Set in the working-class Prenestino neighborhood and using many of its residents in the cast, *Rome Open City* starred Anna Magnani and Aldo Fabrizi in a powerful, if somewhat romanticized, account of Rome's darkest days. The story took place during a seventy-two-hour period and portrayed the collaboration of an underground communist resistance leader and a parish priest, thus depicting the cooperation of former enemies in the common fight against fascism and Nazism. Their deaths and that of the working class woman played by Magnani at the hands of the Germans illustrated the moral courage of those who actively or passively resisted. These events also symbolized the hope that Italians of all political and ideological persuasions, as well as ordinary citizens, had joined against the common enemy to establish a new and just society after the war. At the conclusion of the film, as he is led to his execution by a firing squad, the priest, played by Fabrizi, says to the chaplain at his side, "It is easy to die well, but it is difficult to know how to live well." The film, produced and released in 1945, played a role in the transition from Mussolini's Rome to the

Rome of resistance and antifascism that came to dominate the postwar histor-
ical memory of the Nazi occupation.

The final use of Mussolini's Rome as a stage for fascism was the parading of
Allied prisoners through its streets. The long lines of American and British pris-
oners shuffling past the Colosseum and down the Via dell'Impero in the early
months of 1944 showed Romans that the war might still bring victory. These
weary, defeated soldiers captured at Monte Cassino and Anzio reinforced the
image of the American and British incapacity for military prowess depicted in
the Cinema Room of the final version of the Exhibit of the Fascist Revolution.[28]

By May 1944, such propaganda could no longer mask the reality of the mil-
itary campaign that would liberate Rome. Allied troops finally broke through
the Germans' defenses at Monte Cassino and burst out of the pocket at Anzio.
Seeing the opportunity to enter Rome as its liberator, General Mark Clark
pushed straight for the city. The Germans evacuated Rome, sparing its monu-
ments the destruction of street-by-street, house-by-house combat. Rome, like
Paris and unlike Berlin, survived the war largely intact. On June 4, 1944, the Al-
lies arrived and the Romans rejoiced that at last the war really was over for them.
They could now forget Mussolini's Rome.

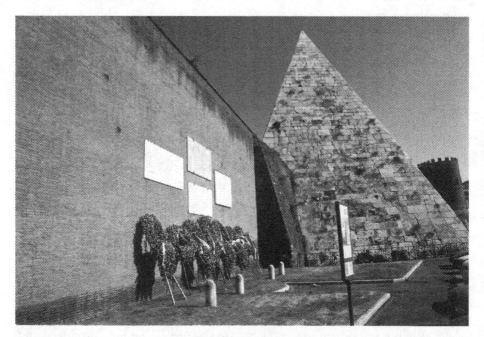

7.2 Pyramid of Caius Cestius, Porta S. Paolo, with memorials to the resistance and the liberation of
Rome, 1997

POSTWAR ROME

The work of erasing and defacing the symbols of Mussolini and fascism began almost immediately, but the results were only partial. Even in places where the fasces symbols were removed, the stained outline remains today. In some cases, such as the Foro Mussolini, renamed the Foro Italico, the removal of the fascist imprint would have required the wholesale destruction of the site. American and British forces occupied the area, and the Foro Mussolini took on a new role as a U.S. Army Rest Center. The occupying forces did block a threat to pull down the Mussolini obelisk.[29] The sports complex remains intact today, and some restoration of the mosaics took place at the time of the 1990 World Cup soccer matches.

Today in Rome, for every place one finds Mussolini's name chiseled out of a plaque or column, there is another where it remains. More obvious are the streets and buildings that survived and are today a part of Rome's urban landscape, even though obviously fascist names were changed. Throughout the city, the fascist imprint remains clear and pervasive.

The end of fascism and the triumph of antifascism did result in a thorough purging of streets and sites bearing fascist names.[30] The Foro Mussolini became the Foro Italico. The Via dell'Impero became the Via dei Fori Imperiali. In some cases, the name changes imposed clearly antifascist labels to formerly fascist locations. The large piazza in front of the Ostiense train station built for Hitler's 1938 visit became the Piazza dei Partigiani to commemorate the partisans of the resistance. The street running from the station to the Porta San Paolo would no longer be the Viale Adolfo Hitler but the Viale delle Cave Ardeatine, to commemorate the victims of the Via Rasella action.

Throughout postwar Rome there appeared memorials to those who had opposed Mussolini, his movement and his regime. The monument for Giacomo Matteotti on the Tiber honors the parliamentary deputy who paid with his life for his vocal opposition to Mussolini's new government. Its dedication in 1974 marked the fiftieth anniversary of his abduction and assassination. Nearby, the first fascist-constructed bridge with the very fascist name of Ponte Littorio became the Ponte Matteotti. Across town, the lovely park near the Porta San Paolo, built by the fascist regime, now bears the name Parco della Resistenza 8 Settembre. The area around the Porta San Paolo and the Pyramide has many plaques and memorials to remember those who began the armed resistance in 1943.

Today in Rome visitors will look in vain for war memorials recalling the battles fought by the Italian Army in World War II.[31] There is no equivalent of

7.3 Memorial to Giacomo Matteotti, 2003

Washington's monument to the flag-raising on Iwo Jima. Instead, there are plaques throughout the city commemorating individuals and groups who fought and died in the resistance. Many of these are relatively small and are placed on buildings where the martyred person lived or the site where he or she died.

The largest and most impressive monument to the victims of the Nazi occupation stands just south of the city in the area of several of Rome's major catacombs. The place where the SS shot the 335 men and boys rounded up the day after the Via Rasella explosion is now their resting place and their memorial. On March 24, 1950, the sixth anniversary of the atrocity, the monument opened. A larger-than-life sculpture has three victims bound together, awaiting their fate. Beyond them is a large slab that covers the 335 tombs. Only a few are not identified. Most have the victim's name, age, occupation and a picture. At the time of construction in 1949–1950, the major theme of the monument was to honor "these holy Martyrs of our Fatherland." An additional theme in accounts at the time portrayed the war as one never wanted by the Italian people.[32]

The Termini train station offers yet another example of a partially covered fascist artifact. A substantial portion of the building went up during the fascist regime, but the dramatic, cantilevered entrance was designed and built after the war. The clearly postwar design masks the fascist design behind it.[33]

7.4 Memorial at the Fosse Ardeatine, 1988

The construction of Mussolini's Africa building came to a halt in 1942, and its completion also took place after the war. In this case, the final result accords with the original plan approved by the regime. Since 1954, it has housed the United Nations' Food and Agricultural Organization, known popularly as FAO. In this case, a fascist monument to nationalism, conquest, and empire now houses the international agency dedicated to improving the world's food supply through agricultural development.

A major legacy of Mussolini's Rome resides in the new city, within the city known as EUR. The buildings begun by the regime remain today as a very visible embodiment of the period's architecture and urban planning. The wide streets and their axial layout offer a sharp contrast to Rome's historic center. By establishing this new area as the first step in channeling the city's development to the south and the sea, the regime paved the way for the tremendous growth of EUR after the war. Corporate builders found both land and permission to construct skyscrapers. The Palazzo dello Sport opened for the 1960 Olympics. The area quickly became a desirable place to live, offering the opportunity to move into that very rare Italian residence, a free-standing single family house.

The major political and institutional change following the war was the elimination of the monarchy. Victor Emmanuel III had, after all, appointed Mussolini prime minister in 1922 over the objections of advisers and politicians who had urged him to declare martial law and put down the March on Rome. The relationship of king and Duce, monarchy and fascist regime, varied during the next twenty-one years. Sometimes it appeared collaborative and cooperative, while at other times it seemed strained and uncertain. Mussolini asserted his own infallibility with such slogans as "Mussolini is always right," and claimed he was creating a totalitarian regime. In reality, as head of government, he had to coexist with the king as head of state. As we have seen, when Hitler, head of both government and state, arrived at the Ostiense station, protocol required the king, not Mussolini, to greet him first with the handshake and salute. Although Victor Emmanuel III dismissed Mussolini in 1943 and formed a new government, he then fled south to the safety of the Allied lines without any clear orders to the armed forces, thus abandoning the Romans. To many Italians, the monarchy had compromised itself through collaboration with fascism and thus should have no place in a postwar, antifascist Italy.

Victor Emmanuel abdicated in May 1946, and his son assumed the throne for the month before the national referendum of June 2 on the "Institutional Question." The vote went against the monarchy. King Umberto left for exile in Portugal. The coalition of parties agreed on electing a Constituent Assembly

that then wrote a new constitution for the Republic of Italy that went in effect on January 1, 1948.

The Italian Republic held antifascism as a fundamental principle, embodied in a constitution that made the Fascist Party illegal. That did not prevent the emergence of a neofascist party with a new name, the Italian Social Movement or Movimento Sociale Italiano. The party initials, MSI, suggested Mussolini's name, and the organization managed to keep alive a semblance of fascism, although it never gained a mass following. The Christian Democratic Party, backed both by the United States and the Vatican, became the largest party; its main job during the Cold War was to keep the second largest party, the Italian Communist Party, out of the national government. Thus, the antifascist alliance of the war years fractured under the pressure of Cold War politics, but all the parties, with the exception of the MSI, continued to pay lip service to antifascism.

The Christian Democrats may have dominated Italian politics as a centrist, anticommunist party that led a series of coalition governments and kept the communists in the opposition, but the influence of the left, Marxism, and antifascism pervaded cultural and intellectual life. The rejection of anything that smacked of fascism was clear. In this view, the fascist transformation of Rome was best either forgotten or ritually denounced. This attitude, however, could not destroy the city that Mussolini had tried to re-create in his own image. It could remove his name and the fascist symbols from some locations, and it could change the fascist names of streets, sites, and buildings, but those streets, sites, and buildings of Mussolini's Rome remain to this day. For that reason, the only way to understand fully the shape of Rome today and the way we see its history and its historical monuments is to open our eyes to the reality of Mussolini's Rome.

The legacy of Mussolini's Rome will continue to generate disagreement on just what that legacy should be. In 1995, Francesco Rutelli, the left-of-center mayor of Rome, sought to honor a native of the city from the fascist era, Giuseppe Bottai, by naming a large piazza, or *largo*, after him. The projected Largo Bottai occupied the large space in front of the National Gallery of Modern Art in the Villa Borghese. The controversy over naming the *largo* after such a prominent member of the Fascist regime caused a political storm, and Mayor Rutelli quickly abandoned the idea.

The fate of the Obelisk of Axum, brought to Rome and erected in 1937, next to the site of the projected Africa building, caused an international struggle between Ethiopia and Italy that lasted from 1947 to 2004. In its peace treaty with Ethiopia in 1947, Italy promised to return the obelisk to its original site.

The Italian government did not follow up, and when pressed by the Ethiopians, the Italians came up with various excuses for delay. In the 1990s, the controversy revived, and by then many Italians favored its return. When the government of socialist Prime Minister Lamberto Dini made plans to send it to its homeland in 1995, the right wing Alleanza Nazionale, heirs to the neofascist Movimento Sociale Italiano, protested, arguing that the monument now belonged to Rome and deserved to remain as part of its urban landscape. In 1996, Italy's president, Oscar Luigi Scalfaro, assured Ethiopia's visiting head of state that the obelisk would soon be on its way, but there was no immediate follow-up. In 2001, lightning hit the monument and the Italians had to decide to repair it, at considerable political and financial cost, or return it. The right-of-center Berlusconi government, which included the Alleanza Nazionale, opted to send it back.[34] The dismantling of the obelisk took place in the fall of 2003, with plans to send it to Ethiopia early the next year. By the summer of 2004 the three pieces of the dismantled obelisk sat in storage near Rome's Leonardo da Vinci airport, as talks continued on how to transport them back to their home country. Delivery to Ethiopia is scheduled for April 2005.

One other recent revision of Mussolini's Rome came in early 2001. The sculptured relief over the entrance to the headquarters building at EUR depicted the history of Rome from Romulus and Remus to Mussolini, as discussed in chapter 6. This dramatic piece survived the war intact except for one act of vandalism, which defaced the Duce. Mussolini remained without his face until early 2001, when it was suddenly restored. No doubt the future will see further revisions to the legacy of Mussolini's Rome.

CONCLUSION

Mussolini's Rome remains evident throughout today's city. The fascist layer of the Roman palimpsest shapes the urban landscape of ancient and papal Rome. Beyond the historic core, defined by the third-century Aurelian Wall, lie the new neighborhoods and the new cities (Foro Italico, University City, EUR, Cinecittà) that Mussolini erected in the effort to create both a fascist city and a Rome capable of absorbing the thousands of migrants flocking to the capital.

As told here, the story of Mussolini's Rome is an integral part of the regime's twenty-year history. Mussolini poured huge resources into his transformation of Rome, and he used the city as his stage to project himself and his fascist revolution to Italy and to the world. In this case, fascism presented not only rhetoric and propaganda, but the concrete, bricks-and-mortar reality of a

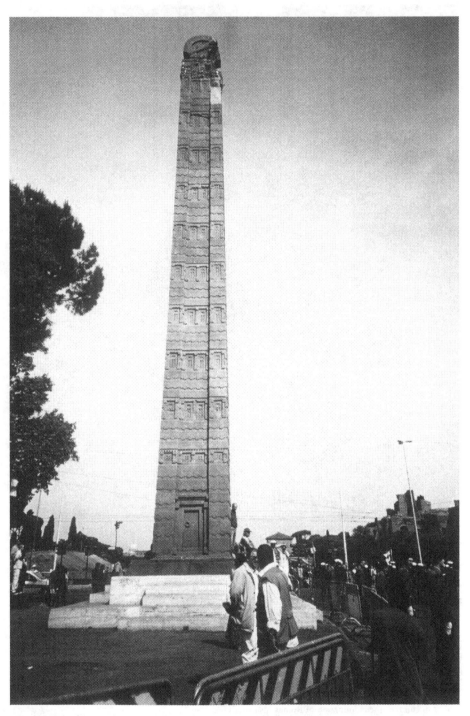

7.5 Obelisk of Axum about to be dismantled, 2003

7.6 Mussolini as the culmination of Rome's history, EUR, 2001

city undergoing constant construction and expansion. Rome was to become the symbol and the reality of a unified and strong Italian nation, capable of creating a new Italy and new Italians in fulfillment of the fascist revolution. Evidence suggests that Mussolini succeeded in getting the attention he wanted and that even critics of his regime found the transformation of Rome impressive.

In particular, Mussolini's Rome demonstrated the *bonifica integrale,* the reclamation of land and people, trumpeted by the Duce. The *bonifica* played a key role in the national struggle to transform Italy and Italians. It represented change as significant for fascism as the military strength Mussolini claimed his regime was amassing.

When Mussolini stood before a cheering crowd on December 18, 1934, to inaugurate the new town of Littorio, built on the once uninhabitable Agro Pontino, he declared: "This is the war we prefer." That statement found a place as a theme of fascist reclamation and building. It hinted that fascism might find its justification and fulfillment in this peaceful struggle to change Italy. After all, the Duce had waged battles for a stable lira, for population growth, for sufficient wheat to feed the nation, and for a self-sufficient economy, *autarchia.* He told Italians that he won or was winning those battles. Now they might also believe his words that "this is the war we prefer."

A painting submitted to the 1940 Cremona Prize competition sponsored by the militant fascist boss of Cremona, Roberto Farinacci, bore the title: "The War that we prefer," "La Guerra che noi preferiamo."[35] Artist Luigi Stracciari showed resolute and smiling peasants harvesting wheat on the left half of the canvas while workers on the right half toiled to eradicate the marshes, aided by a large mechanical dredger. "The war that we prefer" also appeared on posters as a widely used slogan championing the regime's efforts at construction and redemption of land and people. As it soon turned out, Mussolini was not content to stick to this war of reclamation and transformation. When Hitler conquered Norway in April 1940 and began the blitzkrieg campaign that would overwhelm France in May, he decided Italy must enter the war as Nazi Germany's ally, and so declared war on June 10.

If Mussolini had chosen to stay out of the war, historians have speculated that he might have survived as Franco survived in Spain. He was still popular among Italians, and no doubt a decision for peace would have made him more popular. The enthusiasm with which his return to Italy from the Munich conference in 1938 was met demonstrated the widespread yearning for peace. In 1940, however, Mussolini had no choice. The reasons to enter this war as Hitler's ally were compelling.

The German victories created a new Europe dominated by Nazi power. Mussolini understood that Italy must accommodate itself to this situation in the hope that Hitler would agree to an Italian sphere of influence in the Balkans and the Mediterranean. Military victories at the side of Germany would allow the realization of the fascist revolution. This war, like the previous world war, opened the way for revolutionary change, the chance to create a truly fascist Italy. Mussolini had compromised the fascist revolution during the 1930s by politically expedient agreements with the church, the monarchy, big business, and the army. Alexander De Grand summed up the dilemma facing Mussolini in 1940 this way: "Mussolini could set goals but had no way to command execution of his orders. When he wanted to strengthen the totalitarian dimension of his regime, his diplomatic and military policies forced him into greater dependence on the traditional conservative (non-totalitarian) establishment which questioned many of the new policy directives."[36]

Robert Paxton's recent study of generic fascism, *The Anatomy of Fascism,* reaches a similar conclusion on Mussolini's dilemma in 1940: "The final outcome was that the Italian and German fascist regimes drove themselves off a cliff in their quest for ever headier successes. Mussolini had to take his final step into war in June 1940 because Fascist absence from Hitler's victory over France might fatally loosen his grip on his people."[37]

The way out for the Duce was war. He gambled on a victorious war, and in June 1940 it appeared to be a good bet, but of course it was not. His dreams for Italian victory, imperial glory and for Rome, *romanità,* and revolution dissolved into the nightmare of defeat.

Appendix I

CHRONOLOGY

Dates for sites in Rome during the fascist period are for completion or opening unless otherwise noted.

1860–70	Italian Unification
1860–61	Garibaldi's Thousand conquer Sicily and southern Italy; proclamation of the kingdom of Italy
1870	Italy takes Rome from Pius IX and declares it the nation's capital
1883	Birth of Benito Mussolini
1912	Mussolini, a member of the Socialist party, becomes editor of the party's newspaper, *Avanti!*
1914	World War I begins; Italy remains neutral
	Mussolini advocates intervention and is expelled from the Socialist party; he founds the newspaper, *Il Popolo d'Italia*
1915	Italy enters the war on the side of the Triple Entente: Great Britain, France, and Russia
1918	End of the War
1919	Mussolini founds the fascist movement in Milan
1922	March on Rome; King appoints Mussolini prime minister
1924	Murder of socialist deputy Giacomo Matteotti
1926	Mussolini establishes a one-party state
1926	Organization of the Balilla youth organization
1928	Cornerstone laid for the Foro Mussolini
	Casa Madre dei Mutilati
	Land reclamation of Agro Pontino begins
	Ministry of the Navy
1929	Mussolini moves his office to the Palazzo Venezia
	Ponte Littorio

Largo Argentina
1930 First stretch of Via del Mare opened; isolation of Theater of Marcellus
1931 Ministry of the Air Force
 Widening of Via Navicella on Celio Hill
 Piano Regolatore issued
1932 Opening of Parco Colle Oppio
 Garibaldi celebrations: Garibaldian Exhibit, monument to Anita
 Garibaldi
 Decennale, tenth anniversary of the March on Rome
 Exhibition of the Fascist Revolution, the Mostra della Rivoluzione Fascista
 Opening of the Via dell'Impero
 Opening of obelisk and first buildings at Foro Mussolini
 Monument and museum of the Bersagliere, Porta Pia
 Ministry of Corporations
 New town of Littoria in the Agro Pontino
1933 Via dei Trionfi
 Opening of new school on Via Vetulonia
1934 Widening of Viale Aventino
 New town of Sabaudia in the Agro Pontino
 Post office at Ostia
 Via del Circo Massimo and the clearing of the Circus Maximus
 Four maps of the Roman Empire on Via dell'Impero
 Mostra della Rivoluzione Fascista closes
 New town of Pontinia in the Agro Pontino
 Church of Cristo Re, Viale Mazzini
1935 Città Universitaria, University City
 Post offices: Via Marmorata, Piazza Bologna, Via Taranto, Viale Mazzini
 Gioventù Italiano del Littorio (GIL) building, Aventine Hill
1936 Conquest of Ethiopia and Declaration of the new empire
 Rome-Berlin Axis
 Spanish Civil War begins
 Gioventù Italiana del Littorio (GIL) Building, Trastevere
 Case delle Armi, Foro Mussolini
 Via della Conciliazione project begins
 Fifth map of the fascist empire on Via dell'Impero
 Parco Traiano
1937 Cinecittà
 Liceo Giulio Cesare
 Groundbreaking for E'42
 Mostra delle Colonie Estive, Circus Maximus
 Second Mostra della Rivoluzione Fascista
 Mostra Augustea della Romanità
 Mussolini visits Germany
 Addition to Casa Madre dei Mutilati
 Obelisk of Axum
 New town of Aprilia in the Agro Pontino

	Mostra Tessile Nazionale, Circus Maximus
	Stadio Olimpico, Foro Mussolini
1938	Groundbreaking for Casa Littoria, Foro Mussolini
	Hitler annexes Austria
	Stazione Ostiense
	Hitler's Visit to Rome
	Work begins on the subway, the Metropolitana to E'42
	Munich Conference
	Work begins on Ponte XXVIII Ottobre
	Office buildings on the Via del Mare
	Mostra del Dopolavoro, Circus Maximus
	Work begins on new Stazione Termini
	Contest for Ministero dell'Africa Italiana
1939	Luce building
	Mostra Autarchica del Minerale Italiano, Circus Maximus
	Parco Cestio
	Germany invades Poland; Italy remains neutral
1940	Italy enters the war
1942	Variante generale del Piano Regolatore
	Ponte Principe Amedeo Savoia Aosta
	Third version of Mostra della Rivoluzione Fascista
	Battle of El Alamein
1943	Allies bomb Rome
	Mussolini overthrown
	Armistice; Germans occupy Rome
	Germans rescue Mussolini
	Organization of Repubblica Sociale Italiana, or "Salò Republic"
1944	Via Rasella action by resistance
	Executions at Fosse Ardeatine
	Allies liberate Rome
1945	Execution of Mussolini by partisans
	War ends in Italy
1946	Referendum votes down monarchy
1948	New constitution, Italian Republic

Appendix II

FASCIST PLACE AND STREET NAMES

The following is a list of principal fascist sites and streets. Names that changed after the war are given in parentheses: Via dell'Impero (Via dei Fori Imperiali).

SITES

Ara Pacis
Casa Littoria (Ministero degli Affari Esteri or Farnesina)
Foro Mussolini (Foro Italico)
Ministero dell'Africa Italiana (FAO: Food and Agricultural Organization)
Ministero delle Corporazioni (Ministry of Labor)
Museo Mussolini (Museo Nuovo)
Ospedale Littorio (Ospedale S. Camillo)
Sanitorio Carlo Forlanini (Ospedale Carlo Forlanini)
Parco Cestio (Parco della Resistenza 8 Settembre)
Parco Colle Oppio and Parco Traino
Ponte XXVIII Ottobre (Ponte Flaminio)
Ponte Duca d'Aosta
Ponte Principe Amadeo Savoia Aosta
Ponte Littorio (Ponte Matteotti)
Stado del PNF (Stadio Flaminio)

STREETS AND PIAZZAS

Corso del Rinascimento
Piazza Augusto Imperatore

Piazza Albania
Piazza Bocca della Verità
Piazza delle Legione Romane (Piazza dei Navigatori)
Piazzale Romolo e Remo (Piazzale Ugo La Malfa)
Piazzale Ostiense (Piazzale dei Partigiani)
Via Ara Littorio (Via San Pietro in Carcere)
Via Ambra Aradam
Via del Circo Massimo
Via della Conciliazione
Via Guido Bacelli
Via Imperiale (Viale del Terme di Caracalla, Via Cristoforo Colombo)
Via dell'Impero (Via dei Fori Imperiali)
Via del Mare (Via del Teatro di Marcello, Via Petroselli)
Via della Navicella
Via Reginia Elena (Via Barberini)
Via dei Trionfi (Via di San Gregorio)
Via XXIII Marzo (Via Bissolati)
Viale Adolfo Hitler (Viale Cave Ardeatine)
Viale Africa (Viale Aventino)
Viale Libro e Moschetto (Viale Piero Gobetti)
Viale dei Martiri Fascisti (Viale Bruno Buozzi)
Viale Maresciallo Pilsudski

NOTES

INTRODUCTION

1. Spiro Kostof, *The Third Rome, 1870–1950: Traffic and Glory* (Berkeley, Calif.: University Art Museum, 1973): 39.
2. Quoted in a column by Giorgio Bocca, *L'Espresso,* December 26, 1982: "Dove era cultura non era il fascismo, dove è stato il fascismo non c'era la cultura, non c'è mai stata una cultura fascista."
3. Henry Hope Reed, "Rome: the Third Sack," *The Architectural Review,* 107, no. 638 (February 1950): 91–110.
4. See also Spiro Kostof, "The Emperor and the Duce: The Planning of Piazzale Augusto Imperatore in Rome," and Henry A. Millon, "Some New Towns in Italy in the 1930s," in *Art and Architecture in the Service of Politics* (Cambridge, Mass: MIT Press, 1978), edited by Henry A. Millon and Linda Nochlin.
5. See, for example, his "Italian Architecture during the Fascist Period," *The Harvard Architecture Review* 6 (1987): 76–87. Ciucci presented the paper in one of several seminars at an international symposium at Harvard on "The Problem of Patronage."
6. Diane Ghirardo, "Italian Architects and Fascist Politics: An Evaluation of the Rationalists Role in Regime Building," *Journal of the American Society of Architectural Historians* 39: 2 (May 1980): 109–127.
7. "From Reality to Myth, Italian Fascist Architecture in Rome," *Modulus 21, The Architectural Review at the University of Virginia* (1991): 12. See also *Building New Communities, New Deal America and Fascist Italy* (Princeton, 1989); "Architects, Exhibitions, and the Politics of Culture in Fascist Italy," *JAE, Journal of Architectural Education* (February 1992): 67–75. The latter is one of three essays on "Architecture and Culture in Fascist Italy." The other two articles are by Libero Andreotti and Jeffrey Schnapp. All three focus on the Exhibit of the Fascist Revolution, the Mostra della Rivoluzione Fascista, of 1932.
8. For example, see Denis P. Doordan, *Building Modern Italy: Italian Architecture 1914–1936* (New York: Princeton Architectural Press, 1988); Thomas L. Schumacher, *Surface and Symbol, Giuseppe Terragni and the Architecture of Italian Rationalism* (New York: Princeton Architectural Press, 1991); Richard A. Etlin, *Modernism in Italian Architecture, 1890–1940* (Cambridge, Mass: MIT Press, 1991).
9. Philip V. Cannistraro, *La Fabbrica del Consenso, Fascismo e Mass Media* (Rome-Bari: La Terza, 1975).

10. See Marla Stone, *The Patron State: Culture and Politics in Fascist Italy* (Princeton: Princeton University Press, 1998); Ruth Ben-Ghiat, *Fascist Modernities, 1922–1945* (Berkeley: University of California Press, 2001); Jeffrey T. Schnapp, "Epic Demonstrations: Fascist Modernity and the 1932 Exhibition of the Fascist Revolution," in Richard J. Golsan, ed., *Fascism, Aesthetics, and Culture* (Hanover, NH: University Press of New England, 1992), 1–37; Simonetta Falasca-Zamponi, *Fascist Spectacle: The Aesthetics of Power in Mussolini's Italy* (Berkeley: University of California Press, 1997); Mabel Berezin, *Making the Fascist Self: The Political Culture of Interwar Italy* (Ithaca, NY: Cornell University Press, 1997).

11. For a negative reaction to this "culturalist approach to Fascism," see R. J. B. Bosworth, *The Italian Dictatorship: Problems and Perspectives in the Interpretation of Mussolini and Fascism* (London: Arnold. 1998): 26–27.

CHAPTER 1

1. Robert C. Fried, *Planning the Eternal City: Roman Politics and Planning Since World War II* (New Haven, Conn. and London: Yale University Press, 1973): 32.
2. Benito Mussolini, *Opera Omnia*, 44 vols., vol. 3 (Florence: La Fenice, 1951–78): 190–191. (Hereafter cited as *Opera Omnia*). My thanks to Joshua Arthurs of the University of Chicago for this reference. He is writing his dissertation on "Roman Modernities: Nation, Empire and Romanità in Fascist Italy."
3. Kostof, *The Third Rome, 1870–1950*, 30; Kostof's quotation of Mussolini is in *Opera Ominia* 25, 84.
4. *Opera Omnia* 18, 160–161.
5. Peter Bondanella, *The Eternal City: Roman Images in the Modern World* (Chapel Hill: University of North Carolina Press): 177.
6. *Opera Omnia* 20, 235.
7. *Opera Omnia* 22, 48.
8. Spiro Kostof, *The Third Rome*, 22.
9. Bondanella, *The Eternal City*, 178.
10. On the Institute and the cult of *romanità*, see the article by Antonio La Penna, "Il culto della romanità, La rivista 'Roma' e Istituto di studi romani," *Italia Contemporanea*, 217 (December 1999): 605–630.
11. Romke Visser, "Fascist Doctrine and the Cult of *Romanità*," *Journal of Contemporary History* 27 (1992): 5–22; Emilio Gentile, "Fascism as a Political Religion," *Journal of Contemporary History* 25 (1990): 229–251, and "The Conquest of Modernity: From Modernist Nationalism to Fascism," *Modernism/Modernity* 1 (September 1994): 54–57.
12. Mark Antliff, "Fascism, Modernism, and Modernity," *The Art Bulletin* 84:1 (March 2002): 152.
13. Italo Insolera, *Roma moderna: Un secolo di storia urbanistica* (Turin: Einaudi, 1962): 121–122.
14. Edwin Ware Hullinger, *The New Fascist State: A Study of Italy under Mussolini* (New York: Rae D. Henkle, 1928): 143–145.
15. John Patric, "Imperial Rome Reborn," *The National Geographic Magazine* 71:3 (March 1937): 269–325.
16. Patric, "Imperial Rome Reborn," 279.
17. Kostof, *The Third Rome*, 33.

18. *Travel in Italy,* Monthly Tourist Review of E.N.I.T., Italian State Tourist Department (October 1935): 22.
19. *Travel in Italy* (April 1936): 2.
20. Antonio Cederna, *Mussolini Urbanista: Lo sventramento di Roma negli anni del consenso* (Rome-Bari: Laterza, 1981): 97ff.
21. Cederna, *Mussolini Urbanista,* 99.
22. Ezra Pound, *Jefferson and/or Mussolini: l'Idea Statale, Fascism as I Have Seen It* (New York: Liveright, 1995) [originally published 1935], 33–34.
23. See entry on Piacentini in Philip V. Cannistraro, ed., *Historical Dictionary of Fascist Italy* (Westport: Greenwood Press, 182): 421.
24. Spiro Kostof, "The Emperor and the Duce: The Planning of Piazzale Augusto Imperatore in Rome," in Millon and Nochlin, *Art and Architecture in the Service of Politics,* 287–289; Cederna, *Mussolini Urbanista,* xix-xx.
25. Antonio Muñoz, *Roma di Mussolini* (Milan: Fratelli Treves, 1935): 149.
26. Muñoz, *Roma di Mussolini,* x.
27. "Ricostruzione della Chiesa S. Rita in Piazza Campitelli," *Capitolium* (1940): 651–653.
28. Georgina Masson, *The Companion Guide to Rome,* revised by Tim Jepson (Suffolk, UK and Rochester, NY: Boydell & Brewer, 2000): 92.
29. Sergio Lambase, ed., *Storia Fotografica di Roma* (Naples: Intra Moenia, 2003), 254.
30. The others were the Ponte Duca D'Aosta, the Ponte Principe Amedeo Savoia Aosta, and the Ponte XXVIII Ottobre, now the Ponte Flaminio.
31. See "Fascio Littorio" in Cannistraro, *Historical Dictionary of Fascist Italy,* 205.
32. "Il Ministero dell'Aeronautica," *Architettura* (1932): 53.
33. "La Nuova Casa di Lavoro per i Ciechi di Guerra," *Architettura* (1932), 3–26; see also Doordan, *Building Modern Italy,* 95.
34. "La Casa Madre dei Mutilati," *Capitolium* (1929): 1–9.
35. *Guida d'Italia della Consociazione Turistica Italiana, Roma e Dintorni* (Milan 1938): 417–418.
36. "Il Foro Mussolini in Roma," *Architettura* (February 1933): 65.
37. See Chapter 3.
38. See "Mentre l'Obelisco Dedicato al Duce Viaggia Verso Roma," *Capitolium* (1929): 270–276. Italo Insolera, *Roma fascista nelle fotografie dell'Istituto Luce* (Rome: Riuniti, 2001): 32–37.
39. The Foro Mussolini will be examined more thoroughly in chapter 3.
40. Kostof, *The Third Rome,* 50.
41. Kostof, 32.
42. *Emporium,* 72 (July-December 1933): 223–235.
43. *Almanacco Fascista del "Popolo d'Italia," 1932,* 348.
44. Insolera, *Roma moderna,* 146.
45. "Il Nuovo Piano Regolatore di Roma," *Emporium* 78 (1933): 223–235; *Architettura,* "Urbanistica della Roma Mussoliniana," special issue, Christmas 1936.
46. "Il Nuovo Piano Regolatore di Roma," *Emporium* 78 (1933): 223.
47. Fried, *Planning the Eternal City,* 35.
48. Reed, "Rome: the Third Sack," 102.
49. Rossi, *Roma, Guida all'architettura moderna* (Rome-Bari: Laterza, 2000): 72.
50. Ghirardo, "From Reality to Myth," 28.
51. Emil Ludwig, *Talks with Mussolini* (Boston: Little, Brown, 1933). The original edition in German appeared in 1932, as did the Italian translation, *Colloqui con Mussolini* (Milan: Mondadori, 1932).

CHAPTER 2

1. "Do You Know Italy?" (Rome-E.N.I.T., n.d.) [Wolfsonian Collection].
2. "Roma di Mussolini," *Opere Pubbliche-Decennale*, 359. [Wolfsonian Collection].
3. *Travel in Italy* (January 1933): 4.
4. Ghirardo, "From Reality to Myth," 26.
5. *Travel in Italy* (January 1933): 4–5.
6. *Casabella*, 85 (January 1935): 13.
7. Heather Hyde Minor, "Mapping Mussolini: Ritual and Cartography in Public Art during the Second Roman Empire," *Imago Mundi:* The International Journal for the History of Cartography 51 (1999): 153. See also Muñoz, *Roma di Mussolini*, 221–222.
8. See Minor, "Mapping Mussolini," 153ff.
9. Guido Calza, "The Via dell'Impero and the Imperial Fora," *Journal of the Royal Institute of British Architects* (March 1934): 491.
10. Calza, "The Via dell'Impero and the Imperial Fora," 499, 503.
11. On the Mostra della Rivoluzione Fascista, see Marla Stone, "Staging Fascism: The Exhibition of the Fascist Revolution," *Journal of Contemporary History* 28 (April 1993): 215–243, and *Patron State*, chapter 5; also Jeffrey T. Schnapp, "Epic Demonstrations," 1–38; and articles by Schnapp, Diane Ghirardo and Libero Andreotti in *JAE: Journal of Architectural Education* 45 (February 1992): 67–106.
12. Margherita Sarfatti, "Architettura, Arte e Simbolo alla Mostra della Rivoluzione," *Architettura* (January 1933): 1.
13. See Claudio Fogu, "Fascism and *Historic* Representation: The 1932 Garibaldian Celebrations," *Journal of Contemporary History* 31:2 (April 1996): 317–345, and his *The Historic Imaginary: Politics of History in Fascist Italy* (Toronto: University of Toronto Press, 2003): 122–130.
14. Dino Alfieri and Luigi Freddi, *Mostra della Rivoluzione Fascista* (Rome: Partito Nazionale Fascista, 1933; facsimile edition, Milan: Industrie Grafiche Italiana, 1982.)
15. Barbara Allason, *Memorie di un antifascista* (Milan, 1961; originally published in 1947): 123–125.
16. After the exhibit closed, the Fascist Party published a large folio volume with many photographs and a day-by-day chronicle of visitors: Francesco Gargano, *Italiani e stranieri alla Mostra della Rivoluzione* (Rome: SAIE, 1935).
17. Anthony Eden, *Facing the Dictators: The Memoirs of Anthony Eden, Earl of Avon* (Boston: Houghton Mifflin, 1962): 88.
18. *Il Popolo d'Italia*, September 27, 1934.
19. Rossi, *Roma, Guida all'architettura moderna*, 104–107.
20. Herman Finer, *Mussolini's Italy* (New York: Grosset & Dunlap, 1965; originally published in 1935): 397–398.
21. Kostof in Millon, *Art and Architecture in the Service of Politics*, 287.
22. Antonio Muñoz, *Via dei Trionfi* (Rome: Governatorato di Roma, 1933): 5–6.
23. Muñoz, *Via dei Trionfi*, 22.
24. "Il Parco del Colle Oppio," *Capitolium* (1928): 130–138.
25. Antonio Muñoz, *Il Parco di Traino e La Sistemazione delle Terme Imperiali* (Rome: Biblioteca d'Arte, 1936): 16.
26. Muñoz, *Roma di Mussolini*, 412–418.
27. *Travel in Italy* (October 1934): 5.
28. Antonio Muñoz, "La Via del Circo Massimo," *Capitolium* (1934): 479–481.

29. Mazzini had favored a republican Italy, and Ugo La Malfa was the leader of Italy's Republican Party at the time. Hence the fascist *piazzale* became a site celebrating the end of the monarchy and the beginning of the republic.

30. These and other exhibitions will receive full treatment in chapter 4.

31. Bruno Tobia, *L'Altare della Patria* (Bologna: Mulino, 1998): 87–88.

32. Philip M. Hannan, *Rome: Living Under the Axis* (McKees Rocks, Penn.: St. Andrew's Productions, 2003): 31–32.

33. "Nel Natale di Roma," *Capitolium* (1940): 631–636.

34. *Roma e Dintorni*, 111–112; "Il Nuova Museo Mussolini," *Capitolium* (1925–26): 469–481.

35. Masson, *Companion Guide to Rome*, 10.

36. "L'Isolamento del Campidoglio, Demolizioni e Ricordi," *Capitolium* (1940): 521–538.

37. "L'Ara dei Caduti Fascisti," *Capitolium* (1926–27): 424; "L'Ara dei Caduti Fascisti Eretta sul Campidoglio," *Capitolium* (1928): 416–418.

38. *Dizionario Mussoliniano, 1500 Affermazioni e Definizioni del Duce* (Milan: Farigliano, 1992): 154.

39. "L'Isolamento della Mole Adriana," *Capitolium* (1934): 209–210.

40. "La Nuova Sede Provinciale dell'Istituto Nazionale Fascista della Previdenza Sociale," *Architettura* (October 1939): 607.

41. "Mussolini Builds a Rome of the Caesars," *New York Times*, Sunday, March 19, 1933, VI, 6.

42. "Dreams of Empire Kindle Rome," *New York Times*, Sunday, August 25, 1935, VIII, 1.

43. *Il Popolo d'Italia*, October 23, 1934.

44. *Travel in Italy* (October 1936): 39.

45. "Dalla Mostra alle Corporazioni," *Capitolium* (1934): 518.

46. Alexander De Grand, *Italian Fascism*, 3rd edition (Lincoln and London: University of Nebraska Press, 2000): 80.

CHAPTER 3

1. Giuseppe Prezzolini, *Italy* (Florence: Valacchi Publisher, 1939): 95.

2. Quoted in *Dizionario Mussoliniano*, 169.

3. "Nuove Opere al Foro Mussolini," *Capitolium* (1938): 199.

4. "Per L'Incremento dell'Educazione Fisica nell'Urbe," *Capitolium* (1930): 389.

5. For a brief overview of the Foro and its subsequent development see Rossi, *Roma, Guida all'architettura moderna*, 44–48; for a more detailed summary of the Foro's history from the beginning to the World Cup soccer matches in 1990, see Comitato dei Monumenti Moderni, *Il Foro Italico* (Rome: Clear, 1990).

6. "Il Concorso per il Ponte sul Tevere al Foro Mussolini," *Architettura* (July 1936): 310–313.

7. "Mentre l'Obelisco Dedicato al Duce Viaggia Verso Roma," *Capitolium* (1929): 270–276.

8. See Tiziana Gazzini, "Invisible Architecture," in the magazine *Follow Me*: Anno III n. 19 (May 1991): 46–52. See chapter 7 for details of the Allied occupation of the forum.

9. "Nuove Opere al Foro Mussolini," *Capitolium* (1938): 200–202.

10. See "Il Piazzale dell'Impero al Foro Mussolini in Roma," *Architettura* (September-October 1941): 347–351.

11. David Ward, *Antifascisms: Cultural Politics in Italy 1943–46* (Madison, NJ, & London 1996): 135.

12. Peter Aicher, "Mussolini's Forum and the Myth of Augustan Rome," *The Classical Bulletin* 76.2 (2000): 134.

13. "Fontana Marmorea al Foro Mussolini in Roma," *Architettura* (March 1935): 132.

14. For the postwar transformation of the stadium, see Rossi, *Roma, Guida all'architettura moderna,* 351–353.

15. *Travel in Italy* (December 1934): 13.

16. "Lo Stadio Olimpionico ed i Campi di Allenamento per il Tennis al Foro Mussolini in Roma," *Architettura* (February 1935): 65–71.

17. *Almanacco Fascista del Popolo d'Italia 1937,* 160.

18. Rossi, *Roma, Guida all'architettura moderna,* 46.

19. On the debate, see chapter 4.

20. "[Moretti] è moderno, ma si defende a spada tratta dall'essere ritenuto un razionalista: ed infatti, a tener conto dell'equilibrata valutazzione che egli fa degli apporti della forma e del contenuto all'unità attiva dell'opera d'arte, egli è senza dubbio un classico." "La Casa delle Armi al Foro Mussolini in Roma," *Architettura* (August 1937): 437.

21. Robert Kahn, ed., *City Secrets- Rome* (New York: The Little Bookstore, 1999): 236.

22. *Il Foro Mussolini,* preface by Renato Ricci (Milan 1937): 5 [Wolfsonian Collection].

23. *Almanacco Fascista del Popolo d'Italia 1937,* 160.

24. Tim Benton, "Rome Reclaims Its Empire," in Dawn Ades et al., eds., *Art and Power: Europe under the Dictators 1930–1945* (London: Hayward Gallery, 1995): 124.

25. For a summary of the competitions of 1934 and 1937, see Rossi, *Roma, Guida moderna all'architettura moderna,* 104–105, 122–123.

26. The review of the design in Pagano's journal acknowledged the massive building had some of the qualities of a palazzo in the tradition of civic architecture in the Renaissance and of modern rationalist architecture, but unfortunately tended toward a conventional monumentality. "Documenti del Concorso per la Casa Littoria di Roma," *Casabella,* 122 (February 1938): 20–21.

27. "Nuove Opere al Foro Mussolini," *Capitolium* (1938): 197–202.

28. *Il Foro Mussolini* (Milan 1937): 6 [Wolfsonian Collection].

29. *Attraverso L'Italia,* vol. 9, *Roma, Parte II* (Milan: Consociazione Turistica Italiana, 1942): photograph no. 256, p. 125.

30. Guglielmo Ceroni, *Roma nei suoi quartieri e nel suo suburbio* (Rome: Fratelli Palombi, 1942): 205–206; See also Livio Toschi, "Uno Stadio per Roma dallo Stadio Nazionale al Flaminio (1911–1959)" *Studi Romani* 38 (1990): 83–97.

31. *Roma e Dintorni* (1938): 303.

32. Tracy H. Koon, *Believe, Obey, Fight: Political Socialization of Youth in Fascist Italy, 1922–1943* (Chapel Hill and London: University of North Carolina Press, 1985): 101.

33. "Trionfo di Giovinezza," *Capitolium* (1933): 473–476.

34. "Campo Dux," *Capitolium* (1934): 445–456.

35. *Almanacco Fascista del Popolo d'Italia 1937,* 184.

36. Koon, *Believe, Obey, Fight,* 101.

37. Rossi, *Roma, Guida all'architettura moderna,* 203–216.

38. The quotations in this and the previous paragraph are from "La Casa della Giovane Italiana all'Aventino in Roma," *Architettura* (July 1937): 403–411.

39. Rossi, *Roma, Guida all'architettura moderna,* 113.

40. "Casa della Gioventù Italiana del Littorio a Roma in Trastevere," *Architettura* (1941): 360.

41. Patric, "Imperial Rome Reborn," 279.

42. *Almanacco Fascista del Popolo d'Italia 1937,* 174.

43. For a summary see "Educational Policies," Cannistraro, *Historical Dictionary of Fascist Italy,* 180–182.

44. Prezzolini, *Italy,* 164.

45. Quotation and picture are from "La Scuola all'Aperto Rosa Mussolini," *Capitolium* (1929): 588.

46. F. Irace, "L'Utopie Nouvelle: L'Architettura delle Colonie Estive/Building for a New Era: Health Services in the '30s, "*Domus* 659 (March 1985): 3.

47. See chapter 4.

48. See chapter 5.

49. "Progetto per il Nuovo Edificio Scolastico alla Garbatella," *Capitolium* (1929): 148.

50. "La Scuola d'Avviamento Profesionale 'E. F. Duca d'Aosta,'" *Capitolium* (1933), 253–260.

51. "Opere Publiche del Governatorato Inaugurate nella Ricorrenza del 28 Ottobre XVII," *Capitolium* (1939): 433–436.

52. "R. Liceo Ginnasio Giulio Cesare al Corso Trieste in Roma," *Architettura* (August 1937): 455; "Nuova Scuola al Corso Trieste," *Capitolium* (1934): 617–618. See also Irene de Guttry, *Guida di Roma Moderna dal 1870 ad Oggi* (Rome: De Luca, 2001): 72; Giuseppe Strappa and Gianni Mercurio, *Architettura Moderna a Roma nel Lazio 1920–1945* (Roma: EdilStampa, 1990): 191.

53. "Una Nuova Scuola del Governatorato di Roma," *Capitolium* (1933): 35–42; "Scuola Elementare in Roma," *Architettura* (January 1933): 23–34.

54. "Una Nuova Scuola al Lido di Roma," *Capitolium* (1934): 410–412.

55. Mrs. Kenneth Roberts, "Sojourning in the Italy of Today," *National Geographic Magazine* 70:3 (September 1936): 377.

56. Giuseppe Prezzolini, *Italy.*

57. For this paragraph, see Clive Foss, "Teaching Fascism: Schoolbooks of Mussolini's Italy," *Harvard Library Bulletin,* 8:1 (Spring 1997): 5–30; quotation, 10.

58. Alessandro La Bella, *Piccolo Albo di Cultura Fascista* (Milan: Castano Primo, 1934): 27.

59. Foss, "Teaching Fascism," 30.

CHAPTER 4

1. Marla Stone, *The Patron State,* 5–6 and passim.

2. *Fascismo e antifacismo, Lezioni e testimonianze,* third edition (Milan 1971): vol. 1, 335.

3. Etlin, *Modernism in Italian Architecture,* 393, 400.

4. "Casa sul Lungotevere Tor di Nona in Rome," *Architettura* (1932): 582.

5. Doordan, "The Political Content in Italian Architecture during the Fascist Era," *Art Journal* (1983): 130.

6. Benson, "Speaking Without Adjectives, in Ades, *Art and Power,* 42.

7. *Casabella,* 123 (March 1938): 2.

8. Diane Ghirardo, *Building New Communities,* 62.

9. "Architettura Italiana dell'Anno XIV," *Casabella,* 95 (November 1935): 4.

10. Herbert W. Schneider, *The Fascist Government of Italy,* The Governments of Modern Europe (New York: D. Van Nostrand, 1936): 150–51.

11. Ghirardo, "From Reality to Myth, Italian Fascist Architecture in Rome," *Modulus 21* (1991): 18.

12. "Dallo Studium Urbis alla Città degli Studi," *Capitolium* (1933): 603.

13. "Opere Ciclopiche a Roma, La Città Universitaria," *Almanacco Fascista del Popolo d'Italia 1937,* 379–380.

14. Ghirardo, 'From Reality to Myth," 18.

15. Doordan, "The Political Content in Italian Architecture during the Fascist Era," 121.

16. *Architettura,* fascicolo speciale, 1935 as quoted by Rossi, *Roma, Guida all'architettura moderna,* 101.
17. *Casabella,* 99 (March 1936): 2.
18. Rossi, *Roma, Guida all'architettura moderna,* 100.
19. Doordan, "Political Content in Italian Architecture during the Fascist Era," 122.
20. "Opere Ciclopiche a Roma, La Città Universitaria," *Almanacco Fascista del Popolo d'Italia 1937,* 382.
21. "Fascist Architecture," *Travel in Italy* (September 1935): 14–15.
22. *Almanacco Fascista del Popolo d'Italia 1937,* 136.
23. Philip V. Cannistraro and Brian R. Sullivan, *The Duce's Other Woman* (William Morrow and Company: New York, 1993): 475.
24. Christopher Woodward, *The Buildings of Europe: Rome* (Manchester & New York, 1995): 148. See also Rossi, *Roma, Guida all'architettura moderna,* 88.
25. Mirella Duca and Filippo Murgia, "Adalberto Libera: il Palazzo delle Poste, the post office built, Roma," *L'architettura cronache e storia, The Architecture events and history,* 47 (July 2001): 420.
26. See chapter 5.
27. Woodward, *Rome,* 147; Rossi, *Roma, Guida all'architettura moderna,* 87.
28. Strappa and Mercurio, *Architettura Moderna a Roma e nel Lazio,* 200.
29. Rossi, *Roma, Guida all'architettura moderna,* 102.
30. *Opera Omnia* 27, 268–269.
31. Cederna, *Mussolini Urbanista,* xviii-xix, 233–234.
32. "Il Corso del Rinascimento," *Capitolium* (1937): 74–89; Cederna, *Mussolini Urbanista,* 219–232; *Il Popolo d'Italia,* April 26, 1936.
33. Stappa and Mercurio, *Architettura Moderna a Roma e nel Lazio,* 176–77.
34. As quoted in Insolera, *Roma fascista,* 161.
35. "La Parola al Piccone," *Capitolium* (1934): 465–468.
36. See "Lo Scavo e la Ricostruzione dell'Ara Pacis Augustae," *Capitolium* (1938): 479–490. In 2000 this housing for the Ara Pacis was torn down. The planned replacement is the design of American architect Richard Meier, a change that has provoked considerable controversy in Rome.
37. Michael Wise, "Dictator by Design," in *Travel and Leisure* (March 2001): 108.
38. Spiro Kostof, "The Emperor and the Duce: The Planning of Piazzale Augusto Imperatore in Rome," in Millon and Nochlin, *Art and Architecture in the Service of Politics,* 309.
39. Kostof in Millon and Nochlin, 309.
40. Kostof in Millon and Nochlin, 316.
41. Kostof in Millon and Nochlin, 322.
42. "Romanità" in Cannistraro, *Historical Dictionary of Fascist Italy,* 463. See also Philip V. Cannistraro, "Mussolini's Cultural Revolution," *Journal of Contemporary History* (July-October 1972): 127–154.
43. *Almanacco Fascista del Popolo d'Italia 1937,* 306–307.
44. Stone, *The Patron State,* 246.
45. Stone, *The Patron State,* 246.
46. "La Mostra Augustea della Romanità," *Capitolium* (1937): 519–528.
47. "La Mostra Augustea della Romanità," *Architettura* (November 1938): 655–663.
48. "La Mostra della Rivoluzione Fascista a Valle Giulia," *Capitolium* (1937): 515.
49. "La Mostra della Rivoluzione Fascista a Valle Giulia, 517.
50. See *Roma e Dintorni 1938* (CTI *Guida d'Italia*): 325–326.
51. Gigliola Fioravanti, ed., *Mostra della Rivoluzione Fascista, Inventario* (Rome: Ministero per i beni culturali e ambientali, 1990): 40.

52. ACS, PNF Direzione Servizi vari, Serie II, Busta 332, fasc. "A XIX" (April 1941).

53. *Il Popolo d'Italia,* September 4, 1937.

54. Stone, *The Patron State,* 302, n. 13.

55. See Stone, *The Patron State,* 226–244 for a good summary and discussion of the four exhibits in the Circus Maximus.

56. "La Mostra delle Colonie Estive e dell'Assistenza all'Infanzia," *Casabella* 116 (August 1937): 10–15.

57. *Il Popolo d'Italia,* June 16, 1937.

58. *Il Popolo d'Italia,* May 26, 1939.

59. Victoria De Grazia, *How Fascism Ruled Women: Italy, 1922–1945* (Berkeley: University of California Press, 1994) explores fascist policies and practices for women thoroughly, including such contradictions.

60. "La Mostra delle Colonie Estive e dell'Assistenza all'Infanzia in Roma," *Architettura* (June 1937): 307.

61. "Una Visita alla Mostra delle Colonie Estive," *Capitolium* (1937): 496.

62. Stone, *Patron State,* 304, n. 54.

63. Francesco Garofalo and Luca Veresani, *Adalberto Libera* (New York: Princeton Architectural Press, 1992; original Italian edition 1989): 98.

64. "La Mostra delle Colonie Estive e dell'Assistenza in Roma," *Architettura,* 313.

65. "La Mostra delle Colonie Estive e dell'Assistenza all'Infanzia," *Casabella,* 116 (August 1937): 6.

66. See Stone, *Patron State,* 226; *Il Popolo d'Italia,* November 19, 1937.

67. "Abbiamo realizzato l'imperativo del Duce verso il popolo. Le nostre fibre hanno dato al popolo italiano la possibilità di vestirsi degnamente con spesa modesta," in "Discorso sulla Mostra Romana del Tessile," *Casabella,* 121 (January 1938): 26.

68. See article on "Dopolavoro," in Cannistraro, *Historical Dictionary of Fascist Italy,* 175–177. The best book on the Dopolavoro is Victoria de Grazia, *The Culture of Consent: Mass Organization and Leisure in Fascist Italy* (Cambridge: Cambridge University Press, 1981).

69. "La Prima Mostra dell'Opera Nazionale Dopolavoro al Circo Massimo," *Capitolium* (1938): 353.

70. "La Prima Mostra dell'Opera Nazionale Dopolavoro," 355–356.

71. "La Prima Mostra dell'Opera Nazionale Dopolavoro," 358–359.

72. Stone, *Patron State,* 240.

73. Stone, *Patron State,* p. 304, n. 54.

74. Antonella Russo, *Il fascismo in mostra* (Rome: Riuniti, 1999): 25.

75. "Mostra Autarchica del Minerale Italiano in Roma," *Architettura* (April 1939): 197.

76. "La Prima Mostra Autarchica del Minerale Italiano," *Capitolium* (1939): 211–213.

77. "Mostra Autarchica del Minerale Italiano in Roma," *Architettura,* 197–229.

78. Stone, *Patron State,* 242–243.

79. "E non si dobrebbe scrivendo della Roma di Mussolini, parlare della redenzione dell'Agro Pontino?" *Roma, Part I* (Rome: Consociazione Turistica Italiana, 1941): 21.

80. Ruth Ben-Ghiat, *Fascist Modernities,* 4.

81. Quoted in Henry A. Millon, "Some New Towns in Italy in the 1930s," in Millon and Nochlin, *Art and Architecture in the Service of Politics,* 326.

82. Carl Ipsen, *Dictating Demography: The Problem of Population in Fascist Italy* (Cambridge: Cambridge University Press, 1996): 113.

83. Gelasio Caetani, "By Draining the Malarial Wastes Around Rome, Italy Has Created a Promised Land," *National Geographic Magazine* 66:2 (August 1934): 201.

84. Diane Ghirardo, *Building New Communities,* 44–45.

85. Ghirardo, *Building New Communities,* 78–79.

86. Millon, "Some New Towns in Italy in the 1930s," in Millon and Nochlin, *Art and Power in the Service of Politics*, 332.
87. Claudio Galeazzi and Giorgio Muratore, *Littoria-Latina, La Storia, Le Architetture* (Latina: Novecento, 1999): 199–200.
88. *Opera Omnia*, 25, 185.
89. Ipsen, *Dictating Demography*, 112.
90. *Guida d'Italia, Lazio,* Touring Club Italiano (Milan: Touring Editore, 1999): 132.
91. Ghirardo, *Building New Communities*, 62.
92. Ghirardo, *Building New Communities*, 78.
93. *Sabaudia, Città Nuova e Fascista* (London: Architectural Association 1981) [Wolfsonian Collection]: 2.
94. Mellon, "Some New Towns in Italy in the 1930s" in Millon and Nochlin, *Art and Power in the Service of Politics*, 332.
95. Ghriardo, *Building New Communities*, 75. She also states: "Visiting the town now, it is difficult to see why it was so controversial at the time, and why subsequent scholars have lavished such praise on it and not on the other towns" (75) .
96. Ghirardo, *Building New Communities*, 53.
97. *Guida Breve, Italia Centrale* (Milan: Touring Club Italiano, 1949): 360–364.
98. Frank M. Snowden, "From Triumph to Disaster: Fascism and Malaria in the Pontine Marshes, 1928–1946," in John Dickie, John Foot, and Frank M. Snowden, eds., *Disastro! Disasters in Italy Since 1860, Culture, Politics, Society* (New York: Palgrave, 2002): 113–140.

CHAPTER 5

1. Quoted in Carl Ipsen, *Dictating Demography*, 68.
2. *Casabella*, 116 (August 1937): 6.
3. Irene de Guttry, *Guida di Roma Moderna*, 52.
4. Insolera, *Roma Moderna*, 152; Antonio Gollini, "La Popolazione" in Luigi De Rosa, ed., *Roma del Duemila*, (Rome-Bari: Laterza, 2000): 121–122.
5. "Sviluppo Urbanistico di Roma, Attraverso le Nuove Strade Governatoriali," *Capitolium* (1938), 81–86.
6. Diane Ghirardo, "*Città Fascista:* Surveillance and Spectacle," *Journal of Contemporary History* 31 (1996): 349.
7. See Italo Insolera, *Roma Moderna*, ch. 11, "Gli seventramenti e le borgate," 136–151.
8. "Una Giornata ad Acilia," *Capitolium* (1940): 647–650.
9. Muñoz, *Roma di Mussolini*, 372.
10. See the comments of Rossi, *Roma, Guida all'architettura moderna*, 73.
11. Insolera, *Roma Moderna*, 145.
12. See Rossi, Roma, *Guida all'architettura moderna*, "Gli sventramenti e le borgate ufficiali," 74–78.
13. Fried, *Planning the Eternal City*, 38.
14. Kostof, *Third Rome*, 20.
15. *New York Times,* Sunday, March 19, 1933, VI: 6.
16. "Delenda Baracca," *Capitolium* (1931): 44–48.
17. Quoted in Alessandro Portelli, *The Order Has Been Carried Out: History Memory, and Meaning of a Nazi Massacre in Rome* (New York: Palgrave Macmillan, 2003): 62.
18. "L'Ufficio di Assistenza Sociale nel 1931 (IX-X), III-Servizi Vari," *Capitolium* (1932): 134–141.

19. Giuseppe Aldo Rossi, *Monte Mario, Profilo storico, artistico e ambientale dal colle più alta di Roma* (Rome: Montimer, 1996): 154.

20. For example, see Portelli, *The Order Has Been Carried Out*, 236–239, and Franco Ferrarotti, "Tendenze Evolutive," in De Rosa, *Roma del Duemila*, 229–232.

21. Augusto Moltoni as quoted in Portelli, *The Order Has Been Carried Out*, 62. I visited Primavalle in 1996 and talked with two of the original residents who gave similar accounts of their transfer there and told of the antifascist political culture that developed.

22. "Il Nuovo Centro Assistenziale per la Borgata Tiburtina III," *Capitolium* (1939): 177–180.

23. See Rossi, *Roma, Guida all'architettura moderna*, "Quartiere San Saba," 2–3.

24. Its new name was Istituto Fascista Autonomo per le Case Popolari.

25. Strappa and Mercurio, *Architettura Moderna a Roma e nel Lazio*, 148.

26. Irene de Guttry, *Guida di Roma Moderna*, 69. See also Steven Brooke, *Views of Rome* (New York: Rizzoli, 1995): 209. "Innocenzo Sabbatini joined the new Institute for Public Housing [ICP] in 1919. Though not a strict rationalist, Sabbatini joined the group, seeking new solutions to public housing for the rapidly expanding population. His four housing blocks for the new garden suburb of Garbatella, built in 1927, departed from the Italian tradition of large structures built around open-air courtyards. His buildings were often characterized by wings radiating from a central block. Some even included communal facilities."

27. *Architettura* (February 1936): 88–90.

28. Rossi, *Roma, Guida all'architettura moderna*, 56; Irene de Guttry, *Guida di Roma moderna*, 43–44; Strappa and Mercurio, *Architettura Moderna a Roma e nel Lazio*, 168.

29. "Gruppo di Case Popolari in Via Donna Olimpia in Roma," *Architettura* (September 1939): 571.

30. Portelli, *The Order Has Been Carried Out*, 61.

31. See, Rossi, *Roma, Guida all'architettura moderna*, 118; *Opere pubbliche: rassegna mensile illustrate* (Rome 1932): 434–438 [Wolfsonian].

32. "Alloggi e Provvidenze Relative," *Capitolium* (1930): 150–152.

33. "II—Alloggi e Provvidenze Relative," *Capitolium* (1931), 78.

34. John Agnew, *Rome* (New York: John Wiley & Sons, 1995): 64.

35. "II-Alloggi e Providenza Relative," *Capitolium* (1931): 70–83.

36. For more on the film, see chapter 6.

37. See Chapter 6.

38. Rossi, *Roma, Guida all'architettura moderna*, 50.

39. Irene de Guttry, *Guida di Roma moderna*, 71, 51; Strappa and Mercurio, *Architettura Moderna a Roma e nel Lazio*, 173.

40. Insolera, *Roma fascista*, 71.

41. "Mostre delle Abitazioni, L'Istituto per le Case dei Dipendenti del Governatorato," *Capitolium* (1929): 532–537.

42. See "Concorso per gli Uffici postale 1932–1933," Rossi, *Roma, Guida all'architettura moderna*, 84–86.

43. "Sistemazione Edilizia della Zona di Porta Angelica a Roma," *Architettura* (December 1941): 452.

44. Strappa and Mercurio, *Architettura Moderna a Roma e nel Lazio*, 226–227.

45. Agnew, *Rome*, 46; also note: "the villa-apartments (*villini* and *palazzine*) are the building type of the bourgeoisie whereas *la casa intensiva*, or multi-storey block of apartments, is typical for the areas, with status decreasing as the number of storeys increases" (123).

46. For what follows, see the two articles on the Aventine in *Studi Romani* 43: 1–2 (January-June 1995): 56–80 and 43: 3–4 (July-December 1995): 297–319.

47. *Studi Romani* 43: 303.

48. Rossi, *Roma, Guida all'architettura moderna*, 122–123.

49. See "II-Case, Alloggi e Providenze Relative," *Capitolium* (1932): 127–133.
50. Strappa and Mercurio, *Architettura Moderna a Roma e nel Lazio*, 169; de Guttry, *Guida di Roma Moderna*, 70.
51. de Guttry, *Guida di Roma Moderna*, 74.
52. "Il duce capocantiere," in Sergio Luzzatto, *L'immagine del duce, Mussolini nelle fotografie dell'Istituto Luce* (Rome: Riuniti, 2001): 205–207.
53. "Il Viale Maresciallo Pilsudski in Roma," *Capitolium* (1938): 105–116.
54. Strappa and Mercurio, *Architettura Moderna a Roma e nel Lazio*, 157.
55. "Opere Pubbliche del Governatorato Inaugurate nella Ricorrenza del 28 October XVII," *Capitolium* (1939): 427.
56. "Buozzi, Bruno," in Cannistraro, *Historical Dictionary of Fascist Italy*, 93–94.
57. "Villino P. sui Colli Parioli a Roma," *Architettura* (January 1938): 1–4.
58. Rossi, *Rome, Guida all'architettura moderna*, 121.
59. "Palazzina in Via S. Valentino a Roma, Arch. Mario Ridolfi," *Architettura* (May 1939): 283–285; Rossi, *Roma, Guida all'architettura moderna*, 116.
60. Rossi, *Roma, Guida architettura moderna*, p. 115.
61. Rossi, *Roma, Guida architettura moderna*, p. 59.
62. "Casa in Via Archimede in Roma, Arch. Mario Tufaroli Luciano," *Architettura* (November 1936): 547–548.
63. Rossi, *Roma, Guida all'archtiettura moderna*, p. 128; Strappa and Mercurio, 223.
64. "Palazzina in Via Maria Adelaide a Roma, Architetto Gino Franzi," *Architettura* (May 1937): 259–263; Rossi, *Roma Guida all'architettura moderna*, p. 177; Strappa and Mercurio, *Architettura Moderna a Roma e nel Lazio*, 208.
65. "Case d'Abitazione in Roma, Arch. Angelo Di Castro," *Architettura* (July 1937): 413–415.
66. "Palazzetto Papi al Lungotevere Flaminio in Roma," *Architettura* (September 1939): 566–567.
67. Rossi, *Rome, Guida all'architettura moderna*, 131; de Guttry, *Guida di Roma Moderna*, 57; Strappa and Mercurio, 207.
68. "Palazzina ed Appartamenti in Via Bruxelles in Roma, Arch. Andrea Busiri-Vici," *Architettura* (October 1936): 497; Rossi, *Roma, Guida all'architettura moderna*, 109.
69. "Casa in Via Panama in Roma, Arch. Mario Tufaroli Luciano," *Architettura* (November 1936): 552–553.
70. "Palazzine Signorili in Roma, Arch. Mario Tufaroli Luciano," *Architettura* (November 1937): 627.
71. de Guttry, *Guida di Roma Moderna*, 54.
72. Rossi, *Roma, Guida all'architettura moderna*, 62; de Guttry, *Guida di Roma Moderna*, 56; Strappa and Mercurio, *Architettura Moderna a Roma e nel Lazio*, 174.
73. de Guttry, *Guida di Roma Moderna*, 72.
74. Strappa and Mercurio, 188.
75. Irene de Guttry, *Guida, di Roma Moderna*, 51.
76. "Casa Ceradini in Via Amba Aradam in Roma," *Architettura* (October 1936): 503.
77. Strappa and Mercurio, 190.
78. Strappa and Mercurio, 202.
79. Rossi, *Roma, Guida all'architettura moderna*, 93; Garofalo and Veresani, *Adlaberto Libera*, 63.
80. Rossi, *Roma, Guida all'architettura moderna*, 103; Strappa and Mercurio, *Architettura Moderna a Roma e nel Lazio*, 130.
81. Andrea Riccardi, "Capitale del Cattolicesimo," in De Rosa, *Roma del Duemila*, 49.
82. "Cronache Romane, La Chiesa di Cristo Re," *Emporium* (1934): 41–42.
83. Muñoz, *Roma di Mussolini*, 377–381; Prezzolini, *Italy*, 142–150. Today the Ospedale Littorio is the Ospedale S. Camillo.

84. Sepp Schüller, *Das Rom Mussolinis, Rom als Moderne Haupstadt* (Dusseldorf: Mosella-Verlag, 1943): 10 [Text in both German and Italian].

CHAPTER 6

1. Quoted in Simonetta Fraquelli, "All Roads Lead to Rome," in Ades, *Art and Power,* 136.
2. See Cannistraro, *La fabbrica del Consenso* and Renzo De Felice, *Mussolini il duce, Gli anni del consenso 1929–1936* (Milan: Einaudi, 1974).
3. Cannistraro, "Ministry of Popular Culture," in *Historical Dictionary of Fascist Italy,* 339–340.
4. Strappa and Mercurio, *Architettura Moderna a Roma e nel Lazio,* 210.
5. Ruth Ben-Ghiat, *Fascist Modernities,* 139.
6. Lutz Becker, "Black Shirts and White Telephones," in Ades, *Art and Power,* 138.
7. Strappa and Mercurio, 211. See also "Luce," in Cannistraro, *Historical Dictionary of Fascist Italy,* 313–314.
8. Ben-Ghiat, *Fascist Modernities,* 92.
9. "La 'fede' ideale," *Il Popolo d'Italia,* December 19, 1935; *Almanacco Fascista del Popolo d'Italia 1937,* 139, 146–147.
10. Letter of June 8, 1931 from Hitler to Mussolini in "Mussolini and Italian Fascism," in Borden W. Painter, ed., *Cesare Barbieri Courier* (Hartford: Trinity College 1980): 25–27.
11. *Il Popolo d'Italia,* September 1, 1937.
12. Richard Bosworth, *Mussolini* (Arnold: London, 2002): 329. The quotation is from *Opera Omnia* 29, 1.
13. "Padiglione Provvisorio della Stazione di Roma Ostiense, *Architettura* (August 1938): 489–494.
14. Heather Minor, "Mapping Mussolini," 159.
15. "Strutture Lamellari Metalliche per L'Esecuzione di Tettoia," *Casabella* 133 (January 1939): 38–41.
16. "La Sistemazione Ferroviaria di Roma nei suoi Riflessi Urbanistici," *Capitolium* (1938): 391.
17. *New York Times,* May 4, 1938: 1.
18. *New York Times,* May 4, 1938: 18.
19. Hannan, *Rome: Living Under the Axis,* 207.
20. *New York Times,* May 7, 1938: 5.
21. loc cit.
22. "Roma Pavesata," *Capitolium* (1938): 223.
23. Viale XXI Aprile 21–29 in the Piazza Bologna neighborhood. See chapter 5.
24. Memmo Caporilli and Franco Simeoni, *Il Foro Italico e lo Stadio Olimpico, Immagini della Storia* (Rome: Tomo, 1991): 128.
25. "Sistemazione Ferroviaria di Roma nei suoi Riflessi Urbanistici," *Capitolium* (1938): 392.
26. "The Town Plan," *Architettura,* Special Edition (1938): 742.
27. "La Sistemazione Ferroviaria di Roma nei suoi Riflessi Urbantistici," *Capitolium* (1938): 390.
28. "La Statzione di Termini," *Capitolium* (1940): 820–828.
29. "La Sistemazione Ferroviaria di Roma nei suoi Riflessi Urbanistici," *Capitolium* (1938): 389. See also "La Sistemazione dei Servizi Ferroviaria dell'Urbe," *Capitolium* (1938): 378.
30. Rossi, *Roma, Guida all'architettura moderna,* 160.
31. Rossi, *Roma, Guida all'architettura moderna,* 161.

32. *Casabella,* 149 (May 1940): 2–3.

33. *Architettura,* Special Issue (1939): 76.

34. *Capitolium* (1940): 825; *Roma e Dintorni* (1938): 240.

35. *Il Popolo d'Italia,* April 24, 1938.

36. Today the building is the Consiglio Superiore della Magistratura.

37. Apparently the building was originally the Istituto Commerciale designed by Alberto Calza
 Bini and Mario De Renzi, *Roma e Dintorni* (1938): 250; on the unpublished Oriani novel,
 see Painter, *Cesare Barbieri Courier* (1980): 11–12.

38. "Town Planning and Architecture," *Architettura* (December 1938): 728.

39. "The 1942 Universal Exhibition," *Architettura* (December 1938): 723.

40. "Town Planning and Architecture," *Architettura* (December 1938): 728.

41. Italo Insolera, *Roma Moderna,* 171–172.

42. "Del Monumentale nell'Architettura," *Casabella* (March 1938): 1–2.

43. Quoted in Tim Benton, "Speaking Without Adjectives," in Ades, *Art and Power,* 42.

44. Rossi, *Roma, Guida all'architettura moderna,* 136.

45. Fraquelli in Ades, *Art and Power,* 130.

46. "Il Palazzo degli Uffici dell'Esposizione Universale di Roma," *Costruzioni-Casabella,* 151,
 152, 153 (July-September 1940): 4–8.

47. For its postwar history, see chapter 7.

48. See Rossi, *Roma, Guida all'architettura moderna,* 144.

49. "Il Parco Cestio," *Capitolium* (1939): 184–185; "Il Parco Cestio," *Capitolium* (1940):
 654–655.

50. "L'Inaugurazione delle Opere Realizzate nell'Urbe nell'Anno XVIII," *Capitolium* (1940):
 817–818.

51. "La Via Imperiale," *Capitolium* (1939): 1; see also "Opere Pubbliche del Governatorato In-
 augurate nella Ricorerenza del 28 Ottobre XVII," *Capitolium* (1939): 423–427.

52. "Concorso per il ministero dell'Africa Italiana," *Architettura* (November 1939): 665.

53. *Baedecker's Italy from the Alps to Naples* (Leipzig: Karl Baedeker, 1928): 322; "La Passeggiata
 Archeologica," *Capitolium* (1939): 83–87.

54. "Guido Bacelli e il Suo Monumento," *Capitolium* (1931): 175–186.

55. "Il Sistema delle Strade di Accesso all'Esposizione Universale del 1942," *Capitolium*
 (1939): 397–414. This article contains photos, maps, and drawings depicting the Via Im-
 periale.

56. *New York Times,* February 17, 1937, 14:2.

57. See EUR MCMXLII—XX EF [Wolfsonian Collection].

58. "La Via XXIII Marzo," *Capitolium* (1940): 585–594.

59. Cannistraro, *Historical Dictionary of Fascist Italy,* 121–23.

60. Alberta Campitelli, "Villa Paganini Alberoni," in Luisa Cardelli, ed., *Gli Anni del Gover-
 natorato (1926–1944)* (Rome: Kappa): 183–186.

61. "Dallo Studium Urbis alla Città degli Studi," *Capitolium* (1933): 581.

62. "La Via XXIII Marzo," *Capitolium* (1940): 585.

63. Ibid., 593–594.

64. *Roma e Dintorni* (1938): 626.

65. "Nuovi Fabbricati in Via 4 Fontane e Via XX Settembre a Roma," *Architettura* (August
 1938): 457–471.

66. "La Nuova Sistemazione della Mostra della Rivoluzione Fascista in Roma," *Architettura*
 (January 1943): 1–10.

67. Paul Corner sees the war in Ethiopia ushering in "what has been termed the 'totalitar-
 ian phase', a phase which saw the attempt to increase the Fascist presence in the daily
 life of Italians in an effort to produce a truly Fascist nation." "Italy 1915–1945: Politics

and Society," in *The Oxford History of Italy* (Oxford: Oxford University Press, 1997): 282–283.

68. Clive Hirschorn, *The Hollywood Musical* (New York: Crown, 1981): 95.

69. See Borden Painter, "American Films in Fascist Propaganda: The Case of the Exhibition of the Fascist Revolution 1942–43," *Film & History* 22:3 (September 1992): 100–111.

70. Lucilla Albano, "Hollywood: Cinelandia" in *Cinema italiano sotto il fascismo,* edited by Riccardo Redi (Venice: Marsilio, 1979): 230–231.

71. ACS, MRF, b. 15, fasc. 109, December 14, 1942.

72. *Il Popolo d'Italia,* February 23, 1943.

CHAPTER 7

1. "At the army's high point in April 1943 it thus numbered almost 3.7 million officers and men. Its combat units were as under equipped, undermanned, inadequately officered, and poorly supported as they had been at the outset." MacGregor Knox, *Hitler's Italian Allies: Royal Armed Forces, Fascist Regime, and the War of 1940–1943* (Cambridge: Cambridge University Press, 2000): 56–57. See also Denis Mack Smith, *Mussolini's Roman Empire* (New York: Viking Press, 1976) on the gap between rhetoric and reality on the Italian military.

2. Letter of Colonel Paul T. Hanley, February 2, 1953. Copy in possession of the author.

3. *New York Times,* June 11, 1940, 1 & 4.

4. "10 Giugno XVIII," *Capitolium* (1940): 685–686.

5. "L'Inaugurazione delle Opere Realizzate nell'Urbe nell'Anno XVIII," *Capitolium* (1940): 813–819.

6. "I Nuovi Ponti sul Tevere nella Loro Funzione Urbanistica," *Capitolium* (1939): 449–453.

7. Ibid., 453–48.

8. For a concise description of this plan, see Rossi, *Roma, Guida all'architettura moderna,* 150–153.

9. See, for example, the maps in Anna Maria Ramiera, "La via Imperiale e le scoperte archeologiche (1937–1941)," in Cardilli, *Gli Anni del Governatorato,* 111.

10. Rossi, *Roma, Guida all'architettura moderna,* 152. See also Insolera, *Roma moderna,* 171.

11. Original newsreel reproduced in video cassette *La Guerra del Duce 1942, Prima Parte* (Hobby & Work Italiana: Milan, 1997).

12. Caporilli and Simeoni, *Il Foro Italico e lo Stadio Olimpico,* 256–257.

13. M. Zocca quoted in Insolera, *Roma moderna,* 172. See also Rossi, *Roma, Guida all'architettura moderna,* 150–154.

14. Elena Agarossi, *A Nation Collapses: The Italian Surrender of September 1943* (Cambridge: Cambridge University Press, 2000): 87–89.

15. Robert Katz, *The Battle for Rome: The Germans, the Allies, the Partisans, and the Pope, September 1943–June 1944* (New York: Simon & Schuster, 2003): 38.

16. Jane Scrivener, *Inside Rome with the Germans* (New York: Macmillan, 1945): 5.

17. Scrivener, *Inside Rome with the Germans,* 6–7.

18. For an account of Jews during the fascist period, see Alexander Stille: *Benevolence and Betrayal, Five Italian Jewish Families Under Fascism* (New York: Simon & Schuster, 1991).

19. For recent views on this subject, see Joshua Zimmerman, ed., *The Jews of Italy under Fascist and Nazi Rule, 1922–1945* (New York: Cambridge University Press, 2005).

20. For accounts of the fate of Rome's Jews, see Robert Katz, *Black Sabbath: A Journey Through a Crime Against Humanity* (New York: Macmillan, 1969) and *The Battle for Rome.*

21. Scrivener, *Inside Rome with the Germans,* 38–39.

22. Susan Zuccotti, *Under His Very Windows: The Vatican and the Holocaust in Italy* (New Haven & London: Yale University Press, 2000): 155–156.

23. Katz, *The Battle for Rome,* 224–225.

24. Katz, *Death in Rome* (New York: Macmillan, 1967): 73.

25. Stanislao G. Pugliese, *Desperate Inscription: Graffiti from the Nazi Prison in Rome 1943–1944* (Boca Raton: Bordighera Press, 2002): 11.

26. See *Desperate Inscriptions* for examples.

27. Pugliese, *Desperate Inscriptions,* 8–9, 49.

28. See photographs in Antonio Spinosa, *Salò, Una Storia per Immagini* (Milan: Mondadori, 1992).

29. Caporilli and Semeoni, *Il Foro Italico e lo Stadio Olimpico,* 269.

30. See Appendix II for a list of principal examples.

31. There is a Largo dei Caduti di El Alamein in the Via Tuscolana southeast of the center and just beyond Cinecittà.

32. "Fosse Ardeatine, Ara di Martiri XXIV Marzo MCMXXXXIV," *Capitolium* (1949): 65–76; see also "VI Anniversario dell'Eccidio alle Fosse Ardeatine," *Capitolium* (1950): 91–98.

33. Rossi, *Roma, Guida all'architettura moderna,* 164–165.

34. Angelo Del Boca, "The Myths, Suppressions, Denials, and Defaults of Italian Colonialism," in Patrizia Palumbo, ed., *A Place in the Sun: Africa in Italian Colonial Culture from Post-Unification to the Present* (Berkeley: University of California Press, 2003), 21–25; *New York Times,* December 26, 1998 and December 9, 2003.

35. A copy of the painting appears in Galeazzi, *Sabaudia,* 103.

36. Alexander De Grand, "Cracks in the Façade: The Failure of Fascist Totalitarianism in Italy 1935–9," *European History Quarterly* 21:4 (October 1991): 526.

37. Robert O. Paxton, *The Anatomy of Fascism* (New York: Knopf, 2004): 171.

BIBLIOGRAPHY

SOURCES

ARCHIVES AND SPECIAL COLLECTIONS

Archivio Centrale dello Stato (ACS)
Partitio Nazionale Fascista, Mostra della Rivoluzione Fascista
Partito Nazionale Fascista, Servizi Vari
The Wolfsonian, Florida International University (Wolfsonian Collection)

NEWSPAPERS AND PERIODICALS

Almanacco Fascista del "Popolo d'Italia"
Architettura
Casabella
Capitolium
Corriere della Sera
Emporium
National Geographic Magazine
New York Times
Il Popolo d'Italia
Travel in Italy

GUIDE BOOKS

Attraverso L'Italia. Vol. 9 *Roma, Parte I.* Milan: Consociazione Turistica Italiana, 1941.
———. Vol. 10 *Roma, Parte II.* Milan: Consociazione Turistica Italiana, 1942.
———. Nuova Serie. *Roma, Parte Prima.* Milan: Touring Club Italiano, 1960.
———. Nuova Serie. *Roma, Parte Seconda.* Milan: Touring Club Italiano,1960.
Baedeker's Italy from the Alps to Naples. Leipzig: Karl Baedeker, Publisher: 1928.
Guida d'Italia della Consociazione Turistica Italiana, Roma e Dintorni. Milan: Consociazione Turistica d'Italia, 1938.

Guida Breve. Vol. II Italia Centrale. Milan: Consociazione Turistica Italiana, 1939.
Guida Breve. Vol. II Italia Centrale: Milan: Touring Club Italiano, 1949.*

BOOKS AND ARTICLES

Alfieri, Dino, and Luigi Freddi. *Mostra della Rivoluzione Fascista.* Rome: Partito Nazionale
Fascista, 1933. Facsimile edition. Milan: Industrie Grafiche Italiana, 1982.

Caetani, Gelasio, "By Draining the Malarial Wastes Around Rome, Italy Has Created a Promised
Land." *National Geographic Magazine* 66: 2 (August 1934): 200–217.

Calza, Guido. "The Via dell'Impero and the Imperial Fora" *Journal of the Royal Institute of British
Architects* (March 1934): 489–508.

Dizionario Mussoliniano: 1500 Affermazioni e Definizioni del Duce. Milan: Milanostampa—
Farigliano, 1992.

Finer, Herman. *Mussolini's Italy.* New York: Grosset & Dunlap, 1965. Originally published 1935.

Gargano, Francesco. *Italiani e stranieri alla Mostra della Rivoluzione Fascista.* Rome: SAIE,1935.

Hullinger, Edwin Ware. *The New Fascist State: A Study of Italy under Mussolini.* New York: Rae D.
Henkle, 1928.

La Bella. *Piccolo Albo di Cultura Fascista.* Milan: Castano Primo, 1934.

Ludwig, Emil. *Talks with Mussolini.* Boston: Little Brown, 1933.

Missiroli, Mario. *What Italy Owes to Mussolini.* Translated by Edward Hamilton. London: John
Heritage The Unicorn Press, 1938.

Muñoz, Antonio. *Via dei Monti e Via del Mare.* 2nd edition. Rome: Governatorato di Roma, 1932.

———. *Via dei Trionfi.* Rome: Governatorato di Roma, 1933.

———. *Via del Circo Massimo.* 2nd edition. Rome: Governatorato di Roma, 1934.

———. *Roma di Mussolini.* Milan: Fratelli Treves, 1935.

———. *Parco di Traino.* Rome: Biblioteca d'Arte, 1936.

Mussolini, Benito. *Opera Omnia di Benito Mussolini.* 36 vols. Eds. Edoardo and Dulio Susmel.
Florence: La Fenice, 1951–63.

Nevils, W. Coleman. "Augustus—Emperor and Architect." *National Geographic Magazine* 74: 4
(October 1938): 534–555.

Patric, John. "Imperial Rome Reborn." *National Geographic Magazine* 71:3 (March 1937): 269–325.

Prezzolini, Giuseppe. *Italy.* Florence: Valacchi Publisher, 1939.

Roberts, Mrs. Kenneth. "Sojourning in Italy of Today." *National Geographic Magazine* 70:3 (Sep-
tember 1936): 351–396.

Schneider, Herbert W. *The Fascist Government of Italy.* The Governments of Modern Europe. New
York: Van Nostrand, 1936.

Schüller, Sepp. *Das Rom Mussolinis, Rom als Moderne Haupstadt.* Dusseldorf: Mosella-Verlag, 1943.

SECONDARY SOURCES

BOOKS AND ARTICLES

Ades, Dawn, Tim Benton, David Elliott, and Iain Boyd Whyte, eds., *Art and Power: Europe under
the Dictators 1930–1945.* London: Hayward Gallery, 1995.

* Mussolini's campaign in the late 1930s to purge the Italian language of foreign words in-
cluded changing the name of the Touring Club Italiano to the Consociazione Turistica Ital-
iana. After the war it went back to the original Touring Club Italiano.

Agarossi, Elena. *A Nation Collapses: The Italian Surrender of September 1943*. Translated by Harvey Ferguson II. Cambridge: Cambridge University Press, 2000.

Agnew, John. *Rome*. World Cities Series, New York: John Wiley & Sons, 1995.

Aicher, Peter. "Mussolini's Forum and the Myth of Augustan Rome," *The Classical Bulletin* 76:2 (2000): 117–139.

Allason, Barbara. *Memorie di un antifascista*. Milan: 1961. Originally published 1947.

Antliff, Mark. "Fascism, Modernism, and Modernity," *The Art Bulletin* 84:1 (March 2002): 148–69.

Ben-Ghiat, Ruth. *Fascist Modernities: Italy, 1922–1945*. Berkeley: University of California Press, 2001.

Berezin, Mabel. *Making the Fascist Self: The Political Culture of Interwar Italy*. Ithaca: Cornell University Press, 1997.

Bondanella, Peter. *The Eternal City: Roman Images in the Modern World*. Chapel Hill: University of North Carolina Press, 1987.

Bosworth, R. J. B. "Tourist Planning in Fascist Italy and the Limits of a Totalitarian Culture." *Contemporary European History* 6:1 (1997): 1–25.

———. *The Italian Dictatorship: Problems in the Interpretation of Mussolini and Fascism*. London: Arnold, 1998.

———. *Mussolini*. London: Arnold, 2002.

Braun, Emily. *Mario Sironi: Art and Politics under Fascism*. Cambridge: Cambridge University Press, 2000.

Cannistraro, Philip V. *La Fabbrica del Consenso, Fascismo e Mass Media*. Rome-Bari: Laterza, 1975.

———. ed., *Historical Dictionary of Fascist Italy*. Westport, Conn.: Greenwood Press, 1982.

———. "Mussolini's Cultural Revolution, Fascist or Nationalist?" *Journal of Contemporary History* 7 (1972): 127–154.

Cannistraro, Philip V., and Brian R. Sullivan. *Il Duce's Other Woman*. New York: William Morrow, 1993.

Caporilli, Memmo and Franco Semeoni. *Il Foro Italico e lo Stadio Olimpico, Immagini della Storia*. Rome: Tomo, 1991.

Cardelli, Luisa, ed. *Gli Anni del Governatorato (1926–1944)*. Rome: Kappa, 1995.

Cederna, Antonio. *Mussolini Urbanista: Lo sventramento di Roma negli anni del consenso*. 5th ed. Rome-Bari: Laterza, 1981.

Ciucci, Giorgio. "Italian Architects during the Fascist Period." *Harvard Architecture Review* 6 (1987): 76–87.

———. *Gli Architetti e il Fascismo: Architettura e città 1922–1944*. Turin: Einaudi, 1989.

Comitato dei Monumenti Moderni. *Il Foro Italico*. Rome: Clear, 1990.

Corner, Paul. "Italy 1915–1945: Politics and Society." In George Holmes, ed., *The Oxford History of Italy*. Oxford: Oxford University Press, 1997: 264–290.

De Felice, Renzo. *Mussolini il duce, Gli anni del consenso 1929–1936*. Milan: Einaudi, 1974.

Comune di Milano. *Annitrenta: arte e cultura in Italia*. Milan: Mazzotta, 1982.

De Grand, Alexander. "Cracks in the Façade: The Failure of Fascist Totalitarianism in Italy 1935–9." *European History Quarterly* 21:4 (October 1991): 515–35.

———. *Italian Fascism*. 3rd edition. Lincoln and London: University of Nebraska Press, 2000.

De Grazia, Victoria. *The Culture of Consent: Mass Organization of Leisure in Fascist Italy*. Cambridge: Cambridge University Press, 1981.

———. *How Fascism Ruled Women: Italy, 1922–1945*. Berkeley: University of California Press, 1992.

De Guttry, Irene. *Guida di Roma Moderna dal 1870 ad Oggi*. Rome: De Luca, 2001.

De Rosa, Luigi, ed., *Roma del Duemila*. Storia di Roma dall'antichità ad oggi. Rome-Bari: Laterza, 2000.

Del Boco, Angelo. "The Myths, Suppressions, Denials, and Defaults of Italian Colonialism." In Patrizia Palumbo, ed. *A Place in the Sun, Africa in Italian Colonial Culture from Post-Unification to the Present.* Berkeley: University of California Press, 2003: 17–36.

Doordan, Denis P. "The Political Content in Italian Architecture during the Fascist Era," *The Art Journal* (1983): 121–131.

———. *Building Modern Italy: Italian Architecture 1914–1936.* New York: Princeton Architectural Press, 1988.

Duca, Mirella, and Filippo Murgia. "Libera: il Palazzo delle Poste the post office built, Roma." *L'architecttura cronache e storie, The Architecture events & history.* 47 no. 549 (July 2001): 414–421.

Fascismo e antifascimo: Lezioni e testimoniznze. 2 vols. Milan: Feltrinelli, 1971.

Eden, Anthony. *The Memoirs of Anthony Eden, Earl of Avon.* Boston, 1962.

Etlin, Richard. *Modernism in Italian Architecture, 1890–1940.* Cambridge, Mass.: MIT Press, 1991.

Falasca-Zamponi, Simonetta. *Fascist Spectacle: The Aesthetics of Power in Mussolini's Italy.* Berkeley: University of California Press, 1997.

Fioravanti, Gigliola. ed., *Mostra della Rivoluzione Fascista, Inventario.* Rome: Ministero per i beni culturali e ambientali, 1990.

Fogu, Claudio. "Fascism and *Historic* Representation: The 1932 Garibaldian Celebrations." *Journal of Contemporary History* 31:2 (April 1996): 317–346.

———. *The Historic Imaginary: Politics of History in Fascist Italy.* Toronto: University of Toronto Press, 2003.

Foss, Clive. "Teaching Fascism: Schoolbooks in Mussolini's Italy." *Harvard Library Bulletin* 8:1 (Spring 1997): 5–30.

Fried, Robert C. *Planning the Eternal City: Roman Politics and Planning Since World War II.* New Haven: Yale University Press, 1973.

Funigiello, Joanne, and Philip J. Funigiello. "EUR, 1936–1942: Town Planning, Architecture and Fascist Ideology." *Canadian Journal of Italian Studies* 4 (1980–81): 83–103.

Galeazzi, Claudio. *Sabaudia.* Latina: Novecento, 1998.

Galeazzi Claudio, and Giogio Muratore. *Littoria/Latina, La Storia, Le Architetture.* Latina: Novecento, 1999.

Garofalo, Francesco, and Luca Veresani. *Adalberto Libera.* New York: Princeton Architectural Press, 1992.

Gazzini, Tiziana. "Invisible Architecture." *Follow Me* 3:19 (May 1991): 46–52.

Gentile, Emilio. "Fascism as a Political Religion." *Journal of Contemporary History,* 25 (1990): 229–251.

———. "The Conquest of Modernity: From Modernist Nationalism to Fascism," *Modernism/Modernity* 1 (September 1994): 54–57.

———. *The Sacralization of Politics in Fascist Italy.* Translated by Keith Botsford. Cambridge, Mass.: Harvard University Press, 1996.

Ghirardo, Diane. "Italian Architects and Fascist Politics: An Evaluation of the Rationalists Role in Regime Building." *Journal of the American Society of Architectural Historians* 39:2 (May 1980): 109–127.

———. *Building New Communities: New Deal America and Fascist Italy.* Princeton: Princeton University Press, 1989.

———. "From Reality to Myth: Italian Fascist Architecture in Rome." *Modulus 21,* The Architectural Review at the University of Virginia (1991): 10–33.

———. "Architects, Exhibitions, and the Politics of Culture in Fascist Italy," *JAE, Journal of Architectural Education* (February 1992): 67–75.

———. "*Città Fascista:* Surveillance and Spectacle." *Journal of Contemporary History* 31 (1996):347–372.

Gillette, Aaron. *Racial Theories in Fascist Italy.* Routledge: London and New York, 2002.

Hannan, Philip M. *Rome: Living Under the Axis.* McKees Rocks, Penn.: St. Andrew's Productions, 2003.

Helstosky, Carol. *Garlic & Oil: Food and Politics in Italy.* Oxford and New York: Berg, 2004.

Hirschorn, Clive. *The Hollywood Musical.* New York: Crown, 1981.

Insolera, Italo. *Roma Moderna: Una secolo di storia urbanistica.* Turin: Einaudi, 1962.

———. *Roma fascista nelle fotografie dell'Istituto Luce.* Rome: Riuniti, 2001.

Ispsen, Carl. *Dictating Demography: The Problem of Population in Fascist Italy.* Cambridge: Cambridge University Press, 1996.

Irace, F. "L'Utopie Nouvelle: L'Architecttura delle Colonie Estive/Building for a New Era: Health Services in the '30s," *Domus* 659 (March 1985): 2–11.

Kahn, Robert, ed., *City Secrets-Rome.* New York: The Little Bookstore, 1999.

Katz, Robert. *Death in Rome.* New York: Macmillan, 1967.

———. *Black Sabbath: A Journey through a Crime.* (New York: Macmillan, 1969.

———. *The Battle for Rome: The Germans, the Allies, the Partisans, and the Pope.* New York: Simon & Schuster, 2003.

Knox, MacGregor. *Mussolini Unleashed, 1939–1941: Politics and Strategy in Fascist Italy's Last War.* Cambridge: Cambridge University Press, 1982.

———. "Conquest, Foreign and Domestic, in Fascist Italy and Nazi Germany." *Journal of Modern History* 56 (March 1984): 1–57.

———. *Hitler's Italian Allies: Royal Armed Forces, Fascist Regime, and the War of 1940–1943.* Cambridge: Cambridge University Press, 2000.

Koon, Tracy H. *Believe, Obey, Fight: Political Socialization of Youth in Fascist Italy, 1922–1943.* Chapel Hill: University of North Carolina Press, 1985.

Kostof, Spiro. *The Third Rome, 1870–1950: Traffic and Glory.* Berkeley: University Art Museum, 1973.

Lambase, Sergio. *Storia Fotografica di Roma 1930–1939: L'Urbe tra autarchia e fasti imperiali.* Naples: Intra Moenia, 2003.

La Penna, Antonio. "Il culto della romanità: La rivista 'Roma' e Istituto di studi romani." *Italia Contemporanea* 217 (December 1999): 605–630.

Luzzato, Sergio. *L'Immagine del duce: Mussolini nelle fotografie dell'Istituto Luce.* Rome: Riuniti, 2001.

Lyttelton, Adrian, ed. *Liberal and Fascist Italy, 1900–1945.* The Short Oxford History of Italy. Oxford: Oxford University Press, 2002.

MacDonald, William L. "Excavation, Restoration, and Italian Architecture of the 1930s." In Helen Searing, ed., *In Search of Modern Architecture.* New York: Architectural History Foundation, 1982: 298–319.

Mack Smith, Denis. *Mussolini's Roman Empire.* New York: Viking Press, 1976.

———. *Mussolini.* NewYork: Alfred A. Knopf, 1982.

Masson, Georgina. *The Companion Guide to Rome.* Companion Guides. Revised by Tim Jepson. Suffolk, UK, and Rochester, NY: Boydell & Brewer, 2000.

Millon Henry A., and Linda Nochlin, eds. *Art and Architecture in the Service of Politics.* Cambridge, Mass.: MIT Press, 1978.

Minor, Heather Hyde. "Mapping Mussolini: Ritual and Cartography in Public Art during the Second Roman Empire," *Imago Mundi:* The International Journal for the History of Cartography 51 (1999): 147–161.

Murelli, Duca, and Filippo Murgia. "Libera: il Palazzo delle Poste the post office built, Roma." *L'architettura cronache e storie, the Architecture events & history.* 47 (2001): 414–421.

Painter, Borden W. "Mussolini and Italian Fascism." *Cesare Barbieri Courier.* Hartford: Trinity College, 1980.

————. "Renzo De Felice and the Historiography of Italian Fascism." *American Historical Review* 95:2 (April 1990): 391–405.

————. "American Films in Fascist Propaganda: The Case of the Exhibition of the Fascist Revolution, 1942–43." *Film & History* 22:3 (September 1992): 100–111.

Paxton, Robert O. *The Anatomy of Fascism*. New York: Knofp, 2004.

Portelli, Alessandro. *The Order Has Been Carried Out: History, Memory, and Meaning of a Nazi Massacre in Rome*. New York: Palgrave Macmillan, 2003.

Pound, Ezra. *Jefferson and/or Mussolini: L'Idea Statale, Fascism as I Have Seen It*. New York: Liveright, 1955 [originally published 1935].

Pugliese, Stanislao G. *Desperate Inscriptions: Graffiti from the Nazi Prison in Rome 1943–1944*. Boca Raton: Bordighera Press, 2002.

Redi, Riccardo, ed. *Cinema italiano sotto il fascismo*. Venice: Marsilio, 1979.

Reed, Henry Hope. "Rome: The Third Sack." *The Architectural Review* 107:638 (February 1950): 91–110.

Rogers, Ernesto. "L'esperienza degli architetti." *Fascismo e antifascismo (1918–1936), Lezioni e testimonianze*. 3rd edition. Milan: Feltrinelli, 1971. 335–339.

Rossi, Giuseppe Aldo. *Monte Mario: Profilo storico, artistico e ambientale del colle più alto di Roma*. Rome: Montimer, 1996.

Rossi, Piero Ostilio. *Roma: Guida all'archietettura moderna 1909–2000*. Rome-Bari: Laterza, 2000.

Russo, Antonella. *Il fascismo in mostra*. Rome: Riuniti, 1999.

Schnapp, Jeffrey T. "Epic Demonstrations: Fascist Modernity and the 1932 Exhibition of the Fascist Revolution." In Richard J. Golsan, ed., *Fascism, Aesthetics, and Culture*. Hanover, New Hampshire: University Press of New England, 1992.

Schumacher, Thomas L. *Surface and Symbol: Giuseppe Terragni and the Architecture of Italian Rationalism*. New York: Princeton Architectural Press, 1991.

Scrivener, Jane. *Inside Rome with the Germans*. New York: Macmillan, 1945.

Snowden, Frank. "From Triumph to Disaster: Fascism and Malaria in the Pontine Marshes, 1928–1946." In John Dickie, John Foot, and Frank Snowden, eds., *Disastro! Disasters in Italy Since 1860: Culture, Politics, Society*. New York: Palgrave, 2002. 113–140.

Spinosa, Antonio. *Salò: Una storia per immagini*. Milan: Mondadori, 1992.

Stille, Alexander. *Benevolence and Betrayal: Five Italian Jewish Families under Fascism*. New York: Simon & Schuster, 1991.

Stone, Marla. "Staging Fascism: The Exhibition of the Fascist Revolution." *Journal of Contemporary History* 28:2 (April 1993): 215–243.

————. *The Patron State: Culture & Politics in Fascist Italy*. Princeton: Princeton University Press, 1998.

Strappa, Giuseppe, and Gianni Mercurio. *Architettura Moderna a Roma e nel Lazio 1920–1945*. Rome: EdilStampa, 1990.

Tobia, Bruno. *L'Altare della Patria*. Bologna: Mulino, 1998.

Toschi, Livio. "Uno Stadio Per Roma, dallo Stadio Nazionale al Flaminio (1911–1959)." *Studi Romani* 28:1–2 (January-June 1990): 83–97.

Touring Club Italiano. *Lazio*. Milan: Touring Editore, 1999.

Valli, Roberta Suzi. "Riti del Ventennale." *Storia contemporanea* 24:6 (December 1993): 1019–1055.

Visser, Romke. "Fascist Doctrine and the Cult of *Romanità*" *Journal of Contemporary History* 27 (1992): 5–22.

Ward, David. *Antifascisms: Cultural Politics in Italy, 1943–46*. Madison, NJ, and London: 1996.

Wise, Michael. "Dictator by Design," *Travel and Leisure* (March 2001): 102–108.

Woodward, Christopher. *Rome*. The Buildings of Europe. Manchester and New York: Manchester University Press, 1995.

Zuccotti, Susan. *Under His Very Windows: The Vatican and the Holocaust in Italy*. New Haven: Yale University Press, 2000.

INDEX

(**Bold** indicates illustration)

Agro Pontino (Pontine Marshes), 21, 63, 84–90, **85**, 105, 141, 148, 161
 towns
 Aprilia, 85, 86, 89, 90
 Littoria (Latina), 85, 86–88, **88**, 89–90
 Pomezia, 85, 86, 89, 90
 Pontinia, 85, 86, 89
 Sabaudia, 62, 63, 85–90
Alfieri, Dino, 27, 117
Allason, Barbara, 28
antifascism, xvi, xvii, xix, 116, 147, 152, 153, 157
 see also resistance
anti-Semitism, *see* Jews
Anzio, 85, 90, 148, 152
April 21 (Birthday of Rome), 4, 7, 9, 10, 12, 24, 32, 70, 124, 134, 144
Ara dei Caduti Fascisti (Altar of the Fallen Fascists), 35–36, 53, 54
Ara Pacis, 73, 74
architecture, 5, 6, 18–19, 26, 44, 46, 47, 59–63, 64, 65, 67, 81, 85, 89, 102, 109, 119, 122, 127, 156
Architettura, 44, 51, 60, 61, 127, 128
Arch of Constantine, 25, 31, 120, 147
Arch of Janus, xvi, 10, **13**
Aschieri, Pietro, 14, 61, 63, 80, 110
Augustus, emperor, 3, 9, 10, 73–76, 112, 120, 131
 tomb of, 4, 37, 73, **75**, 95
Auschwitz, 148–9
autarchy, 33, 83, 98, 109, 161
Aventine Hill, 31, 33, 50, 51, 53, 105–7

Badoglio, Marshal Pietro, 68, 139, 145, 146
Bacelli, Guido, 133
Basilica of Maxentius, 22, 24, 46
Baths of Caracalla, 52, 132
Bazzani, Cesare, 47, 78
Bellini, Aroldo, 44
Ben-Ghiat, Ruth, xviii
Bentivegna, Rosario, 149–50
Berlusconi, Silvio, 158
Bertolucci, Bernardo, 145
Bianchi, Michele, 54
Bobbio, Norberto, xvii
Boncampagni, Prince Francesco Ludovisi, 5, 17, 47, 98
bonifica, 85–86, 90, 105, 161
Borghese, Prince Gian Giacomo, 5
Bottai, Giuseppe, 5, 31–2, 53, 70, **70**, 115, 127, 157
Brasini, Armando, 47, 108
bridges
 Duca d'Aosta, **16**, 40, 48
 Littorio (Matteotti), 12, 14, 153
 Principe Amedeo Savoia Aosta, 142
 XVIII Ottobre (Flaminio), 49, 142
Bruce, Virginia, 138
Brunetto, Giovanni, 96
Buozzi, Bruno, 108
Busiri Vici, Andrea, 110
Busiri Vici, Clemente, 110

Caetani, Gelasio, 86
Calza, Guido, 24
Calza Bini, Giorgio, 110
Campo Dux, 49–50, 108
Campo Sportivo Guardabassi, 52, 133

Canevari, Angelo, 42
Canevari, Silvio, 41
Cannistraro, Philip, xviii
Capitoline Hill (Campidoglio), xv, 4, 7, 9, 10, 12, 31, 32, 35–36, 53
Capitolium, 4
Capizzano, Achille, 42
Cappelletti, Goffredo, 98
Capponi, Carla, 94, 150
Capponi, Giuseppe, 61, 64, 65
Casa Littoria (Palazzo del Littorio), 24, 29–30, 46–48, **48**, 106, 136, 144
Casa di Lavoro per i Ciechi di Guerra, 14
Casa Madre dei Mutilati, 14, **15**, 36
Casa delle Massaie Rurali, 94
Casabella, 61, 120, 127, 128
Caserma Mussolini, 110, **111**
Castel Sant'Angelo, 14, 36
Cataldi, Amelto, 49
Cederna, Antonio, xvii
Celian Hill (Celio), 31
Centro Sperimentale di Cinematografico, 117
Chamberlain, Austin, 29
Chaplin, Charlie, 120
Chiarini, Luigi, 117
Christian Democratic Party (DC), 157
churches, 112
 Aracoeli, 10
 San Andrea della Valle, 46, 70
 Santa Balbina, 112
 Cristo Re, 112
 Cuore Immacolato di Maria, 108
 San Carlo alle Quattro Fontane, 136
 San Giorgio in Velabro, 10, 112
 San Giovanni dei Fiorentini, 142
 San Lorenzo fuori le Mura, basilica, 145
 Santa Maria della Consolazione, 35
 Santa Maria in Cosmedin, 10, 144
 Santa Maria della Vittoria, 133
 San Nicola in Carcere, 10
 San Paolo fuori le Mura (St. Paul's outside the Walls) 143
 San Pietro, (St. Peter's) basilica, xv, 24, 69, 70, 71
 San Pietro e Paolo (EUR), 131
 Santa Prisca, 106
 Santa Rita, 10
 San Roberto Bellarmino, 108, 110
 San Saba, 95

Santa Sabina, 53, 106, 112
Santa Susanna, 135
Churchill, Sir Winston, 146
Ciano, Galeazzo, 117, 121, 134, 145
Cini, Vittorio, 127
Cinecittà, xv, 117, 158
Circus Maximus, xvi, 30–31, 32–33, 50, 51, 52, 54, 73, 78, **81**, 92, 106, 120, 125, 132, 147
 exhibits in, 79–84
Città Universitaria (University of Rome), xv, 60, 63–66, **65**, 127, 158
Ciucci, Giorgio, xvii
Clark, General Mark, 152
colonia elioterapica, 46
Colosseum, xv, 9, 22, **23**, 25, 31, 32, 46, 50, 98, 105, 120, 123, **143**, 147, 150, 152
Communist Party (PCI), 1, 157
Constantine, emperor, 131
Cooper, Gary, 138
corporatism, 38, 116
Corso Risorgimento, 70–71, 95
Corso Trieste, 55, 100, 110
Costantini, Constantino, 41, 44, 49
Costantini, Innocenzo, 96, 107
Crawford, Broderick, 138
Cremonesi, Ignazio, 5

D'Annunzio, Gabriele, 115
Dante, 115
Decennale (Tenth Anniversary of the March on Rome), 21, 25–26, 40, 46
De Grand, Alexander, 162
De Felice, Renzo, 116
De Grazia, Victoria, 80
De Renzi, Mario, 27, 61, 67, 81, 83, 84, 100, 102, 110
Del Debbio, Enrico, 14, 40, 41, 46, 47, 61
Di Castro, Angelo, 110
Dini, Lamberto, 158
Di Veroli, Michele, 150
Domus Aurea, 31
Dopolavoro, Operazione Nazionale (OND), 29, 33, 51, 53, 82, 88

Eden, Sir Anthony, 29
El Alamein, battle of, 139, 144
Esquiline Hill, 31

Ethiopia, xvi, 145, 157–58
 conquest of, 14, 43, 47, 69, 82, 83,
 117–19, 124, 132
EUR (Esposizione Universale di Roma), xv,
 xvi, 60, 76, 96, 122, 125–31, **128**,
 130, 132, 143–5, 156, 158, **160**
Evans, Robert, 46
Exhibitions
 Mostra Augustea della Romanità, 20,
 75–7, **76**, 121, 131
 Mostra Autarchica del Minerale Italiano,
 33, 83–84,
 Mostra delle Colonie Estive (Summer
 Camps), 33, 55, 79–81, **81**, 92
 Mostra del Dopolavoro, 33, 82–3
 Mostra Garibaldina, 26
 Mostra della Rivoluzione Fascista (Exhibit
 of the Fascist Revolution), 48
 1932–1934, 22, 24, 25, **27**, 30, 34,
 37–38, 46, 49, 67, 73, 75, 76, 77, 81,
 84, 136
 1937–1940, 29, 77–79, 136
 1942–1943, 29, 136–39, 152
 Mostra delle Tessile Nazionale (National
 Textiles), xvi, 33, 80, 82

Falasca-Zamponi, Simonetta, xviii
Fabrizi, Aldo, 151
Fagiolo, Mario, 67
Farinacci, Roberto, 161
fascio littorio (fascist symbol), xvi, 3, 12, 27,
 66, 74
Fasci all'Estero, 78, 81
fascist calendar (Era Fascist or E.F.), 26
Fascist Party (PNF), 1, 2, 24, 46–47, 62, 80,
 81, 82, 86, 87, 89, 106, 108, 109,
 136, 137, 148, 149, 187
Fasolo, Vincenzo, 40–41
films
 Born to Dance, 138
 Conformist, The, 145
 Flirtation Walk, 138
 Great Dictator, The, 120
 Rome Open City (Roma Città Aperta), 100,
 151–52
 Special Day, A (Una Giornata Particolare),
 100, 121–22
 They Gave Him a Gun, 138
Finer, Herman, 30, 84

Florence
 Hitler visits, 115
 Santa Maria Novella Station, 62, 63, 122
Fontana, Carlo, 10
Foro Mussolini (Foro Italico), xv, xvi, 14–16,
 15, **16**, 40–49, **42**, **44**, **48**, 51, 63, 74,
 106, 121, 122, 136, 142, 144, 153,
 158
forums, 4, 9
 Augustus, 24
 Caesar, 24
 Roman, 9, 24, 36, 43
 Trajan, 24
Foschieri, Arnaldo, 47, 64
Fosse Ardeatine, 147, 150, **155**
Frankl, Wolfgang, 109
Franzi, Gino, 109
Freddi, Luigi, 27, 117
Funi, Achille, 130

Galleria Amedeo Savoia Aosta, 142
Garibaldi, Anita, 26, 54
Gelsomini, Manlio, 147
Gentile, Giovanni, 53
Ghirardo, Diane, xvii, 62, 89
Giglio, Giulio, 76
Giovannoni, Gustavo, 69, 143
Giovinezza, 2, 28
Goebbels, Joseph, 29, 121
Göring, Hermann, 29
Governatorato di Roma, 4, 9, 31, 32, 33, **34**,
 53, 54, 55, 59, 94, 98, 99, 100, 102,
 105, 108, 132, 134
Guerrini, Giovanni, 79, 83, 128
Guidi, Giorgio, 96
Guidi, Ignazio, 55

Hannan, Archbishop Philip, 35, 121
Hess, Rudolf, 121
Hitler, Adolf, xvi, 59, 69, 74, 79, 116,
 119–22, 141, 144, 145, 147, 148,
 149, 153, 156, 161–62
Hotel Bristol, 136
Holy Year
 1933, 27
 1950, 70
hospitals, 93, 112–13
 Ospedale Littorio, 112
 Sanitoro Carlo Forlanini, 112

housing
 borgate, 22, 93–5, 96, 99, 112
 Acilia, 94
 Presnestina, 94
 Gordiani, 94
 Primavalle, 94, 95
 Tiburtina, 94, 95
 case convenzionate, 97, 98–105, **101**, **102**,
 107, 110
 case popolari, 94, 95–98, **99**, 107, **107**,
 110
 Istituto per le Case dei Dipendenti del
 Governatorato (INCIS), 100–2, **103**
 palazzine and villini, 105, 109–11
Hullinger, Edwin Ware, 5, 7

Insolera, Italo, xvii
Istituto Nazionale delle Assicurazioni (INA),
 70, 100, 135
Istituto per le Case dei Dipendenti del
 Governatorato (INCIS), 100–2, **103**
Istituto Nazionale per la Previdenza Sociale
 (INPS), 36

Janiculum Hill, 26, 142
Jews, 33, 78–9, 86, 138, 139, 148–49, 150

Kappler, Lieutenant Colonel Herbert, 148,
 150
Keeler, Ruby, 138
Kostof, Spiro, xvi, xvii

La Padula, Ernesto, 128
Largo Argentina, 7, 8–9, **9**
Lateran Accords (1929), 43, 69, 74, 99, 112
League of Nations, 66, 69, 82, 83, 118
 sanctions, 127
 Italy withdraws from, 118
Leo X, Pope, 9
Leopardi, Giacomo,115
Libera, Adalberto, 27, 61, 67, 68, 79, 81,
 106, 111, 128, 131, 146
Lido di Ostia, xvi, 55, 68, 106, 122
Long, Breckinridge, 66
Loren, Sophia, 100, 122
Luce (L'Unione Cinematografica Educativa),
 34, 50, 79, 117, **118**
Luciano, Mario Tufaroli, 109, 110
Ludwig, Emil, 19, 26
Lungotevere Flaminia, 109, 110

McCormick, Anne O'Hare, 37
MacDonald, Ramsey, 29
MacMurray, Fred, 138
Magnani, Anna, 151
Mancini, Italo, 134
Mancini, Luigi, 83
March on Rome, xvi, 3, 7, 21, 28, 29, 34, 36,
 40, 43, 84, 113, 122, 125, 132, 137,
 142, 156
Marconi, Guglielmo, 78
Marinelli, Giovanni, 47
Marino, Roberto, 14, 125
Martini, Arturo, 64
Mastroianni, Marcello, 122
Masons, 78
Matteotti, Giacomo, 2, 12, 50
 monument to, 153, **154**
Mazzini, Giuseppe, 33
Mazzoni, Angiolo, 68, 111, 123–24
Metropolitana, 123, 133, 136, 147
Michelucci, Giovanni, 61, 94
Ministries
 Agriculture, 135
 Air Force, 14, 125
 Corporations, 38, 66, 116, 117, 125, 133,
 149, 150
 Italian Africa, (FAO), 132, 156
 Navy, 14, 125
 Popular Culture (Minculpop), xviii, 117
Minucci, Gaetano, 50, 64, 111, 130
Montecatini Chemical Company Building,
 135
Monte Mario, 40, 46
Morbiducci, Publio, 130, 134
Morpurgo, Vittorio, 47, 73, 136
Moretti, Luigi, 40, 42, 44, 46, 51, **52**, 61, 65,
 81
Mosley, Sir Oswald, 29
Movimento Italiano per l'Architettura
 Razionale (MIAR), 61
Movimento Italiano Sociale (MSI), 157, 158
Munich Conference, 161
Muñoz, Antonio, 8, 10, **13**, 31, 32, 36, 60,
 61, 73, 106, 112
Mussolini, Arnaldo, 41
Mussolini, Benito, passim,
 and architecture, xvii–xviii, 59–60, 62
 and Ethiopia, 68–69
 and Hitler, 69, 79, 116, 119–22, 141,
 147, 149

at projects and sites, xv-xvi, 7–9, 10, **13**, 16, 21, 25–26 27, 31, 32, 37, **44**, 66, 67, **67**, 69–70, **70**, 71, 73, 75, 77–8, 84, **85**, 85, 86, 87, 90, **103**, **118**, 120–21, 133, **143**, 144

and the new Rome, xv-xvii, 2–6, **15**, 23, 33–35, 36, 62, 93, 112–13, 115, 123, 124, 125, 127, **128**, 134–35, 136, 158, **160**, 161

Narducci, Roberto, 119–20
National Geographic Magazine, 61
Neighborhoods
 Appio, 54, 68, 100
 Ardeatina, 143
 Aventino, 67, 105–8
 Flaminio, 100, 108, 142
 Garbatella, 54, 96–98, **97**, 106, 143
 Ghetto, 148–49, 150
 Magliana, 133, 143
 Milvio, 68
 Monte Sacro, 111
 Nomentana, 14, 68, 97, 100, 133, 134
 Parioli, 40, 49, 105, 108–9, 110, 142
 Portuense, 142
 Prati, 102, 135
 Prenestino, 100, **102**, 151
 San Lorenzo, 145
 Testaccio, 51, 67, 95, 107, **107**, 142
 Trastevere, 51, **52**, 65, 92, **93**, 106
 Trionfale, 102
Nervi, Paolo, 50
New York Times, 36–37, 94, 120, 133, 142
Niven, David, 138

Obelisk of Axum, xvi, 132, 157–8, **159**
October 28 (Anniversary of March on Rome), 1, 7, 10, 21, 24, 26, 31, 33, 38, 50, 63, 67, 70, 86, 132, 136
Opera Nazionale per la Maternità e Infanzia (OMNI), 81, 88, 91–92, **93**, 97
Opera Nazionale per i Combattenti (ONC), 86,88
Oppo, Cipriano Efisso, 83, 143
Oriani, Alfredo, 125
Ostiense Station, xvi, 106, 119–20, 122, 123, 153, 156

Pact of Steel, 141

Pagano, Giuseppe, xviii, 44, 46, 61–62, 63, 64, 79, 81, 89, 92, 109, 120, 122, 127–28, 136
Palace of Justice (Palazzo della Giustizia), 14, 36
Paladini, Arrigo, 151
Palatine Hill, xv, 31, 33, 50, 106
Palazzo Barberini, 149
Palazzo delle Esposizioni, 26, 75
Palazzo Venezia, 2, 6, 35, 71
Palazzo Vidoni, 46
Paniconi, Mario, 43, 83, 109, 110
Pantheon, 4
Papen, Franz von, 29
Parks, 134
 Colle Oppio, 31
 Cestio (Park of the Resistance of 8 September) 106, 132, 146, 147, 153
 Traino, 32
 Villa Ada, 110, 111
 Villa Borghese, 53, 78, 108, 121
 Villa Paganini Alberoni, 134
 Villa Glori, 49, 108
Passeggiata Archeologica, 133
Paxton, Robert O., 162
Pediconi, Giulio, 43, 83, 109
Petrucci, Franco, 81
Piacentini, Marcello, 8, 14, 38, 44, 47, 49, 51, 60–62, 63–64, 65, 66, 68, 108, 112, 125, 127–28, 135–36, 143
Piano Regolatore (Master Plan of 1931), 6, 16–19, 31, 32, 107, 123, 125, 135, 142, 143
 Variante Generale del Piano Regolatore, 1942, 143–44,
piazza
 Albania, 132
 Augusto Imperatore, 73–75, **75**
 Barberini, 135–36, 149
 Bocca della Verità, 10, **13**, 32, 33, 144
 Bologna, 67, 100, 104, 109, 110
 Campitelli, 10
 Cinquecento, 123
 Domenico Sauli (Garbatella), 54
 Euclide, 108
 Independenza, 124
 La Casa dei Marescialli d'Italia, 124–25, **126**
 Mazzini, 12, 100, 102
 Montanara, 10

Navona, 63, 70, 71, **72**, 95
del Popolo, 12, 108
di Porta Capena, 132
di Porta Metronia, 102
Risorgimento, 104
Siena, 53
Ungheria, 108, 110
Venezia, xv, xvi, 2, 8, 22, 23, 24, 26, 30, 31, 32, 33, 35, 68, 106, 120, 125, 141–42, 147, 148
Piazzale Romolo e Remo (Ugo La Malfa), 33, 50, 106
Piccinato, Luigi, 107
piccone (pickaxe), 3, 37, 70, 73,
Pilsudski, Marshal Josef, 108
Pius IX, Pope, 123
Pius XI, Pope, 69, 74
Pius XII, Pope, 97, 145
Ponte, Gio, 64, 65
Pontine Marshes, *see* Agro Pontino
Il Popolo d'Italia, xv, xvi, 37, 41, 66, 110, 137, 139
Popular Party (PPI), 1
Population, 80, 87, 89
of Rome, 4, 5, 17–18, 92–93, 94, 98, 112, 113, 144
policy, 91–92
porta
Flaminia, 108
Latina, 55, 102, 110, 111
Metronia, 55, 102, **103**
Pia, 134
San Giovanni, 110
Maggiore, 123
San Paolo, xvi, 54, 67, 106, 107, 119, 132, 146–47, 153, **152**
post offices, 66–68, 93, 123
Aventine, 67, **67**, 132, 146
Piazza Bologna, 67
Viale Mazzini, 67, 68
Via Taranto, 67, 68
Ostia Lido, 68, 111, 123
Potenziani, Prince Ludovico Spada, 5
Pound, Ezra, 8
Powell, Dick, 138
Prampolini, Enrico, 28, 82
Prezzolini, Giuseppe, 39–40, 55

racial laws, *see* Jews

Reed, Henry Hope, xvii
Repubblica Sociale Italiana (RSI), 146, 151
resistance, armed, xvii, xix, 146–48, 149, 150, 151–52, **152**, 153, 155
Ribbentrop, Joachim von, 121
Ricci, Corrado, 8
Ricci, Renato, 40, 48, 51
Ridolfi, Mario, 67, 109
Risorgimento, 3, 26, 28, 73, 115, 124, 134–35, 142
Rogers, Ernesto, 60
Roman Empire, 61, 68, 77
Romanelli, Romano, 132
romanità, 3, 5, 22–23, 27, 29, 34, 64, 71–77, **76**, 131, 136, 162
Romano, Mario, 128
Rome-Berlin Axis, 115–19
Rommel, Field Marshal Erwin, 144
Roosevelt, President Franklin Delano, 142
Roosevelt, James, 29
Rossellini, Roberto, 100, 151
Rossi, Ettore, 81
Rosso, Giulio, 42, 43
Ruspoli, Prince Francesco, 150
Rutelli, Francesco, 157

Sabbatini, Innocenzo, 96, 97, 102, 107
Sacerdoti, Angelo, 33
Salò Republic, *see* Repubblica Sociale Italiana (RSI)
Samonà, Giuseppe, 68
Sarfatti, Margherita, 26, 59
Scalfaro, President Oscar Luigi, 158
Scanderberg, Giorgio
Monument to, 132
Schnapp, Jeffrey, xviii
Schneider, Herbert, 62–63
Schools, 53–57, **56**, 95, 96, 97, 102, 110, 111, 112
Scrivener, Jane (Mother Mary Saint Luke), 147
Severini, Gino, 42
Simon, Sir John, 29
Sironi, Mario, 28
Sixtus V, Pope, 9, 36
Skorzeny, Otto, 146
Società Generale Immobiliare (SGI), 99–100, 105
Spain, 161

civil war, 69, 78, 116
Sparcarelli, Attilio, 36
Stadio del PNF (Parioli), 49, 50, 108, 109
Stalin, Josef, 58, 141
Stalingrad, battle of, 139, 144
Starace, Achille, 43, 47
Statue of Fascism (Foro Mussolini), 47
Stone, Marla, xviii, 59, 77, 80, 83
streets, *see* via, viale
Stracciari, Luigi, 161
Studi Romani (Istituto Nazionale di Studi
 Romani), 5

Taylor, General Maxwell, 146
Temple of Fortuna Virilis, xvi, 10, 12, 32
Temple of Vesta, xvi, 10, 12, 32
Teatro Argentina, 7, 8
Termini Station, 22, 26, 63, 67, 122–25, 135,
 136, 142, 155
Terragni, Giuseppe, xviii, 28, 61
Theater of Marcellus, xvi, 3, 4, 9, 10, **12**, **13**,
 32, 33, 42, 145
Thomson, Valentine, 36
Titta, Armando, 68
Tracy, Spencer, 138
Travel in Italy, 6
 Umberto II, king, 156

Valle, Cesare, 55, 92, 110
Vatican, 2, 12, 14, 57, 69, 70, 74, 78, 95, 99,
 135, 157
Veroli, Carlo, 41
via
 Archimede, 109
 Amba Aradam, 111
 Andrea Doria, 102
 dell'Ara Littoria (Via San Pietro in
 Carcere), 36
 delle Botteghe Oscure, 8
 Bruxelles, 110
 Cavour, 123, 124
 del Circo Massimo, 32, 33, 50, 106
 della Conciliazione, 68–71, **70**, **71**, 95,
 105, 136, 142, 144
 Donna Olimpia, 97, 98, **99**
 Flaminia, 108, 109, 135
 Galvani, 142
 Giulia, 142
 Imperiale, xvi, 120, 132–33, 144

dell'Impero (Via dei Fori Imperiali), 21,
 22–25, **23**, **25**, 30, 31, 32, 34, 35, 36,
 46, 50, 68, 120, 147, 152, 153
della Lega Lombarda, 97
del Mare (Via del Teatro di Marcello),
 xvi, 7, 10, **11**, 12, **12**, **13**, 30, 31, 32,
 33,
34, **34**, 35, 36, 42, 106, 107, 144
Maria Adelaide, 109
Marmorata, 47, 67, **67**, 104, 106, 107,
 107, 132
Marsala, 124
dei Mille, 124
Nazionale, 24, 26, **27**, 29, 75, **76**, 121,
 124, 131
Nomentana, 55, 110, 111, 133, 134
Panama, 110
Petroselli, Luigi, 12
del Plebiscito, 8
delle Quattro Fontane, 136, 149
Porta Angelica, 104–5, **104**
Rasella, 149–50, 155
Roveretto, 14
Salaria, 55, 111
Solferino, 124
San Alberto Magno, 106
San Martino, 124
San Valentino, 109
Taranto, 54, 67, 88, 100, 102, 104
Tasso, 150–51,
 Gestapo Prison, 150
 Museo della Liberazione di Roma, 151
del Teatro di Marcello, 12
Trionfale, 102
dei Trionfi, 30, 31–32, 34, 36, 120, 121,
 132, 147
XX Settembre, 133, 136
XXIII Marzo (Via Bissolati), 133–36
Veneto, 38, 117, 125, 133, 135, 136,
 149
Vetulonia, 111
Zanardelli, 71
viale
 Adolfo Hitler (Viale delle Cave Ardeatine),
 xvi, 120, 153
 XXI Aprile, 100, **101**, 122
 Aventino (Africa), 47, 106, 120, 123,
 132–33, 142
 Europa, EUR, 131

dei Martiri Fascisti (Viale Bruno Buozzi),
 108
Mazzini, 67, 68, 104, 112
Metronio, 102
Parioli, 108
Victor Emmanuel Monument, xv, 2, **11** 23,
 23, 25, 31, 32, 33, 34, 35, 36, 54, 63,
 94, 105, 122, 148
Victor Emmanuel II, king, 148
Victor Emmanuel III, king, 1, 71, 89,
 120–21, 125, 136, 145, 146, 156
Villa Torlonia, 134
Viviani, Alessandro, 22

Walburn, Ray, 138
women, women's organizations, 39, 80,
 91–92, 94, 95, 118, 122

World War I, 3, 14, 25, 34, 78, 95, 108, 137,
 162
World War II, xix, 24, 33, 60, 90, 108,
 141–52, 153, 161–62

youth, 2, 5, 14, 16, 39–40, **40**, 44, **44**, 46,
 49–50, 52, 63, 77, 79, 87, 88, 89, 92,
 108, 112, 121
 organizations
 Avanguardisti, 49
 Balilla (ONB), 40, 44, 48, 49, 50, 51, 54,
 80, 81, 106
 Gioventù Italiano del Littorio (GIL),
 48–9, 51, 65, 88, 111, 122
 Gioventù Università Fascista (GUF), 80, 81
 Piccole Italiane, 53
 Giovani Fasciste, 80

CPSIA information can be obtained
at www.ICGtesting.com
Printed in the USA
LVHW031733270123
738099LV00005B/284

9 781403 980021